the camera i

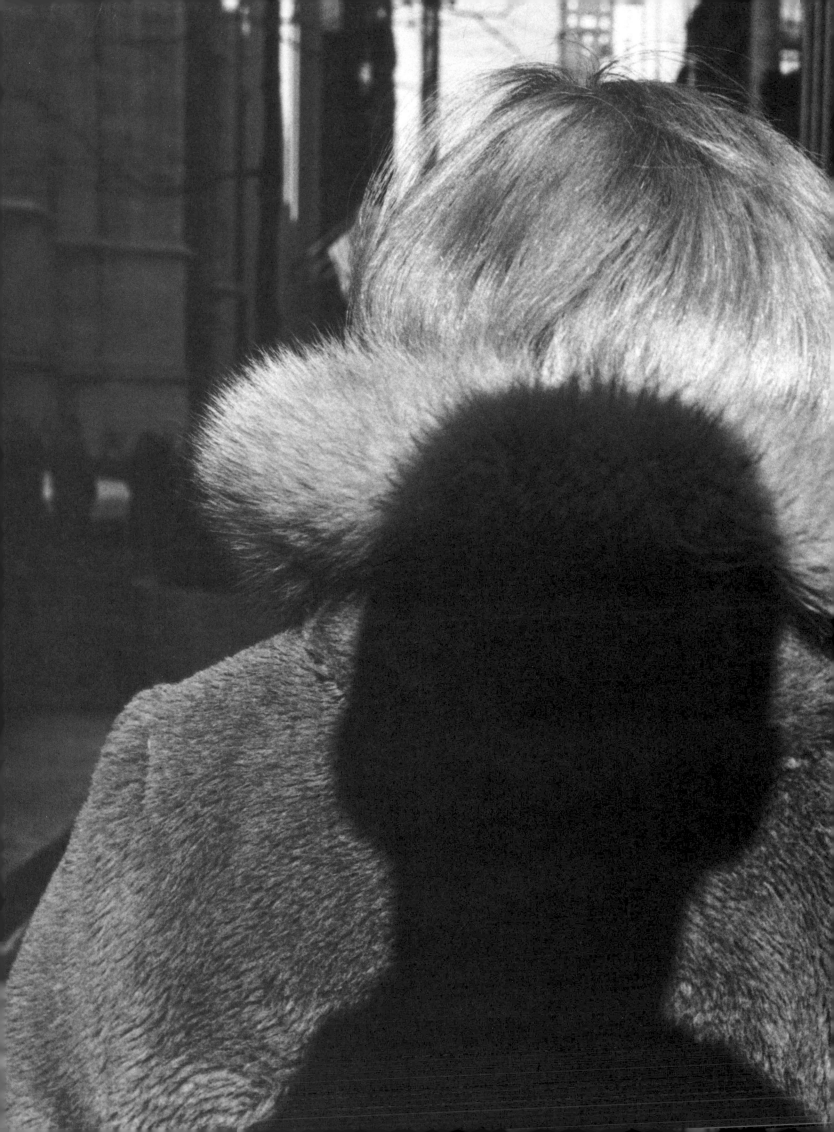

"For however dutifully we record what we see around us, the common denominator of all we see is always, transparently, shamelessly, the implacable "I""

Joan Didion

Robert A. Sobieszek

Deborah Irmas

the

LOS ANGELES COUNTY MUSEUM OF ART | HARRY N. ABRAMS, INC., PUBLISHERS

camera i

Photographic Self-Portraits from
the Audrey and Sydney Irmas Collection

Copublished by

Los Angeles County
Museum of Art
5905 Wilshire Boulevard
Los Angeles, CA 90036
and
Harry N. Abrams, Inc.,
Publishers
100 Fifth Avenue
New York, NY 10011

This book was published in
conjunction with the exhibition
The Camera I: Photographic
Self-Portraits from the Audrey
and Sydney Irmas Collection.

Exhibition Itinerary
Los Angeles County
Museum of Art
August 11–October 23, 1994

Akron Art Museum
November 19, 1994–
January 15, 1995

Det Nationalhistoriske
Museum på Frederiksborg,
Hillerød, Denmark
March 23–June 4, 1995

The Audrey and Sydney Irmas
collection of photographic
self-portraits was donated
to the museum in 1992 via the
Irmas Intervivos Trust of
June 7, 1982.

LIBRARY OF CONGRESS CATALOG
CARD NUMBER: 94-75974
ISBN: 0-8109-3197-4 (CLOTH)
ISBN: 0-87587-171-2 (PAPER)

COVER:
Ralph Bartholomew, Jr.
Self-Portrait, 1940s
PLATE 74

FRONTISPIECE:
Lee Friedlander
New York City, 1966, 1966
PLATE 101

Editor
Chris Keledjian
Designer
Pamela Patrusky
Photographers
Peter Brenner and Steve Oliver
Printer
Nissha Printing Co., Ltd.,
Kyoto, Japan

Contents

In April of 1992 Audrey and Sydney Irmas donated their collection of photographic self-portraits to the Los Angeles County Museum of Art, a highly generous act of philanthropy occasioned by the dual realization that the collection had grown too vast for their private delectation and much too important to remain hidden from public view. They had begun acquiring photographic fine art more than fifteen years earlier and specializing in self-portraiture in the early 1980s. By 1992 the Irmases had gathered nearly 140 works ranging from the traditional to the postmodern, each selected for its intrinsic aesthetic value as well as for its affinity with works already in their collection.

The Irmases' charitable act substantially contributed to building the photography collection at the museum not only by adding key works by a number of well-known artists but also by helping to give definition to the museum's holdings. The museum's photography collection now uniquely surveys nearly the entire history of the medium, from early salt and albumen prints to contemporary, computer-assisted images. Also, having within the museum's collection such a coherent grouping of works devoted to a single theme ensures a specialized focus that will complement those self-portraits previously owned by the museum, create a center for researchers and scholars of the subject, and set the stage for future directions and acquisitions.

The museum's curator of photography, Robert Sobieszek, worked closely with the Irmases on this exhibition and has provided a fine essay on self-portraiture for this volume, which also contains a cogent and illuminating essay by photo-historian Deborah Irmas on the formation of the collection.

Nearly every great museum's permanent collection is the result of the generosity of its benefactors. We are sincerely grateful for the enlightened support of Audrey and Sydney Irmas and their commitment to the photography collection of the Los Angeles County Museum of Art.

Stephanie Barron
Coordinator of Curatorial Affairs
Los Angeles County Museum of Art

Foreword

The Photography Department of the Los Angeles County Museum of Art, only a decade old, has a collection that is relatively modest but expanding rapidly. Since 1984 the department's holdings have grown from a few hundred to nearly five thousand prints, illustrated books, albums, and various incunabula related to this highly accessible medium. Until 1992 the collection was essentially a survey of twentieth-century international photography with certain strengths and characteristics; in that year the donation of the Audrey and Sydney

The exhibition and this publication of The Camera I: Photographic Self-Portraits from the Audrey and Sydney Irmas Collection owe much to a number of individuals, most especially the collectors themselves, who passionately assembled this vital body of work and now magnanimously share it with the public.

Specifically for this project inestimable thanks are due to Chris Keledjian, Pamela Patrusky, Howard Read III, Eve Schillo, Buzz Spector, Dale Stulz, and S. J. Youn. Finally, the exhibition checklist and biographies were compiled by Tim B. Wride, assistant curator of photography, as part of his internship with the department while a graduate student at the University of Southern California.

Preface

Irmas collection of photographic self-portraits significantly modified the complexion of the museum's holdings by incorporating the premier private collection of this genre into the museum's permanent collection.

Over the years, the Irmases were wisely counseled by their daughter, Deborah, an author and respected historian of photography, and assisted by many photography dealers and auction-house specialists who brought significant and rare images to their attention.

Robert A. Sobieszek
Curator of Photography
Los Angeles County Museum of Art

Every passion borders on the chaotic, but the

collector's passion borders on the chaos of memories.

More than that: the chance, the fate, that suffuse

the past before my eyes are conspicuously present

in the accustomed confusion of these books.

Walter Benjamin[1]

Memory does not make films, it makes photographs.

Milan Kundera[2]

Moving Pictures:

Deborah Irmas

It happened slowly, over time. Thus it is impossible to state exactly at what point this accumulation of photographs became a "collection" and we became part of those consumers designated "collectors." In 1977 a handsome group of protomodernist landscapes by Karl Struss, a member of the Photo-Secession, was acquired from a Los Angeles gallery. One of these six "pretty" platinum prints was an ordinary view of Avalon Bay, Catalina Island, and unlike the other more urban and boldly designed photographs that were selected, this one was included strictly for nostalgic reasons. It spoke to our family's collective memory, for it was on that island that my father's maternal grandparents set down roots in this country in the late nineteenth century.

Other "precollection" purchases included a complete set of the *Galerie Contemporaine*, a prototypical *People* magazine spiked with luscious portraits by such nineteenth-century French photographers as Carjat and Nadar and reproduced in the rare woodburytype process, which made photographs look like they were rendered in cocoa. As a photohistorian and instructor in the history of photography, I found these books to be useful teaching aids.

Notes on a Collection

Connoisseurship is part of the history of photography, and my students at least learned to recognize the visible differences between albumen prints, salt prints, photogravures, and other examples of photography's experimental beginnings. The recognition of and knowledge about the nineteenth century's most important writers and political leaders held less importance in the scheme of late twentieth-century education; so after my teaching career ended, these red-leather, gold-embossed tomes spent most of the 1980s unopened on a bookshelf. There they accompanied other photographic books of albumen prints and calotypes: Francis Frith's illustrated volumes of travels in the Middle East, selections from Auguste Saltzmann's views of Jerusalem's ancient architecture, and other volumes of nineteenth-century photographs of Europe and the Middle East.

1

Walter Benjamin, "Unpacking My Library: A Talk about Book Collecting," in *Illuminations*, ed. Hannah Arendt, trans. Harry Torn (New York: Schocken Books, 1969), 60.

2

Milan Kundera, *Immortality* (New York: Grove Press, 1991), 314.

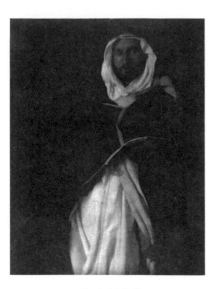

Frederick H. Evans
England, 1853–1943
Portrait of F. Holland Day in
Arab Costume, c. 1900
Platinum print
Los Angeles County
Museum of Art, gift of
the Irmas Intervivos Trust
of June 7, 1982
AC1992.197.40

12

3

Milan Kundera, *The Art of the*
Novel (New York: Grove
Press, 1988), 34.

4

See Estelle Jussim, *Slave to*
Beauty (Boston: David R.
Godine, 1981), 156–57; and
Beaumont Newhall, *Frederick*
H. Evans (Millerton, New
York: Aperture, 1973), 16.

It would appear that the germination of a "process-oriented" collection of nineteenth- and early twentieth-century photography had begun, concentrating on archeological records, travel photography, formal portraiture, and early aesthetic exercises. Instead, two rare photographs that dovetailed with earlier purchases revealed the path the collection would take. An 1862 albumen print by Nadar (Gaspard-Félix Tournachon) became the next acquisition. The bohemian redhead, known for photographing Paris from a hot-air balloon and for lending his spacious studio on the Boulevard des Capucines to the impressionists for their celebrated first exhibition, photographed himself dressed in an eighteenth-century-style wig and fringed chamois American Indian costume. He looks like a curious cross between Louis XIV and Buffalo Bill. Printed as a cabinet card, a deluxe version of a photographic calling card (and forerunner of the postcard), this image served a specific function much like other nineteenth-century travel material: it satisfied the European public's fascination for things exotic. Nadar presented himself (for business purposes, no less) as something strange and wondrous, a living, breathing Great Pyramid of Cheops or Temple of Dendur.

One wonders if Noah, quite possibly the first collector, actually sought out particular animals or they simply came to him by chance and circumstance. What part did luck play? What part determination? And what mistakes, if any, propelled him on his path nonetheless? Shortly after obtaining the Nadar we were offered a rich, dark, platinum photograph said to be a self-portrait by F. Holland Day. Day was a practitioner of pictorialism, a strategy of photographic picture making that was considered by some to be a "sin" against the "medium of veracity." The term *pictorialism* implies a sentimental representation or glorification of the past rather than a straightforward depiction of reality. For example, Day's notorious suite of photographs enacting Christ's last moments on the cross (*The Seven Last Words*, 1898–1900), posed by the semistarved photographer himself, was considered antiphotographic and, moreover, the ultimate in bad taste. Today they might be looked at as documentation of a performance/body artist on the order of Chris Burden or Gina Pane. Day was an exotic other, a character like Nadar, exemplifying what the novelist Milan Kundera called the "experimental self."[3] When a fire destroyed Day's Boston studio in 1907, his life's work went up in flames. So this dark, shadowy photograph of a man dressed in Arab robes and burnoose was believed in 1978 to be a rare find. The photograph, which was a gift from Day himself to the California photographer Louis Fleckenstein, helped to define our collecting strategy. Yet while preparing this exhibition it became clear that the photograph was, in fact, a portrait of Day by his friend Frederick Evans.[4] Nonetheless, in believing it to be a rare and beautiful self-

portrait, we were determined to begin a quest that would lead us over fifteen years to other self-portraits—even to some with uncertain identities.

The subject of self-portraiture in photography gave rise to numerous questions. What "stories" do self-portraits tell us about the people who made them? Why are they dressed in costume? If we know the photographer's larger body of work, does a self-portrait tell us something more? Something else? Can we gain insight into the character of photographic activity (in the nineteenth or twentieth century) from such self-portraits? And, I wondered, were there perhaps other histories of photography different from the "official" histories that might emerge from looking exclusively at self-portraits?

These questions were linked. One picture could speak to another, and the notion of a project began to materialize. We continued looking for photographers' images of themselves, including documents, formal portraits, commercial tests, playful exercises, and serious works of art. Without going very far, we found one. The frontispiece of Francis Frith's 1855 volume of albumen prints of Egypt and the Middle East is a photograph of a man dressed in North African costume of white trousers, striped blouse, and pointed moccasins. It is Frith himself. Another self-portrait was already there on the bookshelf!

The strategic change in American collecting and taste came with the new economic era that began in the [eighteen] eighties. The increasing population, the exploitation of natural resources, and the whole expanding economy created enormous fortunes and released men from physical labor into the pursuits and professions of a leisure class. Aline B. Saarinen[5]

Of course it can do without the El Greco, because El Greco is not a really great, not a first-class painter, Reger said, but not to have a Goya is downright fatal for a museum such as the Kunsthistorische Museum. Thomas Bernard[6]

Collecting photography was hardly fashionable in affluent West Los Angeles in the late 1970s. Photography was mostly considered, as the art historian Henri Focillon described it, "art from another planet, where music might be a mere graph of sonorities, and ideas might be exchanged without words, by wavelengths."[7] Small, colorless, often scratchy or blotchy-looking works on paper offered little in the way of appeal for most collectors. Instead, to complement the economic boom that was manifested (among other ways) in trendy restaurants, more expensive residential real estate, and museum expansion programs, Angelenos opted for large, colorful contemporary objects to display in their white-walled, gallerylike homes. It was not difficult

5
Aline B. Saarinen, *The Proud Possessors* (New York: Random House, 1958), xxxi.

6
Thomas Bernard, *Old Masters: A Comedy*, trans. Ewald Oser (Chicago: University of Chicago Press, 1992), 13–14.

7
Henri Focillon, *Form in a Work of Art* (New Haven: Yale University Press, 1942), 73.

to see that there existed during this time a preference for abstraction, especially asymmetrical, angled, bold works that made an immediate, albeit confrontational, impression. The Los Angeles County Museum of Art's seminal 1980 exhibition of Russian avant-garde art paved the way for an expansive, popular appreciation of abstract painting; the limited, rigid, color schemes born of ascetic social revolution were transformed by Los Angeles artists into a more luxurious palette that fulfilled the desires of a capitalist society verging on a decade of unbridled abundance.

Thus, to choose to own dozens of representational, mostly monochromatic objects made by (often) little-known artists was, in itself, an eccentric activity. And the fact that for almost ten years most of these purchases were hidden away in a drawer, to be looked at only occasionally, signified a manner of possessing more akin to collecting stamps or butterflies. To my parents' peers, collecting photography offered little social endorsement, and the collection was often received with indifference or outright disdain.

And then there is a curious tendency—as soon as collecting becomes part of a conscious goal—to rationalize choices based on the baseball-card or safari model: one Henry Aaron, one Sandy Koufax; one lion, one gazelle. The same can be said even about the unfashionable act of collecting photography. In the late 1970s and early 1980s it was obligatory for photography collectors to own at least one Ansel Adams print. Every collection was supposed to contain an image by the most immediately recognizable of twentieth-century photographers. If *Moonrise over Hernandez* or another of Adams's celebrated landscapes was not in evidence, something was amiss. Even a collection as acutely defined as consisting of self-portraits was subjected to the same "listing test" as other collections of photography. And most photographers—even Adams—made at least one self-portrait!

This approach is even more overt in the amassing of institutional collections. There has been an almost universal false sense of responsibility that requires the safeguarding of the safe, the preserving of the already acknowledged. Purchases of photography were often determined by what was generally considered within the "photography community" (i.e., market, publishing, institutional) as worthy. The bible for this community was for many years Beaumont Newhall's *History of Photography*. Newer collections of photography followed Newhall's selections, especially in regard to twentieth-century works, so that exhibitions of photography across the country tended to look very much alike. And while Los Angeles is today considered a center for institutional photography collections—J. Paul Getty Museum, Los Angeles County Museum of Art, Museum of Contemporary Art—the range of photography collecting fifteen years ago was narrow.

14

One overriding characteristic of the Irmas collection is that its individual components could only have been gathered in a noninstitutional atmosphere. Many of the photographs in this collection were purchased because they were objects that corresponded to particular yet personal notions of beauty and attraction. We made many quixotic and idiosyncratic choices, records of the changes in our taste over time. There were, over the past fifteen years, several periods of little purchasing—at times few images seemed engaging enough to acquire. To choose freely, because of one's interest in an image, without preexisting requirements, is often the most difficult of tasks. Learning how to wait is an equally difficult part of collecting.

My mother recognized early on that she favored the complex patinas of vintage photographs over newer prints and afterward refrained from buying anything that had been re-created for the burgeoning photography market. Bauhaus photographers Umbo (Otto Umbehr) and Herbert Bayer, for example, gained a new notoriety prior to their deaths and had made limited editions of some of their best-known works. This type of "merchandise" would no longer be purchased. The abundance of interesting vintage photographs available, even by less-acclaimed artists, allowed her to acquire broadly. Fred Archer, for instance, is not recognized today as having been an important photographer, yet the untitled surrealistic image of his face merging with the front of a large-format camera and an obedient fly resting on his trigger finger was too intriguing to resist. So was the erotically wonderful self-portrait of Pierre Molinier cross-dressed. Molinier, whose work was rarely exhibited in the United States, was appreciated for his surrealist-style paintings and repudiated for his photographs (mostly sexually charged images filled with organs and body parts), which predate by several decades Robert Mapplethorpe's similarly aggressive homoerotic studies.

But obscurity was certainly not a prerequisite. When we learned that a Diane Arbus self-portrait, dated 1945, was going to be auctioned, my mother was determined to own it. After ten years of acquiring self-portraits it seemed that this remarkable photograph was essential to a collection that, by this time, contained more than 120 works. The passion of ownership precluded any reasonable judgment of monetary value, for this image is believed to be the only self-portrait by one of the twentieth century's most important photographers. The photograph of the young woman standing next to her camera and tripod wearing only underpants was made to announce to Arbus's soldier-husband, stationed overseas, that she was pregnant. My mother correctly foresaw that this major photograph would be a cornerstone in the broad inclusionary approach of the collection, which

valued equally personal mementos, commercial tests, and deliberately invented works of art.

At some point in the practice of collecting, there is the realization that the material is indeed a corpus. Individual works have a greater relevance within the context of the collection than they might have separate from it. Patterns emerge, similarities are noticed, and subjects appear again and again. As the collection expanded, many of its images were taken out of drawers, framed, and displayed in a small room. As collecting photography became increasingly acceptable, so certain photographic issues dovetailed with those of contemporary art in the 1980s. Cindy Sherman explored her female identity in relation to the pictorial images of women in film and traditional art and became one of the decade's most important artists. Her work made it easier to recognize the programmatic disguises of Claude Cahun, née Lucy Schwob, a surrealist whose collages and male/female photographic studies explored issues of gender and identity a half-century before the emergence of this subject in the lexicon of contemporary self-portraits. William Wegman, with his posed Polacolor portraits of his weimaraner Man Ray, mocked the conventions of stylized portraiture. His black-and-white self-portrait in the collection, split horizontally through the middle and hung side by side, resembles a montage of two disparate frames of a film sequence. It prefigures Wegman's later work and testifies to his roots in video and performance. Wegman and his dog gaze at each other, while Man Ray, up on his hind legs, paws his master's torso. In this photograph touching equals looking. Similarly, *Self-Portrait*, c. 1944, by Wegman's spiritual forefather, the photographer Man Ray, proposes a touch/look equation as well. The artist points to the distorted image of his face reflected in an undulating mirror, while on the surface of the print a barely visible fingerprint in ink—a tactile residue—reiterates the intervention of touch in the moment of seeing.

8
Herve Guibert, "L'Auto-por-trait," in *L'Image fantome* (Paris: de Minuit, 1981), 64–65 (my translation).

16

Norman Rhoads Garrett's c. 1939 portrait showing his image laid upon the polished fender of his automobile or Clarence John Laughlin's reflection in the fender of a Ford cleverly reinterpreted the standard stratagem of looking into a mirror. The mirror became any reflective surface. Both of these works prefigured Lee Friedlander's cryptic self-portrait series of the 1960s and 1970s, an ongoing body of work that researched the formal language of the self photographed. The experimental pictorial devices employed in the previous photographs were elaborated upon in this series. The photograph in this collection is of Friedlander's head silhouetted in the fur collar of a woman on the street; the shadow is charged by its appearing to be within the fuzzy substance of the collar as the previous images were enlivened by their appearances on slick metal surfaces. Together the three seemed like a triumvirate within the growing collection. Yet, separated by time and circumstance, these photographs remind us that the ownership of an idea, especially as it is associated with one particular artist, is mostly a ludicrous notion.

Visual ideas exist and are only reinvented, reformulated, or simply reintroduced. In the printing of Berenice Abbott's self-portrait the photographer deliberately warped the projection of the negative so that the upper half of her face is stretched to look catlike. Fifty years later Nancy Burson reinterpreted Abbott's "woman/feline" experiment using her own computer software program. The composite image of Burson's features and those of a cat might suggest the possibility of futuristic interspecies cloning, but it also makes us wonder why these two women were fascinated with the image of themselves as felines.[9]

Other works from the collection ricochet meanings off one another in ways their creators might not have imagined. Several pictures, when juxtaposed and considered together, give rise to questions regarding the structure of the family and how members of a given family relate to the photographer. Like costumes, pets, or favorite objects, other people describe other facets of the photographer. Larry Fink presents his daughter Molly. Tony Mendoza takes us underwater on his honeymoon with his new wife. Henry Hamilton Bennett's self-portrait reminds us how families have changed during the last one hundred years. While Bennett holds tightly to the shutter release snaking its way beneath the expensive Persian rug, he seems in firm control of the positions and postures of the other members of his terrified-looking family. The photographer is the boss! In counterpoint, Eileen Cowin's 1980 family portrait testifies to the end of the era of the all-powerful dad. The father here, banished from the mother-father-child trinity, is stripped of authority, and he no longer holds the shutter release.

9

See *Photographies*, no. 4 (April 1984). The front and back covers of this issue, devoted to the self-portrait in photography, are illustrated with two woman/cat self-portraits: Wanda Wulz, *Moi plus chat*, 1932; and Dora Kallmus, *Auto-portrait*, c. 1928.

Ownership is the most intimate relationship that one can have to objects. Not that they come alive in him; it is he who lives in them. Walter Benjamin[10]

For however dutifully we record what we see around us, the common denominator of all we see is always, transparently, shamelessly, the implacable "I." Joan Didion[11]

Sometimes a pseudo-intimate relationship develops between the maker and the owner of a self-portrait. During private moments the photograph and the imagination of its owner are aligned. "Is there a secret," the owner asks, "hidden here for *me*?" When the self-portrait is fundamentally different from the usual style or method of the photographer, the search for the secret is more alluring. Even the merest trace or evidence of some hidden reference can stimulate this imaginative game. Cropped bodies, shadows, or partially obscured faces do not limit our capacity to invent imaginary truths about these subjects. Walker Evans's 1927 self-portrait shows his shadow in profile against a blank wall. How incongruous that Evans, celebrated for his clear, modern, direct, detailed, and deeply penetrating portraits of American sharecroppers, represents himself through a silhouette reminiscent of an eighteenth-century cutout. But this contradiction could be the secret, one we imagine tells us something about him we are not supposed to know. Evans's Farm Security Administration colleague Jack Delano photographs himself in an alley, late at night, his elongated, shadowy form rising out of the darkness. The lower half of Henri Cartier-Bresson, resting upon a stone wall, is all that he wishes to show us. We fill in the blanks of the photograph with our imagination, our knowledge of its maker, or perhaps more accurately his body of work, a half-century of "decisive moments" that we piece together thinking we know something more than what he has told us. Moreover, this particular print, made especially for the New York art dealer Julien Levy, has the aura of an object that passed through the hands of two important figures of twentieth-century photography. We feel the presence of the elusive Cartier-Bresson somewhere in the space between the warm, silvery tones of the image and his signature on the verso of the print. The photographer-filmmaker Lou Stoumen removed his shoes and planted his feet in the sand of a beach. The feeling of poetic detachment, of man alone at the edge of the land, is a counterpoint to his oeuvre, which consists of scenes from mid-century urban America. Can we presume to know him more accurately by this private gesture than through his published photographs?

Even as we have become skeptical of photography's truth-telling capabilities, we still tend to believe its smaller truths, its particular details, as if they were hidden messages. As with the straw hat in photography's very first self-portrait—Hippolyte Bayard's *The Drowned*, 1840—we search for meaning

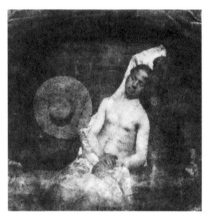

Hippolyte Bayard
France, 1801–87
The Drowned, 1840
Salted-paper print
Collection Société Française
de Photographie

18

10
Benjamin, "Unpacking My Library," 67.

11
Joan Didion, "On Keeping a Notebook," in *Slouching towards Bethlehem* (New York: Dell Publishing Company, 1968), 136.

in Judy Dater's shutter release flying across the picture plane, Edmund Kesting's paintbrush, John Boskovich's costume rabbit ears, or Edouard Boubat's vase of flowers. Each image provides clues for a deductive narration, an explanation that is the collector's response, an appropriate and equally narcissistic rejoinder to the artist.

Perhaps true, total photography, he thought, is a pile of fragments of private images, against the creased background of massacres and coronations. Italo Calvino[12]

At some point in the building of a private collection it becomes apparent that its contents must either be passed on to an institution or another individual collector, through gift or sale, or that its separate objects be dispersed. As every owner of a work of art knows, one's relationship to the object is primarily custodial. As the Irmas collection increased in size and value, it became apparent that it needed to be "institutionalized." The time had come to ensure the future security of the collection and let it begin a public life in a museum. The position of my parents is now somewhat similar to that of Marcel Duchamp when he considered his *Large Glass* definitively incomplete.[13] From the beginning this collection of self-portraits could never be complete, and although at the outset this was a private quest, it was hoped that assembled it would convey an idea Milan Kundera proposed in *Immortality*:

And it isn't enough for us to identify with our selves, it is necessary for us to do so *passionately*, to the point of life and death. Because only in this way can we regard ourselves not merely as a variant of a human prototype but as a being with its own irreplaceable essence.[14]

19

12
Italo Calvino, "The Adventures of a Photographer" (1955), in *Difficult Loves*, trans. William Weaver (London: Martin Secker and Warburg, 1983), 52.

13
Calvin Tomkins, *The Bride and the Bachelors* (New York: Viking Press, 1965), 52.

14
Kundera, *Immortality*, 12.

That the outer man is a picture of the inner,

and the face an expression and revelation of the

whole character, is a presumption likely enough

in itself, and therefore a safe one to go by;

borne out as it is by the fact that people are always

anxious to see anyone who has made himself famous...

photography, on that very account of such high value,

affords the most complete satisfaction of our curiosity.

Arthur Schopenhauer, 1850[1]

Other Selves in Photo

Robert A. Sobieszek

There is a fundamental duality in all faces, a duality essential to all human interchange as well as to nearly all representations of the human countenance. In any given face two distinct selves are revealed concurrently: a readily available exterior self formed by the face and its distinctive features and a relatively privileged interior self only hinted at by the visible face. Popular lore, social conventions, and to some degree scientific research each hold that the "real" self—the one customarily hidden beneath the surface—is decipherable from the face's outer features and gestures. The German philosopher Arthur Schopenhauer understood this mechanism and so did Sigmund Freud, the father of psychoanalysis, when he posited that the "public self is a conditioned construct of the inner psychological self."[2]

All actual faces and portraits are thus read for their hints of inner personality and character. The face, whether in person or in representation, is a stage upon which are enacted the physical manifestations of pain or laughter, the emotional dispositions of love or enmity, the psychological levels of fear or desire, and even the spiritual states of piety or evil. In real life we are customarily left to ourselves to interpret the inner character of those we encounter. In portraiture we frequently have the advantage, or at times the disadvantage, of having an artist interpret for us the inner persona of the sub-

1

Arthur Schopenhauer, "Physiognomy," in *Religion: A Dialogue and Other Essays*, trans. T. Bailey Saunders (London: George Allen and Unwin, undated [c. 1890]), 75.

graphic Self-Portraiture

ject being depicted. In self-portraiture, however, we are confronted with a much different set of issues. No longer is it just us viewing and reading the face of another, nor is it a simple case of one individual artist estimating the character of another human. In self-portraiture, where the artist and subject are ostensibly the same person, the dynamics of reading, interpreting, analyzing, and representing involve by definition a cycle of self-regard, self-presentation, self-revelation, and self-creation. Moreover, facing one's own face in an attempt to achieve an honest and convincing representation of the self invariably embodies the realization that the inner and outer are ultimately distinct, that there are at least two selves, one accessible and another hidden, and that comprehending the "I" in self-portraiture is truly comprehending an "other."[3]

2

Cf. John Yau, "Self-Portraiture = Self-Representation," in Luís Serpa, *"Je est un autre" de Rimbaud* (Lisbon: Galeria Cómicos/Luís Serpa, 1990), 32.

3

Cf. Chaké Matossian, "Car c'est moi que je peins," in ibid., 22–23.

Watchman and Spy

"Beware of the body and the mind," wrote the artist Jasper Johns in his "Sketchbook Notes." "Avoid a polar situation."[4] Rough ideas for a group of object-paintings produced around 1965, Johns's studio notes outline specific strategies for painting and assemblage as well as list common objects such as flashlights and plates used in the works. The notes also discuss various options open to an artist for rendering or including a self-portrait within a work. Should it be in profile, distorted, mirrored, pictorial, or manifested linguistically? Each option needs to be attended to, Johns suggested when he noted, "Watch the imitation of the shape of the body."

In a curiously written second paragraph Johns differentiated between two distinct forms of observation, anthropomorphizing them as *watchman* and *spy*:

The watchman falls "into" the "trap" of looking. The "spy" is a different person....There is continuity of some sort among the watchman, the space, the objects. The spy must be ready to "move," must be aware of his entrances and exits. The watchman leaves his job & takes away no information. The spy must remember and must remember himself and his remembering. The spy designs himself to be overlooked. The watchman "serves" as a warning. Will the spy and the watchman ever meet?...The spy stations himself to observe the watchman. If the spy is a foreign object, why is the eye not irritated? Is he invisible? When the spy irritates, we try to remove him. "Not spying, just looking"—Watchman.[5]

The watchman is a neutral observer carefully monitoring the objective facts of his or her surroundings. The spy is a prying voyeur anxious to get a glimpse of some hidden secret. The watchman does not have to think, simply look. The spy, however, must surreptitiously steal about, remembering and remaining overlooked.

Although at least one critic has claimed that in this passage Johns intended the watchman to refer to the artist and the more loathsome character of the spy to the art critic, it might prove more supportable to view this duality as two distinct facets of the same and more complex character—the artist.[6] It is the artist who must observe with precision both the physical presence of the work being created as well as the visual look of what is being pictured. ("There is continuity of some sort among the watchman, the space, the objects.") It is also the artist who needs to penetrate beneath the surface of things and adjust whatever secrets of the self are discovered for representation on that surface. After all, Johns began his notes with the admonition "Beware of the body and the mind." Avoiding a "polar situation," then, the artist is both watchman and spy; and nowhere is this duality more apparent than in the self-portrait, to which Johns alludes.

[4] Jasper Johns, "Sketchbook Notes," *Art and Literature*, no. 4 (Spring 1965), 185.

[5] Ibid., 184–92; quoted in Carla Gottlieb, "Self-Portraiture in Postmodern Art," *Wallraf-Richartz Jahr*, no. 42 (1981), 279–80; and reprinted in John Russell and Suzi Gablik, *Pop Art Redefined* (New York: Frederick A. Praeger, 1969), 84–85.

[6] Cf. Gottlieb, "Self-Portraiture in Postmodern Art," 280.

Stilled Countenances

According to critic Susan Sontag, "The self is a text—it has to be deciphered....The self is a project, something to be built."[7] Physiognomists from the Swiss Johann Caspar Lavater to the French Duchenne de Boulougne fully appreciated the appearances of the self, evident in the face and its gestures, as some sort of secret narrative to be decoded. The discipline of physiognomy, from the Greek *physis* (nature) and *gnōmōn* (interpreter), holds that we can discern "particular passions of the soul from the particular shape of the body," most notably the face.[8] Understanding the face and how it communicates affords a skilled reader the chance to pry, much as a spy, into the hidden character and psychology behind the face and confront the persona of the subject.

But the self is also something that can be constructed, created, or assumed and thereby invariably falsified. Actors and confidence criminals have known this all too well for centuries, as have most artists when it comes to recording their self-portraits. Photographer Richard Avedon maintained that every portrait (and by extension every self-portrait) is a form of acting or performance:

> Because portraiture is performance, and like any performance, in the balance of its effects it is good or bad, not natural or unnatural. I can understand being troubled by this idea—that all portraits are performances—because it seems to imply some kind of artifice that conceals the truth about the sitter. But that's not it at all.[9]

Whereas physiognomists remained convinced that the soul could be measured from the features of the face, here we are on completely different grounds, having to read a fictional narrative, a performance of disguise that conveys whatever "truth" the subject wishes. Yet when this occurs are we not somehow privy to the personal fantasies of the subject, and do they not then testify to the sitter's psyche?

Portraits, whether traditional, modernist, or postmodernist, whether text or performance, can be construed as maps of the subjects' inner workings. Self-portraits are even more revealing—charts of the most personal sort usually done in quiet complicity with the self, the only other, again usually, present at the time. The German artist Otto Dix remarked that "self-portraits are confessions of an inner state....There is no objectivity there, only ceaseless transformation; a human being has so many facets. The self-portrait is the best means of studying them."[10] Some critics have argued that the distortions and formalist reductions associated with modernist art have rendered such confessions mute and that the face "is no longer a mirror for the soul or an assigned marker for the narrative flow."[11] While to some extent faces in modern and especially contemporary art have become more

7
Susan Sontag, "Under the Sign of Saturn," in *Under the Sign of Saturn* (New York: Vintage Books, 1978), 117; cited in James Lingwood, "Introduction," in Lingwood, ed., *Staging the Self: Self-Portrait Photography 1840s–1980s* (London: National Portrait Gallery, 1986), 5.

8
G. B. della Porta, *De humana physiognomia* (Naples, 1586), 58; quoted in Patrizia Magli, "The Face and the Soul," trans. Ughetta Lubin, in *Zone 4: Fragments for a History of the Human Body, Part Two*, ed. Michel Feher et al. (New York: Zone Books, 1989), 87.

9
Richard Avedon, "Borrowed Dogs," in Ben Sonnenberg, ed., *Performance and Reality: Essays from Grand Street* (New Brunswick: Rutgers University Press, 1989), 17. I would like to thank Thomas F. Barrow for bringing this essay to my attention.

10
Quoted in Erika Billeter, "The Exhibition," in Billeter, ed., *Self-Portrait in the Age of Photography: Photographers Reflecting Their Own Image* (Lausanne: Musée Cantonal des Beaux-Arts, 1986), 8.

11
John Welchman, "Face(t)s: Notes on Faciality," *Artforum* 27, no. 3 (November 1988): 135.

ciphers than texts to be decoded, self-portraits have for the most part stayed remarkably true to their traditional values of unmasking the artist's ego or persona.

In his "Self-Portrait in a Convex Mirror," perhaps one of the most encompassing meditations on the idea of self-portraiture, poet John Ashbery responds to Parmigianino's famed self-portrait of 1524 (in the Kunsthistorisches Museum, Vienna), in which the Italian mannerist painter depicts a distorted self-image as seen in a convex mirror or globe held in his right hand. Ashbery contends that "the soul establishes itself" in the painting, and the point expressed in this particular work is that

The soul is a captive, treated humanely, kept
In suspension, unable to advance much farther
Than your look as it intercepts the picture.[12]

It is precisely at that interception of picture and looking, of display and observation, that something of the inner passions is revealed.

Texts are temporal experiences, regardless of whether they are written or constructed. Facial expressions are equally temporal, engaged as they most often are in what Dix called "ceaseless transformation"; they are just as frequently evanescent, fugitive, and fleeting. Early physiognomists understood this; they clearly distinguished between *physiognomy* as a study of the facial expressions in stasis and *pathognomy* (from *patho*, or disease) as a study of the face or body in motion. But in order to clarify and systematically classify the various emotions, humors, passions, and psychological states exhibited by the face, they sought to distill from this flux discrete sets of measurable expressions. According to historian Patrizia Magli,

To isolate a face is to isolate a permanent form, one whose "unchanging traits" are to be perceived through a process that attempts to freeze the face's state of constant flux into a state of immutability....It is the time of a "measure" that stills things, develops a formal image and locks it into an absolute fixity, wherein it then interprets proportions, defines outlines, and attempts to establish essential traits.[13]

Still photography's advent into the pictorial arts was first embraced as a godsend to those charting the inordinate gestures of the human countenance, but the sheer deluge of uncodified portraits produced by the camera quickly outstripped and overloaded physiognomic systems proving them untenable as science.

The scientific systems of physiognomics may have crashed from an overload of information, but the sentiment expressed by Schopenhauer cited in the epigraph at the head of this essay remains sound. The photograph does pro-

12
John Ashbery, "Self-Portrait in a Convex Mirror," in *Self-Portrait in a Convex Mirror* (New York: Viking Press, 1975), 68–69.

13
Magli, "The Face and the Soul," 90.

24

vide us great satisfaction of our curiosity when it comes to looking at the famous or the infamous. And when the subjects are artists portraying themselves, the satisfaction is that much keener, more direct, and intensely personal since the photographic self-portrait, whether a text or a project, is by definition unmediated by anyone except the combined personality of watchman and spy.

The watchman simply looking and the spy prying for secrets are the two inextricably joined halves of self-portraiture. Delineating the facts and the existence of the self is the job of the watchman, while searching for the essential identity of the persona and the meaning of that self is a matter for the spy. How the watchman and spy perform at their tasks, as well as just how the facts are put down and how they are interpreted or expressed, is as wide-ranging as the personalities of the individual artists despite the many attempts to categorize and outline the various species and subgenres of self-portraiture. Beyond mere identification and the mapping of facial features, self-portraits have been subdivided into any number of aspects from the narrative to the iconic, from disguised to dismembered, from a shadow to a double entendre, from partial to multiple, from simple traces to anamorphic distortions.[14] Yet, regardless of how refined, how discrete any taxonomy of self-portraiture may get, the simple matter is that the subject is ultimately divisible by three: delineation, distortion, and disguise. And by no means are these classifications mutually exclusive.

Delineation and Surface

Fundamentally, a self-portrait is the charting of the isolated face or body of the subject. The photographic record delineates the artist who stares back into the camera, looks away, poses, is reflected in a mirror or otherwise represented in some naturalistic manner. What we see is what was, for a moment, before the camera's lens. What we see, also, is only the outward appearance, the surface of the subject. But, then, surface is all there is to see. Photographers comprehend this lesson from the start; what is of concern is light reflected from the surface of things and captured on film. Avedon said it most succinctly:

The point is that you can't get at the thing itself, the real nature of the sitter, by stripping away the surface. The surface is all you've got. You can only get beyond the surface by working with the surface. All that you can do is to manipulate that surface—gesture, costume, expression—radically and correctly.[15]

The real problem, then, rests in how the artist radically alters the surface in order to get beyond it when there is only the surface with which to work.

25

14
Cf. David Mellor, "The Watchmen, or Notes on the Imaginary Male Self in 20th-Century Photography," in Lingwood, ed., *Staging the Self*, 79–85; also cf. Gottlieb, "Self-Portraiture in Postmodern Art," 268–99.

15
Avedon, "Borrowed Dogs," 17.

"But your eyes proclaim/That everything is surface," wrote Ashbery concurring in principle with Avedon. "The surface is what's there/And nothing can exist except what's there."[16] But a few lines later the poet further suggests that there also is a certain amount of pathos in confronting these surfaces, resulting from the recognition that any deeper or broader experience will never be grasped from mere appearances:

And just as there are no words for the surface, that is,
No words to say what it really is, that it is not
Superficial but a visible core, then there is
No way out of the problem of pathos vs. experience.[17]

Earlier, the British novelist D. H. Lawrence wrote about the fundamental isolation of the modern self when he asserted that "each man to himself is a picture....He is a complete little objective reality, complete in himself, existing by himself, absolutely, in the middle of the picture....We *are* what is seen; each man to himself an identity, an isolated absolute, corresponding with a universe of isolated absolutes."[18] Art historian Erika Billeter summed it up cogently when she wrote that "every self-portrait imparts a sense of loneliness."[19]

Almost in illustration of the phrase "each man to himself is a picture," John Collins stares at a mounted photograph of himself staring back while holding another photograph of himself looking at another print of himself looking back and so on in infinitely diminishing fashion. Also using photographic elements as enframing tropes, Fred Archer isolates himself behind his camera, while Pierre Dubreuil's forehead and intently staring eyes are tightly outlined by the opened face of his view camera. Other artists confine themselves within window and door frames and thereby enhance a sense of abject isolation, such as in the self-portraits of Frederick H. Evans, Louis Faurer, John Gutmann, Otto Hagel, and Max Yavno.

In his 1989 film *Notebook on Cities and Clothes*, German filmmaker Wim Wenders remarked that mirrors are like a "private screen" on which you are "able to look at your reflection in such a way that you can recognize and more readily accept your body, your appearance, your history, in short, yourself."[20] "As Parmigianino did it,"[21] so too have many photographers captured their self-images as reflected in mirrored surfaces. Seneca Ray Stoddard, Georg Muche, and Gordon Coster each did it the same way the sixteenth-century Italian mannerist did it—with a convex mirror. Similarly, Clarence John Laughlin and Norman Rhoads Garrett used the convex surfaces of automobile fenders to reflect their likenesses. Bill Brandt, Florence Henri, and Ilse Bing (in her self-portrait of 1931) appear to be completely entrapped by the strict, planar geometries of rectangular mirrors. Dieter

16
Ashbery, "Self-Portrait in a Convex Mirror," 70.

17
Ibid.

18
D. H. Lawrence, "Art and Morality," in Edgell Rickword and Douglas Garman, eds., *Calendar of Modern Letters*, vol. 2 (September 1925–February 1926) (New York: Barnes and Noble, 1966), 172; quoted in Jean-François Chevrier, "The Image of the Other," in Lingwood, ed., *Staging the Self*, 12.

19
Billeter, "The Exhibition," 9.

20
Wim Wenders, with Yohji Yamamoto, *Notebook on Cities and Clothes*, 1989.

21
Ashbery, "Self-Portrait in a Convex Mirror," 68.

Appelt aggressively exhales onto his reflection thus fogging or obliterating it. And, in an apparently unique print, Diane Arbus pensively examines her pregnant body in a mirror mounted on a door, accepting her body, her appearance, and her history, it would seem.

W. Eugene Smith's deportment is as a brooding and melancholic artist alone in his studio. Elfriede Stegemeyer, Edward Weston, and Arnold Genthe locate themselves in front of neutral backgrounds with distanced and nearly vacant expressions. Alfred Stieglitz portrays himself as a sleeping young artist on a flight of steps, and Roman Vishniac poses atop Notre Dame Cathedral in Paris à la Charles Nègre's famous nineteenth-century portrait of his friend Henri Le Secq. Jack Delano portrays himself as an unaccompanied pedestrian in a dramatically backlighted night scene, while Ralph Bartholomew and Brassaï are in solitude with their cameras at night. The shadow of Umbo's camera falling across the artist's eyes suggests an ultimate blindness or visual isolation. And then there is the hauntingly spectral image of Robert Mapplethorpe, whose brightly lighted face and hand holding a skull-topped cane emerge out of a pitch-black void. Facing an unavoidable death, the artist renders himself an utterly "isolated absolute."

The visage of the artist need not actually appear in his or her self-portrait. Lawrence Bach's naked torso stands next to a table, while Lance Carlson portrays himself as only a clothed body whose hands hold paint brushes, suggesting as does Edward Steichen's that the photographer is also a painter. Having a part stand for the whole, Lou Stoumen shows us only his bare feet and shoes, while Henri Cartier-Bresson, notorious for refusing to have his face photographed, chooses to depict only his right leg and foot. Bruce Nauman photographs his mouth, chin, and throat, each variously distended or distorted by his hands. Walker Evans, Lee Friedlander, and Piet Zwart reduce their likenesses to mere shadows, even less than surfaces: Evans's as a solitary silhouette, Friedlander's on the back of a woman he was following, and Zwart's cast beneath him on a walkway.

The photographic artist may have only the subject's surface to work with, but the self-portraitist is scarcely limited to the single, objective photograph by which to correctly go beyond the surface. The French critic Jean-François Chevrier has pointed out that "objectivity is no longer held to be a sure criterion of knowledge; mechanical recording is considered a dubious procedure, which leaves great scope for every possible imaginary distortion. There is no longer a truth of the self, but—to use Lacan's term—only its 'imaginary.'"[22] Obviously there can never be any single "truth" discoverable in even the

27

Distortion and Dreams

[22] Chevrier, "The Image of the Other," 9.

most objectified and clinical self-portrait, only mere attempts at visualizing a momentary, selected facet of the persona. The straightest and most direct self-portrait will reveal only a partial and imaginary self. Even a serialized set of self-portraits over time, as in Robert Heinecken's, can only hint at a synoptic representation. Conversely, because an artist abandons objectivity for any of the imaginary distortions open to him or her does not necessarily mean that the self-portrait will gain an advantage in probing the artist's psyche, just that the end product will look novel or different.

Anyone familiar with László Moholy-Nagy's or Franz Roh's writings of the 1920s, centered as they are on German and Bauhaus theories of modernism, will recognize the gamut of photographic techniques available to distort any conventional expectation of the "normal" self-portrait: photomontage, photocollage, negative printing, combination printing, X-ray photography, optical deformations, blurred motion, selective focus, serialization, chronophotography, the photogram, and others. Nearly all of these options afford the artist an opportunity to create visual analogues of psychological states, to construct or deconstruct an image whose text is neither not real nor beyond reality, and to replace the conventional self-portrait with one that might be called *irreal*, to use a term coined by the French symbolist poet Stéphane Mallarmé. The term suggests neither the unreal nor the surreal but rather something just to the side of reality, something laconic or dreamlike.

Again Ashbery pointed out this "irreal" aspect of distortion:

The forms retain a strong measure of ideal beauty
As they forage in secret on our idea of distortion.
Why be unhappy with this arrangement, since
Dreams prolong us as they are absorbed?
Something like living occurs, a movement
Out of the dream into its codification.[23]

Though Wenders's film *Until the End of the World*, of 1991, may prove to be prophetic, the recording of dream images of the self is not yet a reality; but simulations of dream images have certainly been prevalent in photographic self-portraiture. Manipulated, pushed, deformed, the artist is reconstructed as if in another state—not real, just to the side of it—as in Herbert Bayer's image of himself looking aghast into a mirror while literally taking himself apart.

In fairly conventional depictions Clarence Sinclair Bull, Floris Neusüss, and Emery Révés-Biró portray themselves along with their models (other than themselves) as a normal part of their environment; André Kertész, on the other hand, shows himself relatively minuscule and in toned color along-

23
Ashbery, "Self-Portrait in a Convex Mirror," 73.

side a greatly oversized monochrome nude reflected in a distorting mirror. Hans Bellmer also poses with his model, *La Poupée* (The doll), an articulated female mannequin, but next to her he is a vague, dematerializing ghost. Berenice Abbott's mirror reflection is so distorted that it appears grotesquely singular and feline. Susan Unterberg's face looms close to the camera with a dramatic expression made all the more disturbing by the slight blurring of details. Val Telberg seems to be dissolving before his camera. Josef Breitenbach appears lost in a tangle of *cliché-verre* markings. Konrad Cramer is a faint specter amid a montage of a classicized head and drawing. John Brill is a blurred streak racing across a foreboding railroad yard. Roger Parry even goes so far as to negate his self, by inverting the tones of his self-portrait in a negative print; as does Tim Gidal, whose self-image is a photogram, a reversed shadow formed by directly printing his silhouette on the print.

Fracturing and multiplying the self-image are other avenues for constructing the self. Whereas Eadweard Muybridge's chronophotograph of his nude self swinging a pickax appears protocinematic and thus fairly conventional, the use of sequential images of the self in Andy Warhol's and Renata Bracksieck's photographs are anything but: the four deadpan countenances of tuxedoed Warhol posing in a photobooth become progressively more radically cropped, while one of Bracksieck's four stage-lighted selves is turned upside down. Peter Keetman multiplies his face through what appears to be an oil-saturated screen so that a multitude of small self-portraits are what the overall portrait is made up of.

Effacing, marking, and otherwise physically obliterating the "normal" look of the subject are additional means by which an inner state of mind or interior agitation may be suggested. Collaged amid ten postage and tax stamps, Wallace Berman's face is dematerialized by an aura of radiating lines in near transcendent fashion. Bayat Keerl's seemingly naked body all but disappears beneath a lurid cover of applied paint and linear scrapings. Arnulf Rainer's interest in prelinguistic and psychopathic forms of expression informs his aggressively marked-over self-portrait, masked in such a way that it becomes, according to one critic, "an expression of mental suffering etched into the body."[24] Similarly, in an image of himself along with his reflection, Lucas Samaras manually pushed and dragged the emulsion of the Polaroid print before it solidified, completely reconfiguring the body of one of his selves into a nebulous, inchoate shape. In instances like these, where the figure is seen as acting out some personal or dramatic code, Avedon's notion of portraiture as performance or "extreme stylized behavior" becomes patently clear.[25]

29

24
Roger Marcel Mayou, "Portrait of the Artist as a Work of Art," in Billeter, ed., *Self-Portrait in the Age of Photography*, 16.

25
Avedon, "Borrowed Dogs," 19.

Disguise and Otherness

The performance aspect of self-portraiture takes on a slightly different cast when the person portrayed is playing a role, in disguise, or otherwise fictionalized. Ultimately, of course, every self-portrait is a fiction, a portrait of someone else, and an arena in which another is confronted or an alter ego encountered. Art historian Kirk Varnedoe has suggested that through such surrogates as public and private roles the artist is able to "simultaneously expand his persona and control access to his personality."[26] An element of confrontation is, furthermore, vital to the genre; a self-portrait confirms its reality from a position of "disengagement or even hostility": "The theatrical overtone—the implied consciousness of an audience before which the self performs as self, or in the role of self—is especially disturbing since the division between observer and observed must first occur within the artist."[27] Avedon stressed as well that all portraits require a sense of confrontation if they are to succeed.[28]

Multiple personality, alter ego, fantasy role—whatever it is, it is definitely another that is confronted in a self-portrait, even in the most clinical depiction. As Ashbery pointed out,

...this otherness, this
"Not-being-us" is all there is to look at
In the mirror, though no one can say
How it came to be this way.[29]

And our believing in this "not-being-us" may have much to do with a loss of certainty about who we are and what we see. If we follow Chevrier, "Belief in the truth of the self and belief in the objectivity of the photographic record have perished simultaneously. Every self-portrait, even the simplest and least staged, is the portrait of another."[30] The self that looks is simply not the self that is rendered and looks back at us. Given this freedom, anything is possible, even the collision of text and construction, discourse and theater. "The theatrical face," wrote French critic Roland Barthes, "is not painted (made up), it is written....It is the act of writing which subjugates the pictural gesture, so that *to paint* is never anything but *to inscribe*."[31]

"The body is not only a means of communication," wrote French critic Roger Marcel Mayou, "it is the very realization of the multi-personality, the place where the otherness is visible."[32] Barthes, again, stated more simply, "The face is only: *the thing to write*."[33] What is written may be anything the artist wishes or may deal with any issues he or she desires to represent as either simile or metaphor. Dressing up or making up, the self can be like any other. Disguising the self can also disclose another persona, another self that for whatever reasons is customarily veiled or not openly apparent. The

26
Kirk Varnedoe, "The Self and Others in Modern Portraits," *Art News* 75, no. 8 (October 1976): 67.

27
Ibid., 70.

28
Avedon, "Borrowed Dogs," 21.

29
Ashbery, "Self-Portrait in a Convex Mirror," 81.

30
Chevrier, "The Image of the Other," 9.

31
Roland Barthes, *Empire of Signs*, trans. Richard Howard (New York: Hill and Wang, 1982), 88.

32
Mayou, "Portrait of the Artist as a Work of Art," 18.

33
Barthes, *Empire of Signs*, 88.

"imaginary" becomes the image, as in Robert Mapplethorpe's self-portrait in makeup—a clear and poignant signifier of a "differently aspected" self.[34]

Photographers have acted before the camera since nearly the start of the medium. The most famous and possibly the earliest case would be that of the French photographer Hippolyte Bayard, who posed himself as a drowning victim in 1840 (see p. 18).[35] In keeping with the nineteenth-century romantic vogue for *l'orientalisme*, Roger Fenton dressed as a Zouave soldier and Francis Frith donned a Turkish summer costume. Looking westward for exotic inspiration, Nadar (Gaspard-Félix Tournachon) dressed in North American Plains Indian finery. Little separates these self-portraits from those of the Italian futurist Tato dressing as a buffoon, T. Lux Feininger imitating Charlie Chaplin, Lejaren à Hiller impersonating a drunk, or Paul Outerbridge staging himself as an agricultural salesman. Similarly, there is a parallel between Oscar Gustav Rejlander acting the role of a down-and-out, Dickensian character (which was hardly the case with this artist) and Werner Rohde's role as an impoverished bohemian artist in a garret studio (which may have been close to true).

Striving to underscore their roles within the fine arts, Anne Königer assumed the classical pose of some unspecified muse, Edward Steichen presented himself in the traditional stance and costume of a nineteenth-century painter, Edmund Kesting portrayed himself in the act of painting his own visage, and George Platt Lynes struck a pose as Harlequin thereby linking himself with both the *commedia dell'arte* and modernist theater. Less seriously, Mehemed Fehmy Agha, the art director of Condé Nast, cast himself as a foot wearing glasses, Angus McBean put himself in a tub held aloft by an umbrella, Ralph Eugene Meatyard assumed the character of his fictional alter ego Lucy Belle Carter, and Nancy Burson conflated her persona with that of a white cat.

Narratives of self-portraiture may also be more open-ended than not. Judith Golden's face stares out at us through a fashion or advertising plate as if in collision with mass media's standards of idealized beauty. Eileen Cowin enacts a mute, pictorial theater of domestic ambiguity and emotional tension with members of her real-life family. Cindy Sherman, in two images from her *Untitled Film Stills* series, poses as some undefined but somehow strangely familiar ur-actress caught at a critical moment in some vaguely remembered B movie. In another form of theater, the manipulated self-portraits of Pierre Molinier are concerned with "the hermaphrodite and show sexual ambiguity through figures that carry characteristics of both sexes at one and the same time."[36] In her *Self-Pride* portrait, surrealist Claude Cahun (Lucy Schwob) surrounds multiple images of her visage with the words, "Under this mask, another mask. I will not finish taking off all these faces," thereby stressing the modern impossibility of delineating any true self.

34
Cf. ibid., 89. For the phrase "differently aspected," I am indebted to Joe Smoke, in conversation, 9 July 1993.

35
Three variations of this image are in the collection of the Société Français de Photographie in Paris. See Jean-Claude Gautrand, *Hippolyte Bayard: Naissance de l'image photographique* (Paris: Trois Cailloux, 1986), pl. 10.

36
Mayou, "Portrait of the Artist as a Work of Art," 17.

Self-portraiture is ultimately a confrontation with the self's mortality. The self that stares back at the artist was once, when the photograph was made, and is no longer; marking a time immediately removed in time, it portends the imminency of death. As noted by critic Patricia Storace, writing about the novels of Ann Beattie, "What is perceived fully will include an ominous consciousness of coming death."[37] While this may be quite true in any self-portrait, certain artists illustrate the point directly. In a series of six self-portraits Jan Saudek personified himself as a soldier with his back literally to a wall and progressively stripped of his uniform, his undergarments, his materiality until nothing remains but a marker. Joel-Peter Witkin fashioned himself as some sort of satanic priest, wearing a domino mask with a small figure of the crucified Christ attached to it: the artist at once a watchman delineating his appearance and a furtive spy or shaman revealing the final secret.

In his self-portrait Duane Michals stands to the right, arms crossed, quietly contemplating his own dead body stretched out on a gurney to the left. The image is a subtle and quite possibly inadvertent homage to Bayard's famous self-portrait as a drowned man, but it differs remarkably from the earlier image. No longer, Michals would seem to suggest, can the self-portraitist merely don the guise of some fictional other in affirmation of any singular self, pictured or otherwise, living or not. In this portrait the artist pictures himself as two, one living and one dead, simultaneously existing side by side. The Argentinean Jorge Luis Borges described with words the very same condition when, in his literary self-portrait "Borges and I," he distinguished between himself as a person and himself as the writer. "Things happen to him, the other one, to Borges....Thus is my life a flight, and I lose everything, and everything belongs to oblivion, or to him."[38]

Each self-portrait in the Audrey and Sydney Irmas collection, which spans nearly a century and a half, is only a single image or discrete set of images (a sample or samples) of the self's reflection once removed. At the same time, these samples affirm the individual selves of these artists, not as shards or fragments "but as everything as it / May be imagined outside time—not as a gesture / But as all, in the refined assimilable state."[39] But each self-portrait also seems to evidence the essential multiplicity of selves that were and are the artists and by implication shows that none of us in turn is a singular self. It has been said that when two minds come together a third and superior one accompanies them.[40] Perhaps it might be more apt to say that when one mind exists, another (or others) accompany it. The watchman observes the outer while the spy investigates the meaning or meanings of the inner. In a self-portrait they just may have a chance of meeting.

37

Patricia Storace, "Seeing Double" (review of *What Was Mine*, by Ann Beattie), *New York Review of Books* 38, no. 14 (15 August 1991): 10.

38

Jorge Luis Borges, "Borges and I," in *A Personal Anthology*, ed. and trans. Anthony Kerrigan (New York: Grove Press, 1967), 200–201.

39

Ashbery, "Self-Portrait in a Convex Mirror," 77.

40

Gérard-Georges Lemaire, "23 Stitches Taken by Gérard-Georges Lemaire and 2 Points of Order by Brion Gysin," in William S. Burroughs and Brion Gysin, *The Third Mind* (New York: Viking Press, 1978), 19.

Plates

[PLATE 1]

Alphonse-Louis Poitevin

C. 1853

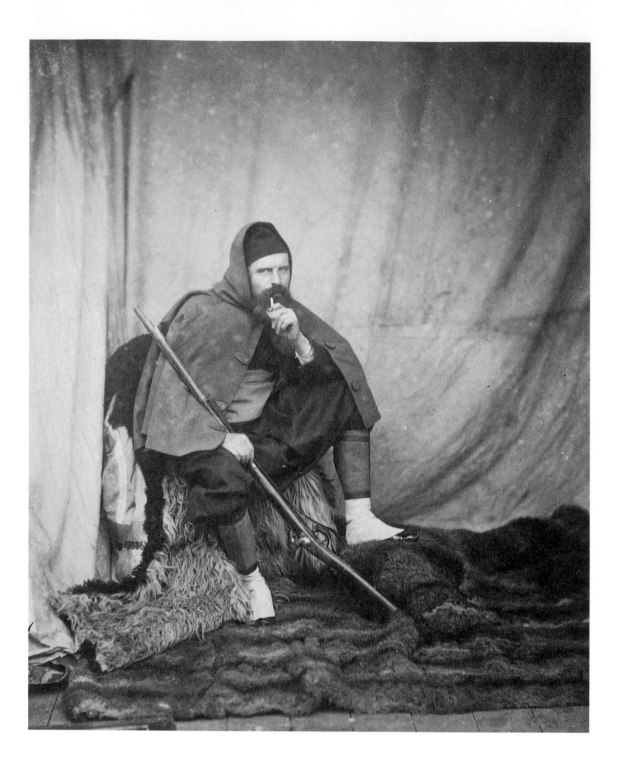

[PLATE 2]

Roger Fenton

1855

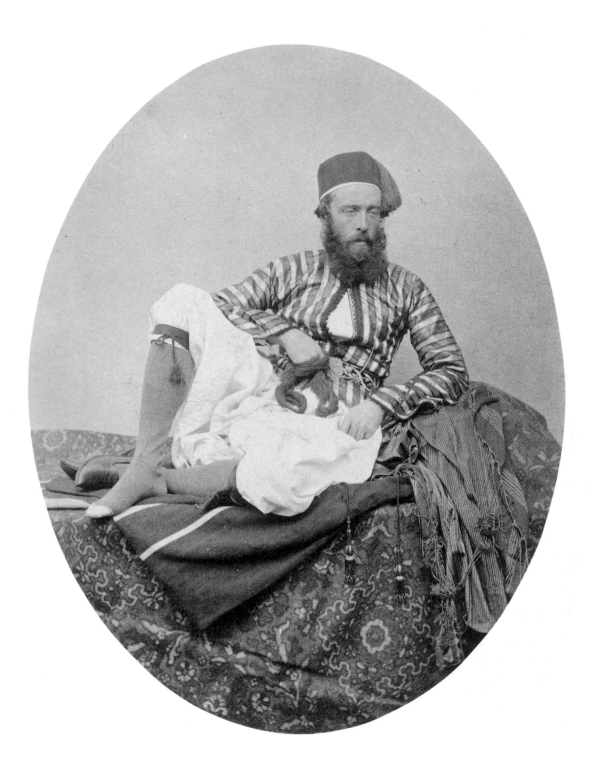

[PLATE 3]

Francis Frith
1857

[PLATE 4]

André-Adolphe-Eugène Disdéri

C. 1860

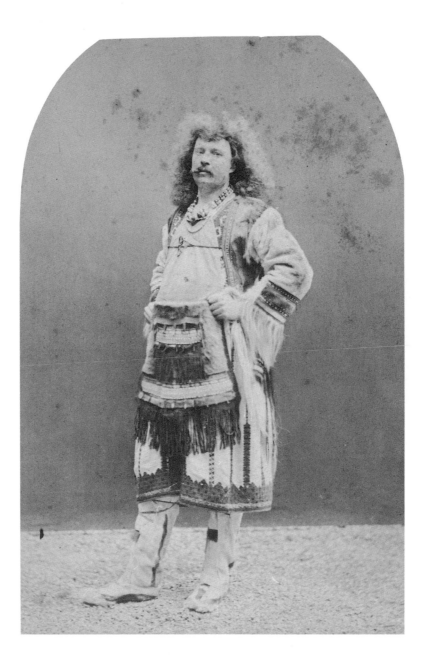

[PLATE 5]

Nadar (Gaspard-Félix Tournachon)

c. 1863

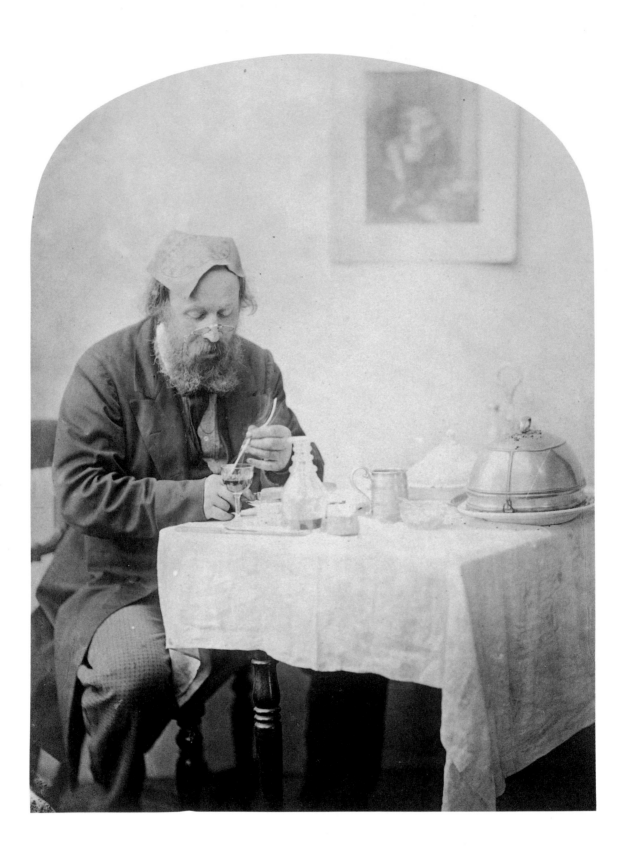

Oscar Gustav Rejlander

C. 1860

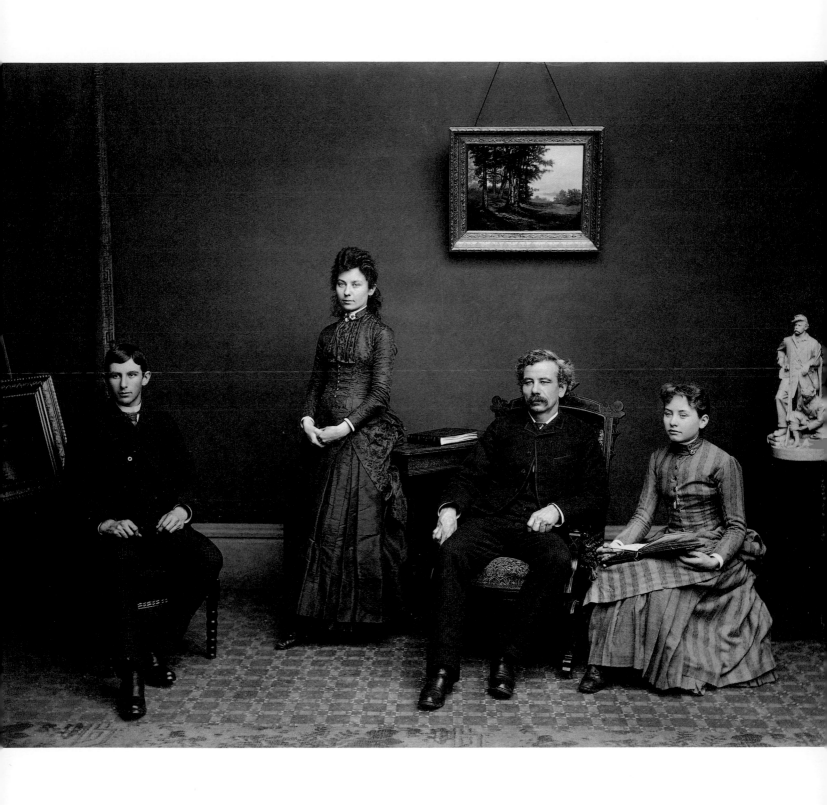

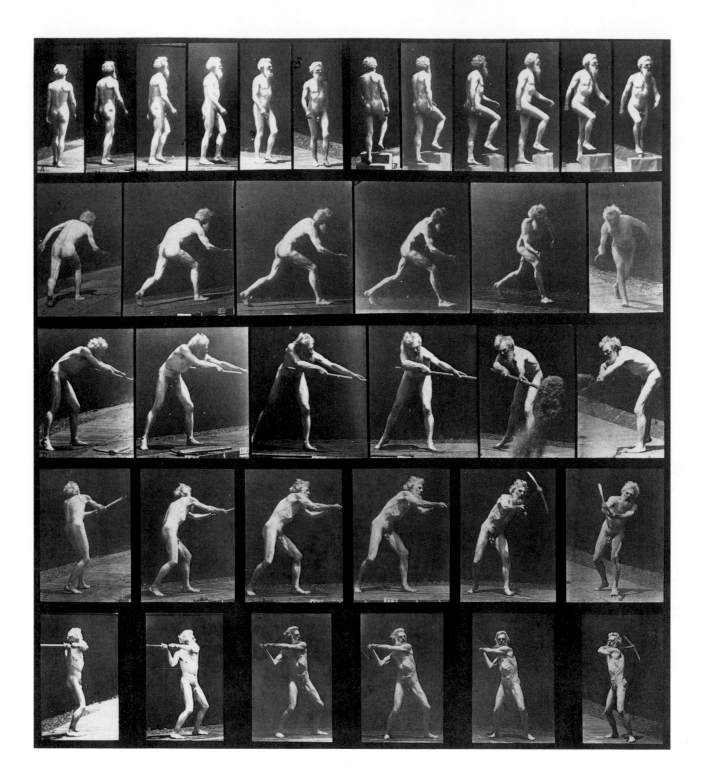

[PLATE 10]

Dallett Fuguet

1895

[PLATE 11]

Edward Sheriff Curtis

1899

[PLATE 12]

Alfred Stieglitz
1890

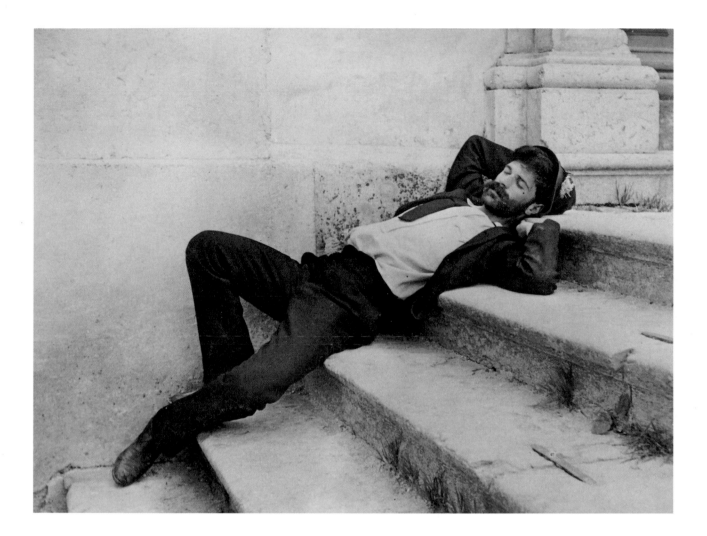

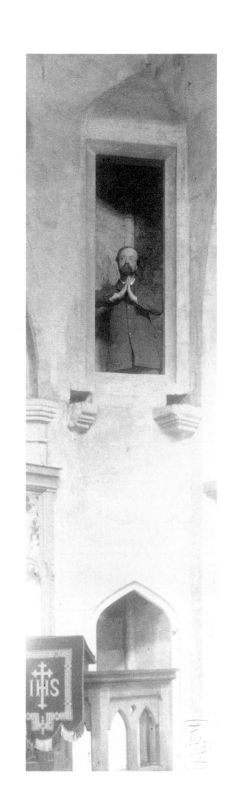

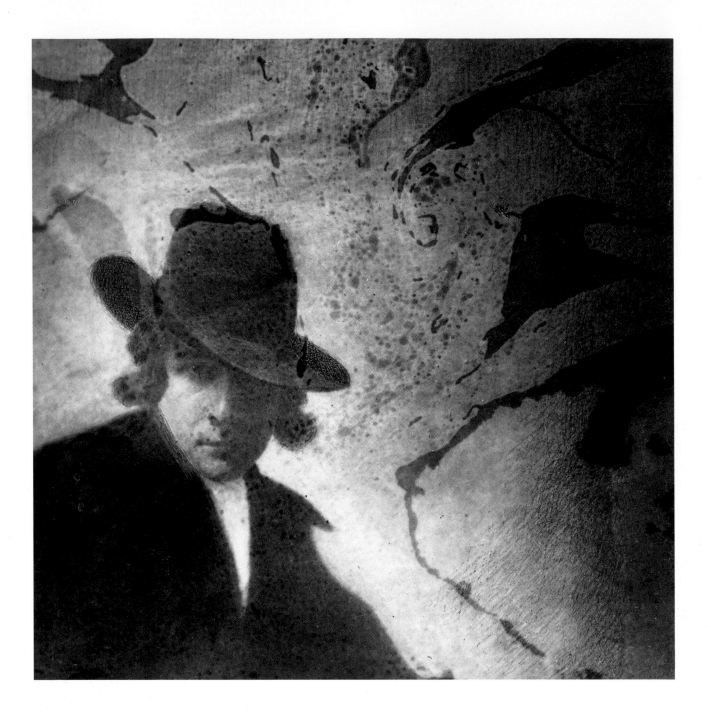

[PLATE 14]

Emil Otto Hoppé

1910

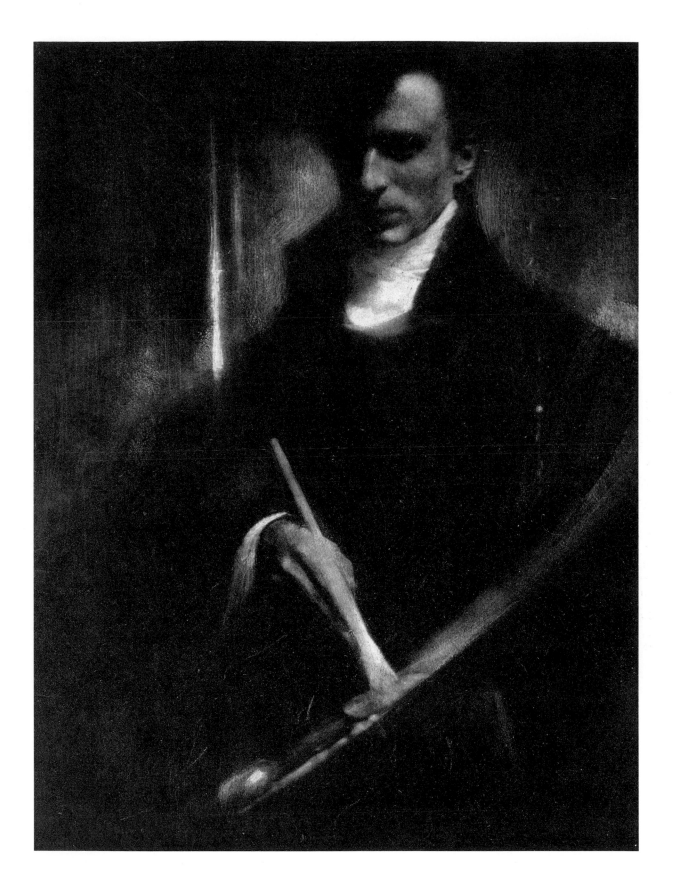

Edward Steichen

1901

[PLATE 16]

Imogen Cunningham

c. 1908

[PLATE 17]

Baron Adolph de Meyer

1905

[PLATE 18]

Edward Weston

1911

[PLATE 19]

Anne Königer
1913

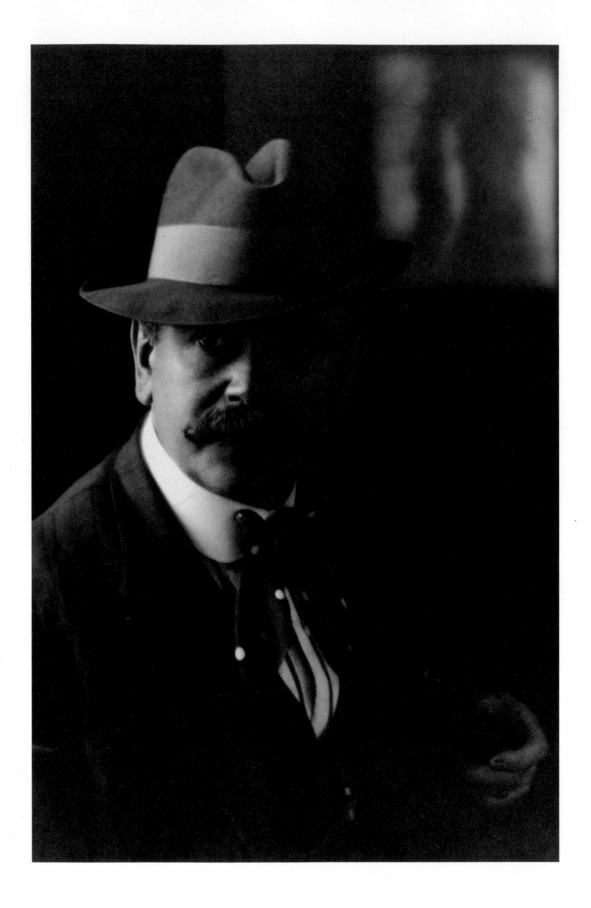

[PLATE 20]

Louis Fleckenstein

C. 1910

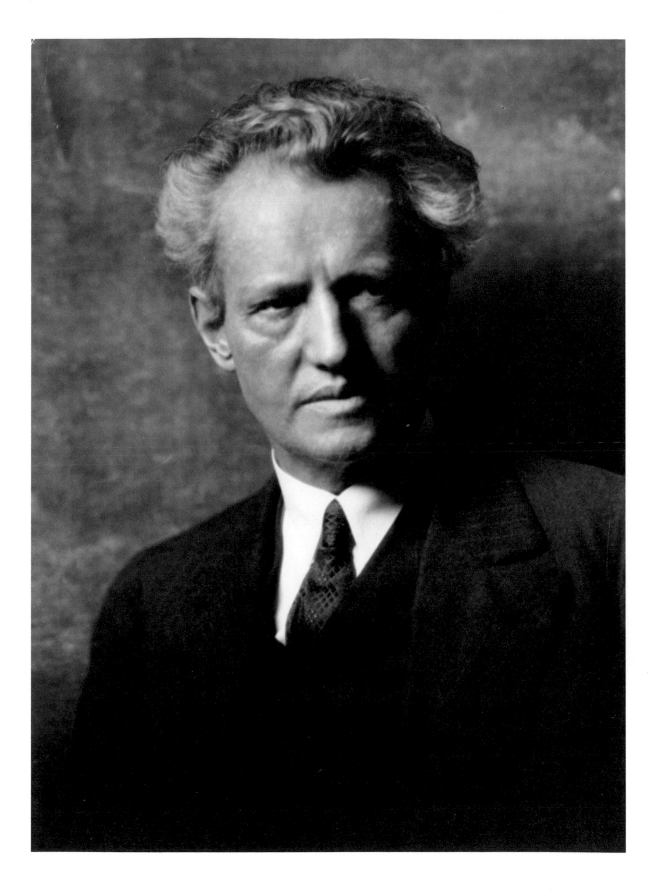

[PLATE 21]

Arnold Genthe

C. 1906

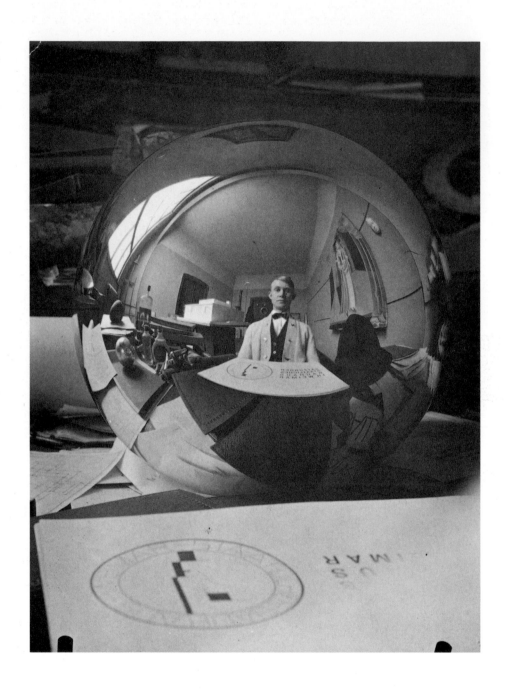

[PLATE 23]

Georg Muche

C. 1920

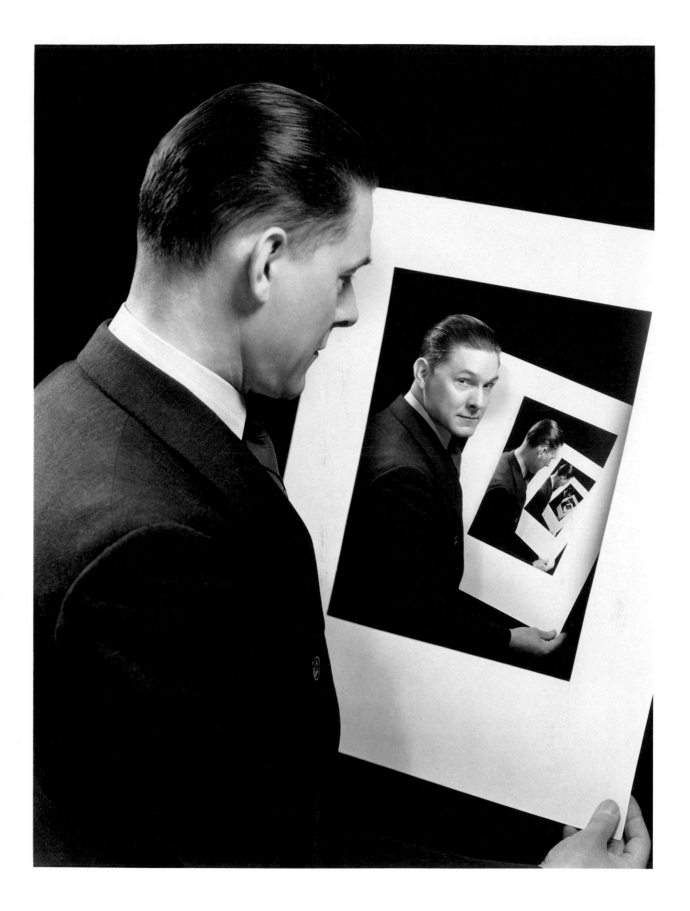

[PLATE 24]

John F. Collins

1935

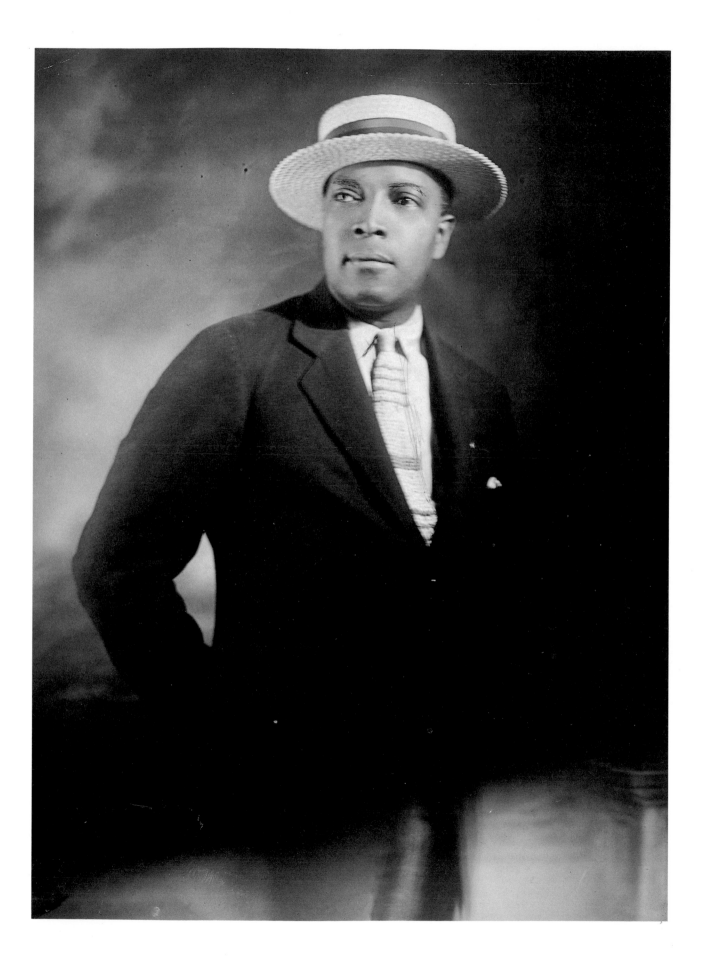

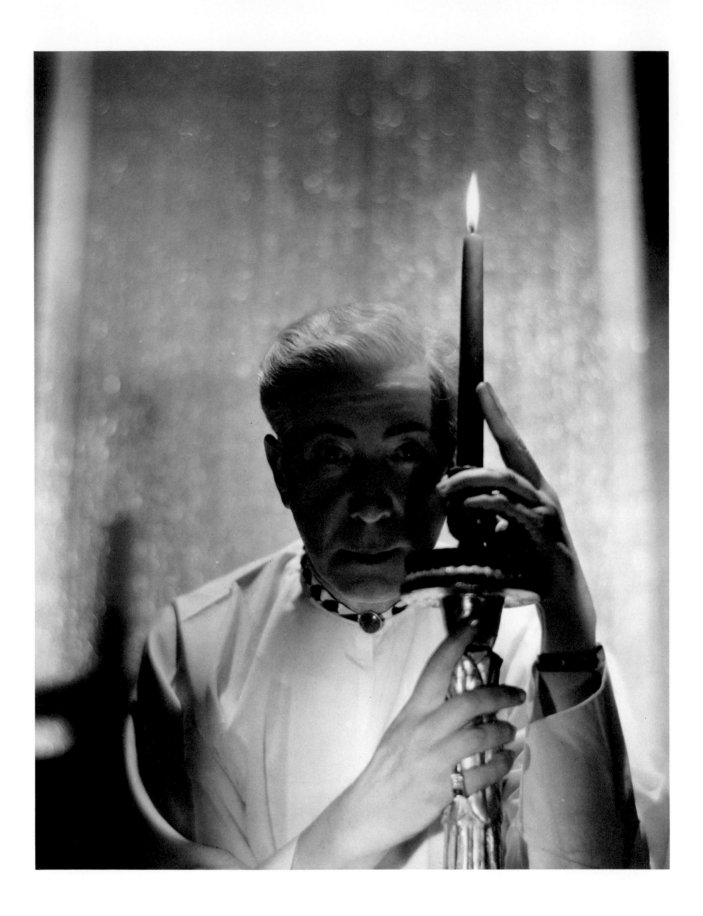

[PLATE 26]

Baron Adolph de Meyer

C. 1920S

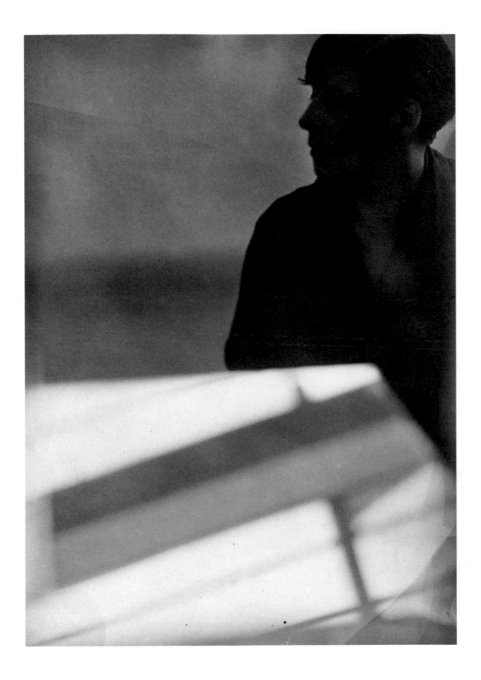

[PLATE 27]

Florence Henri

1928

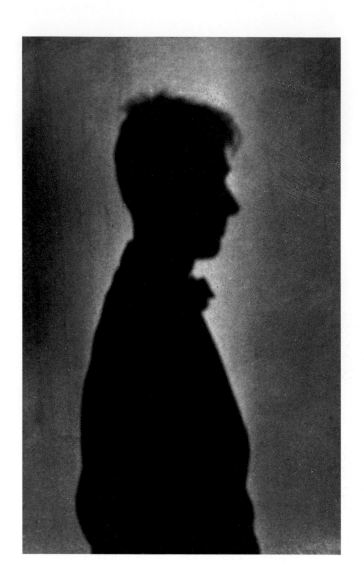

[PLATE 29]

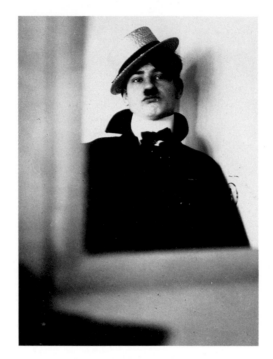

[PLATE 29]

T. Lux (Theodore Lukas) **Feininger**
1927

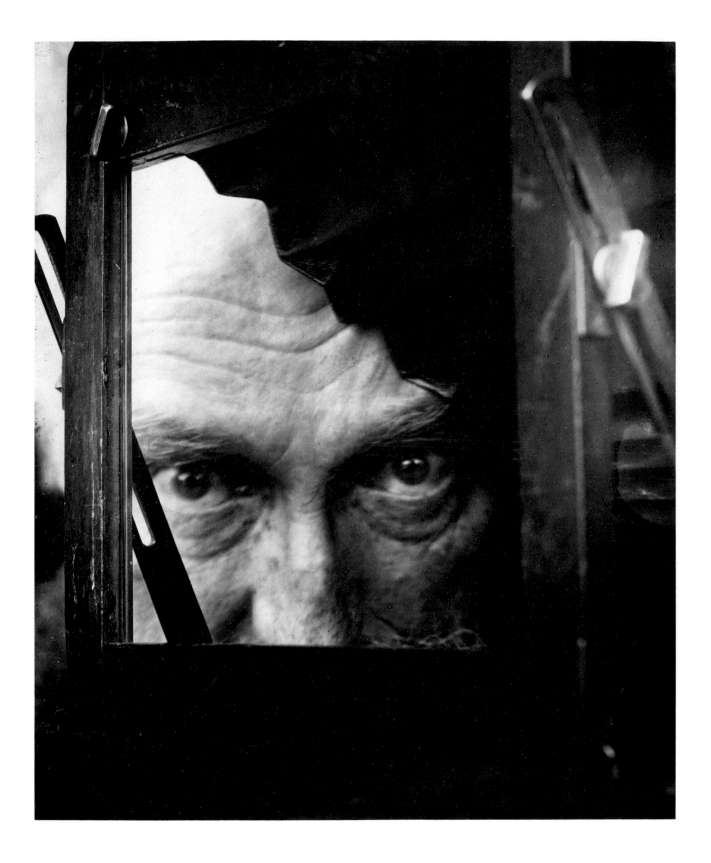

[PLATE 30]

Pierre Dubreuil

1929

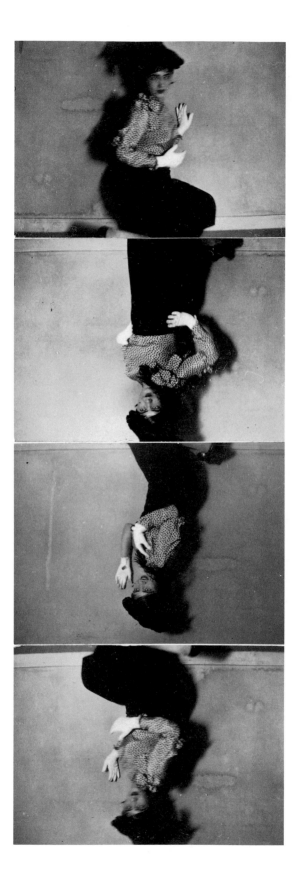

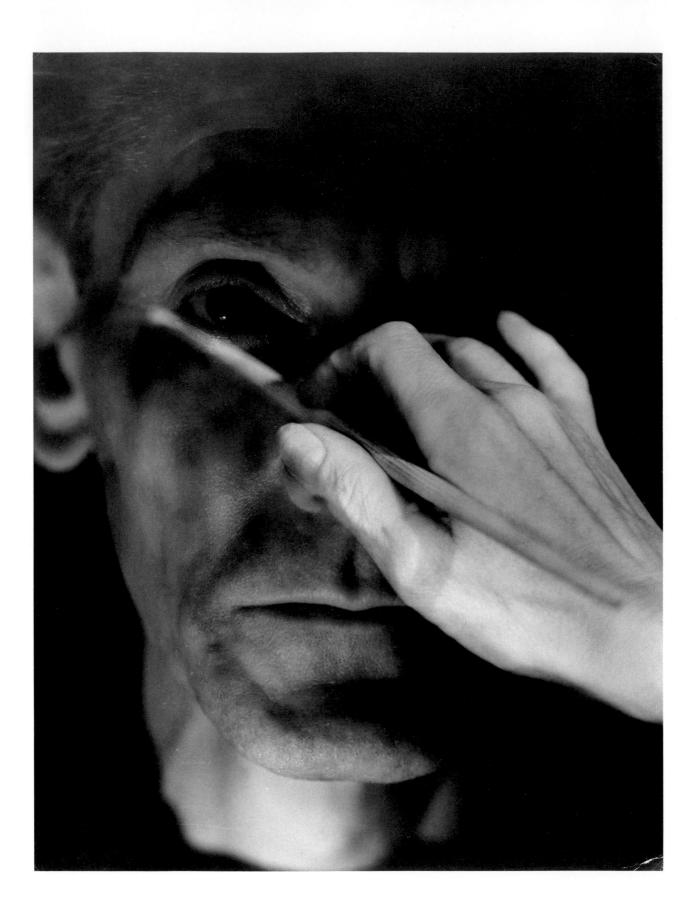

[PLATE 32]

Edmund Kesting

C. 1925

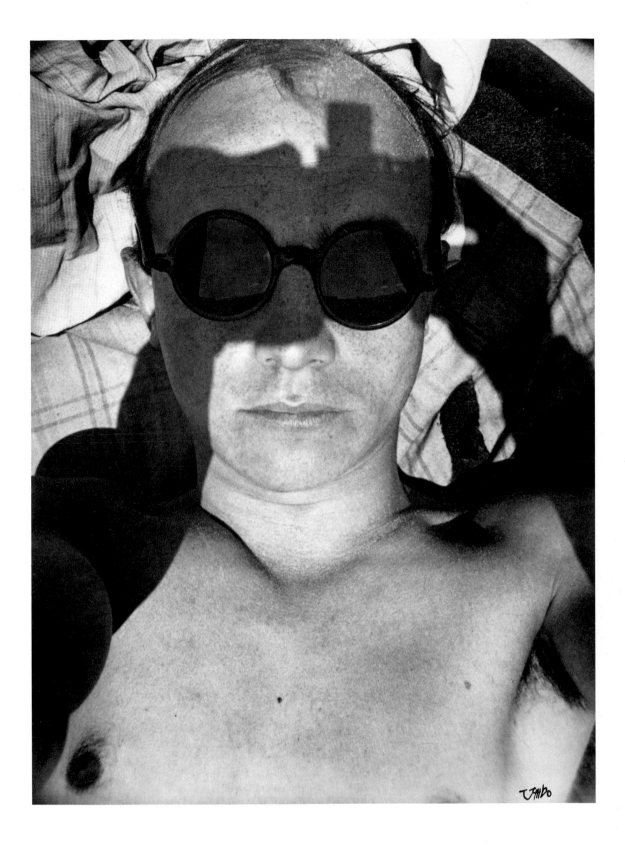

[PLATE 33]

Umbo (Otto Umbehr)

C. 1930

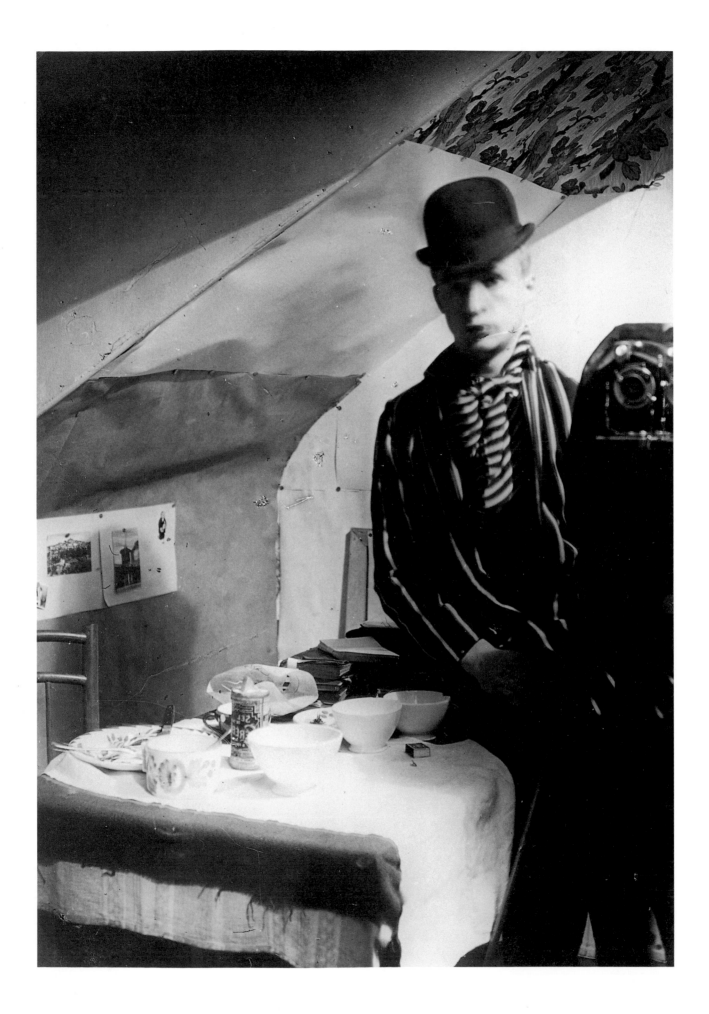

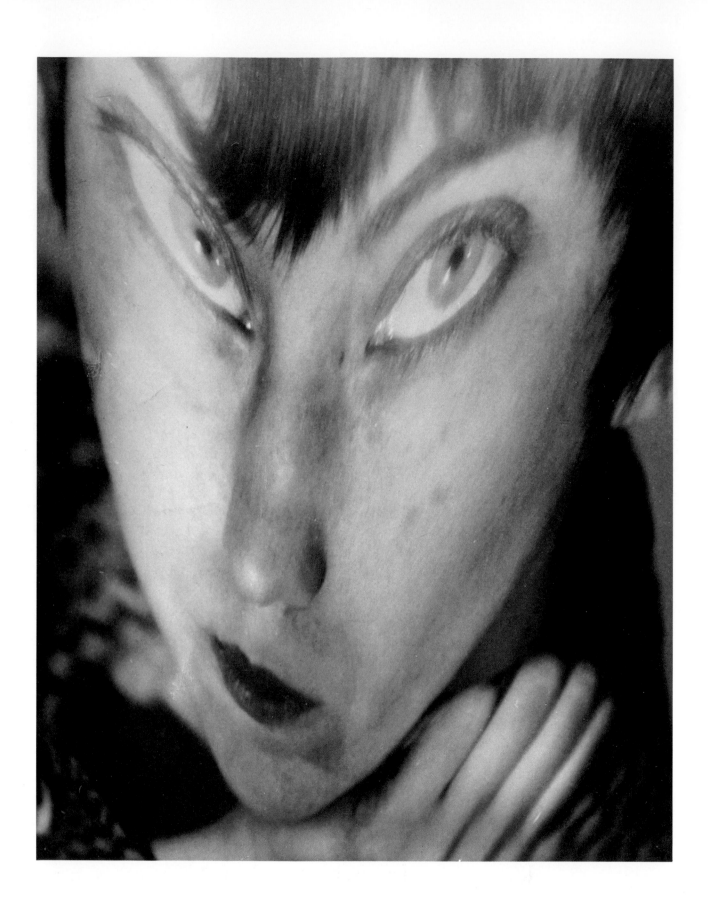

[PLATE 35]

Berenice Abbott

C. 1930

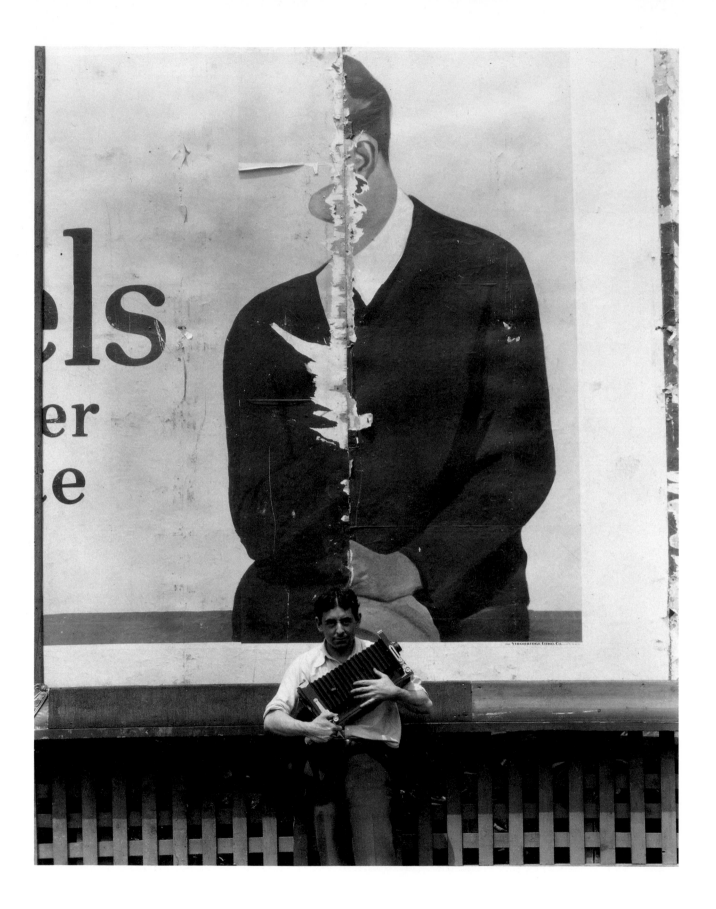

[PLATE 36]

Ralph Steiner

1929

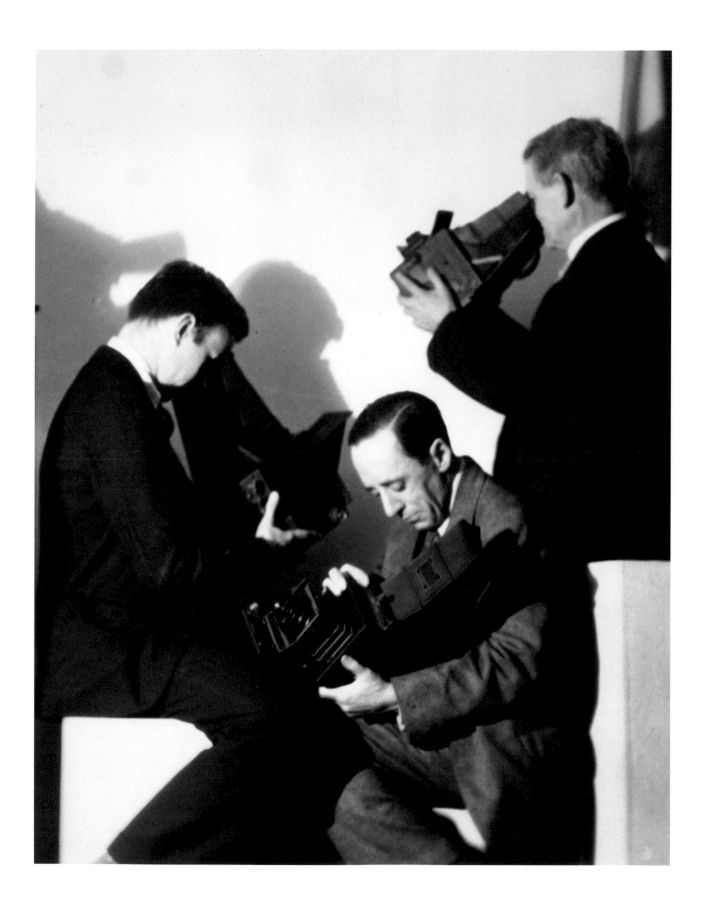

Edward Quigley

C. 1931

[PLATE 38]

Claude Cahun (Lucy Schwob)

1929–30

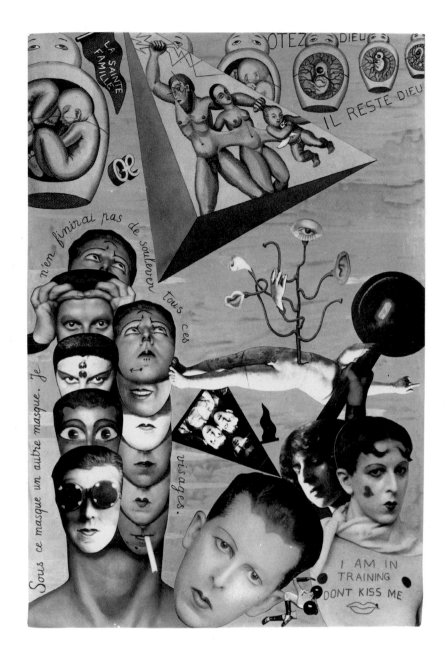

[PLATE 39]

Lejaren à Hiller

C. 1930

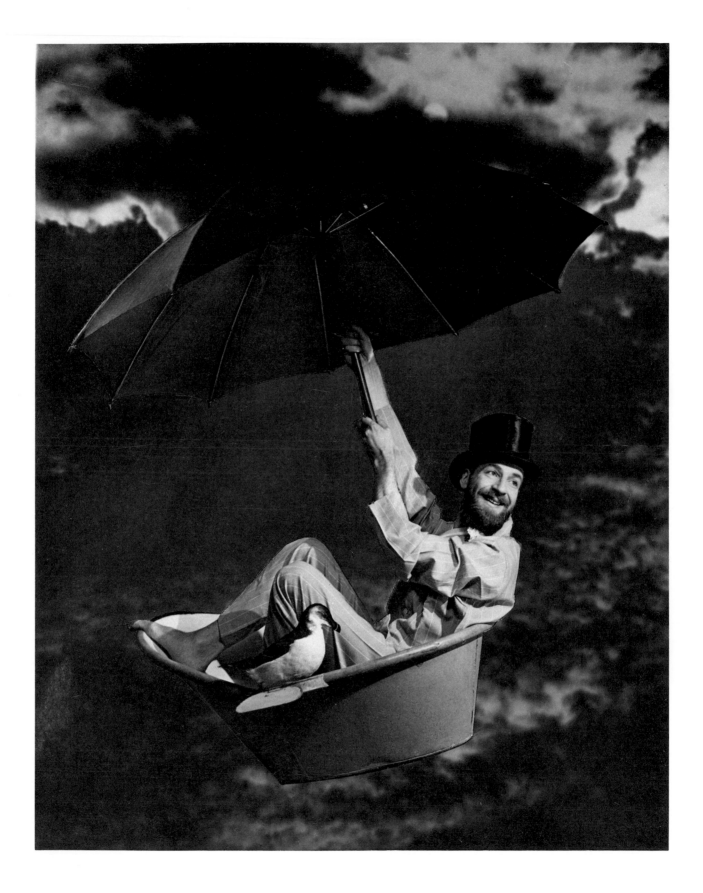

[PLATE 40]

Angus McBean

1938

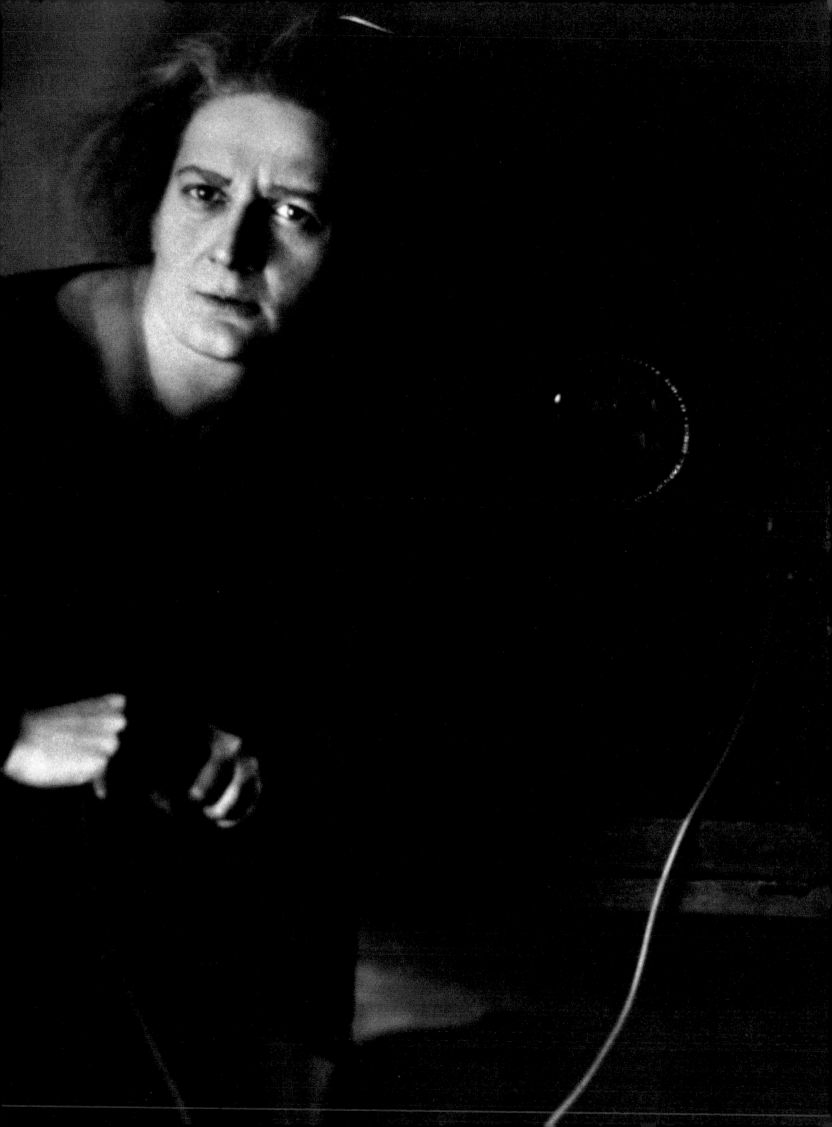

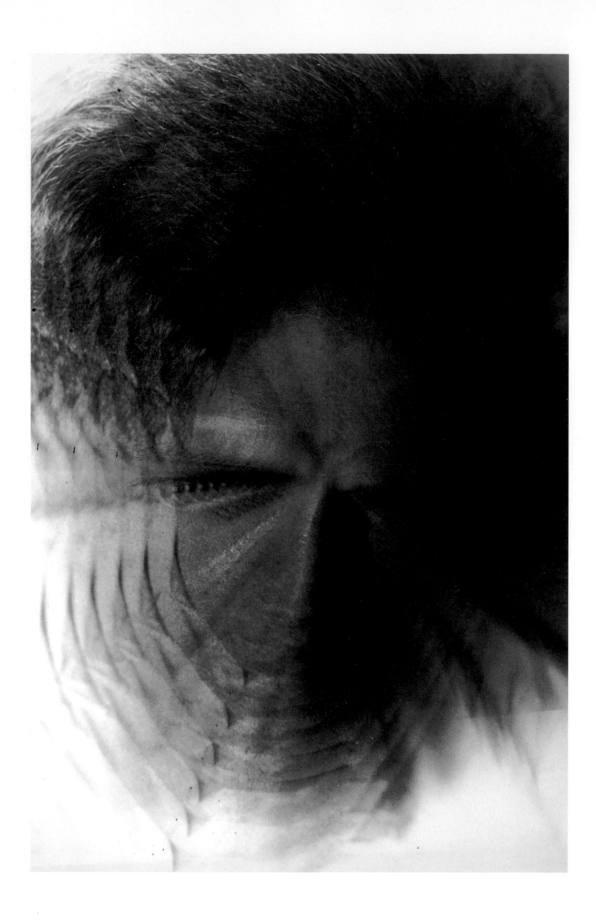

[PLATE 42]

Anton Stankowski

1937

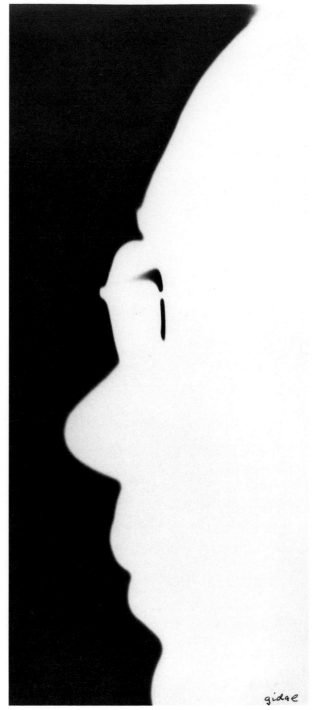

[PLATE 43]

Tim N. Gidal

1930

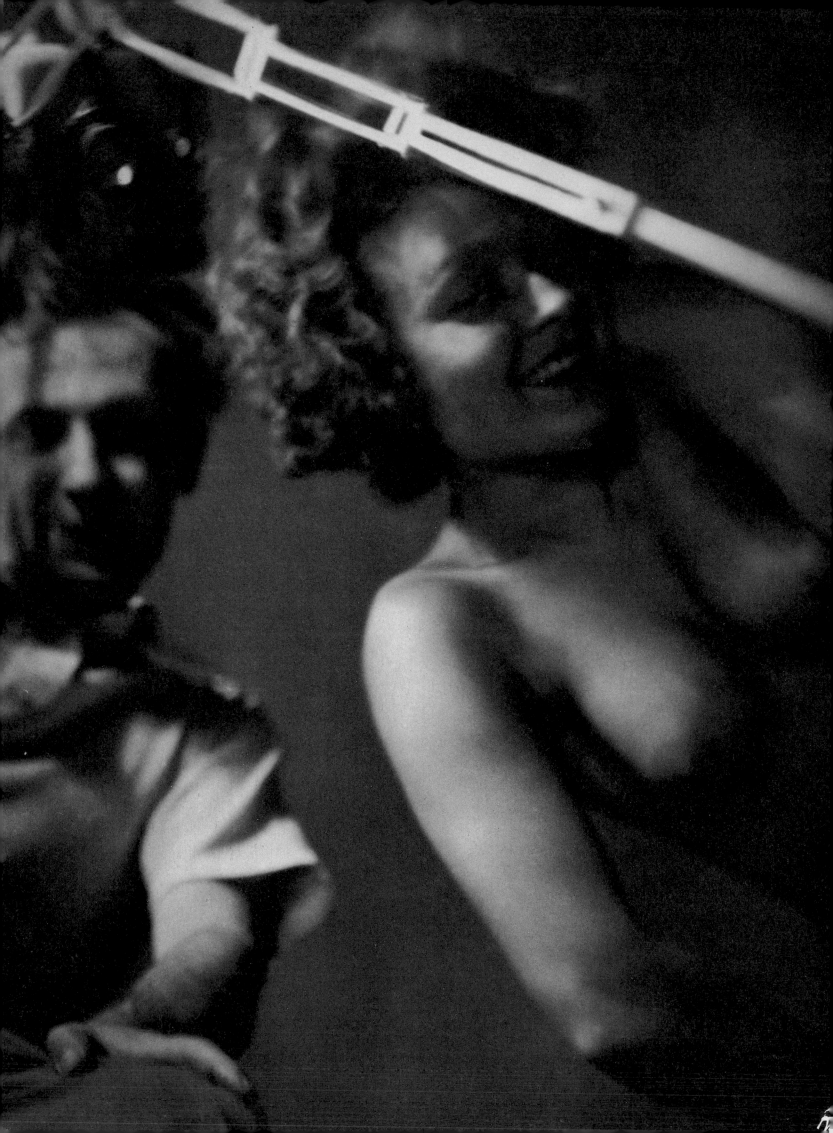

[PLATE 44]

Emery P. Révés-Biró

1930S

[PLATE 45]

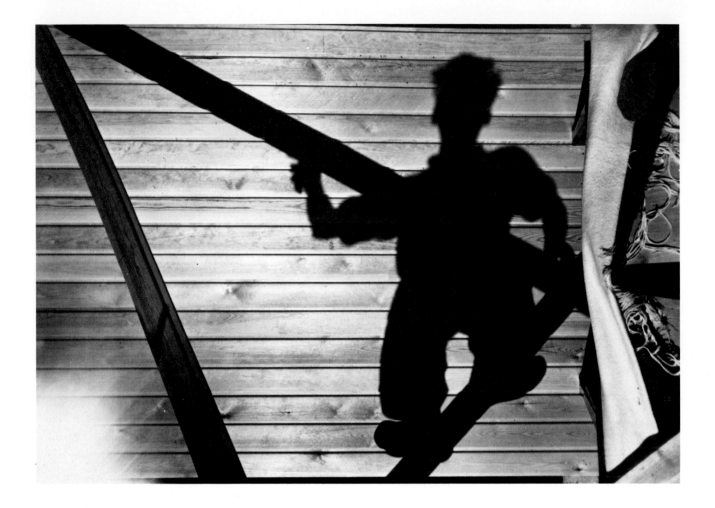

[PLATE 45]

Piet Zwart

C. 1930

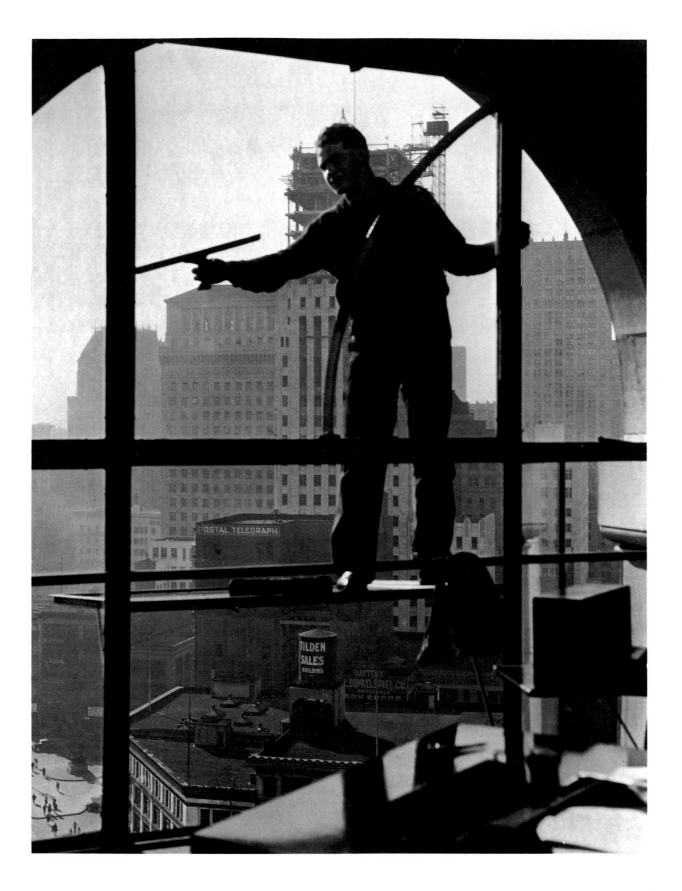

[PLATE 46]

Otto Hagel

1931

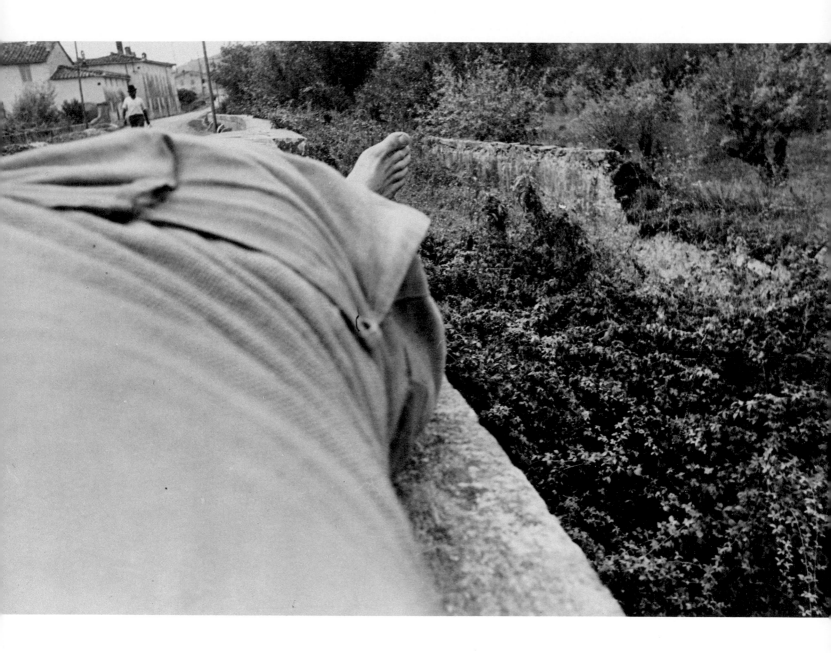

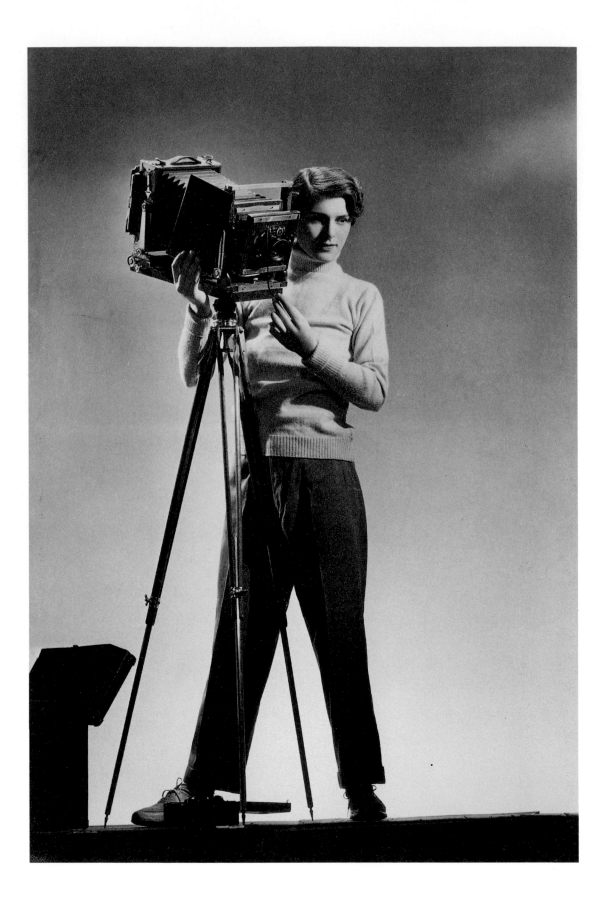

[PLATE 48]

Margaret Bourke-White

C. 1933

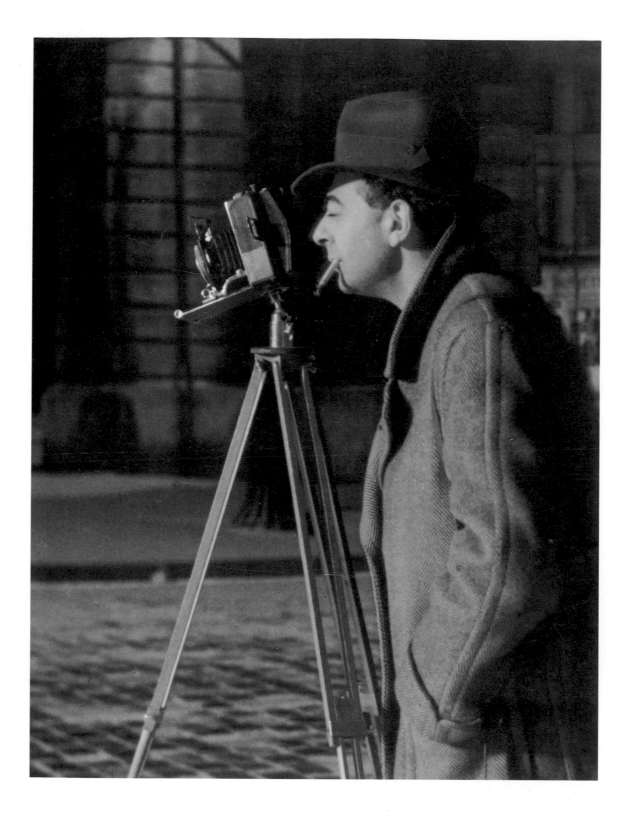

Brassaï (Gyula Halász)

1932

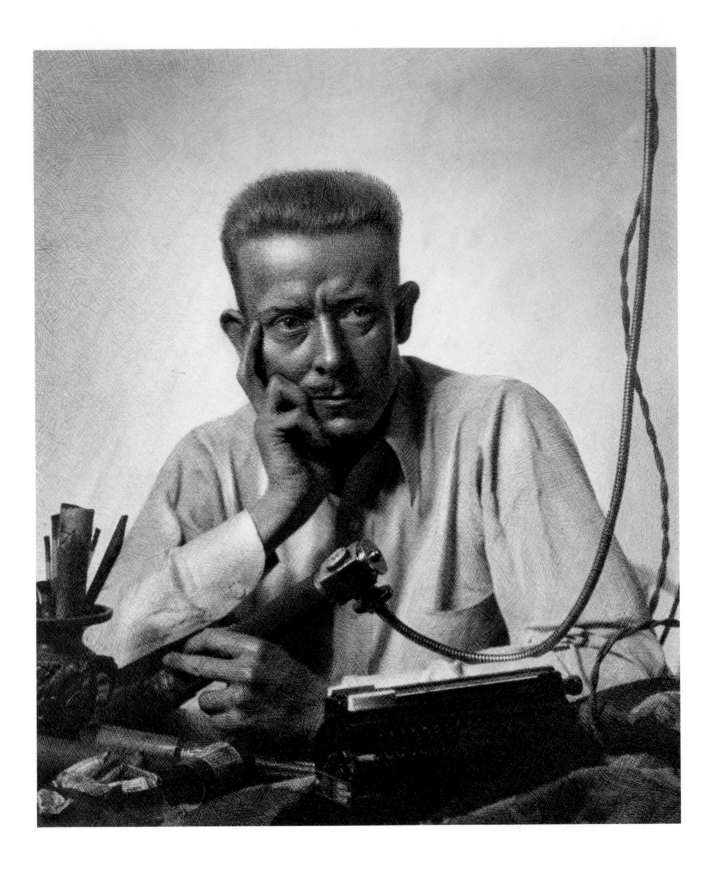

[PLATE 50]

William Mortensen

1932

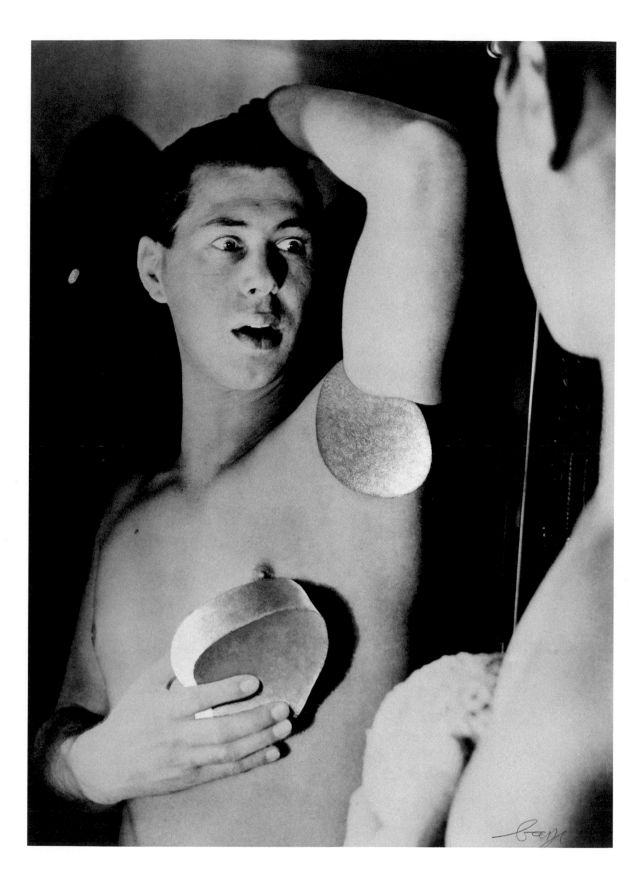

[PLATE 51]

Herbert Bayer

1932

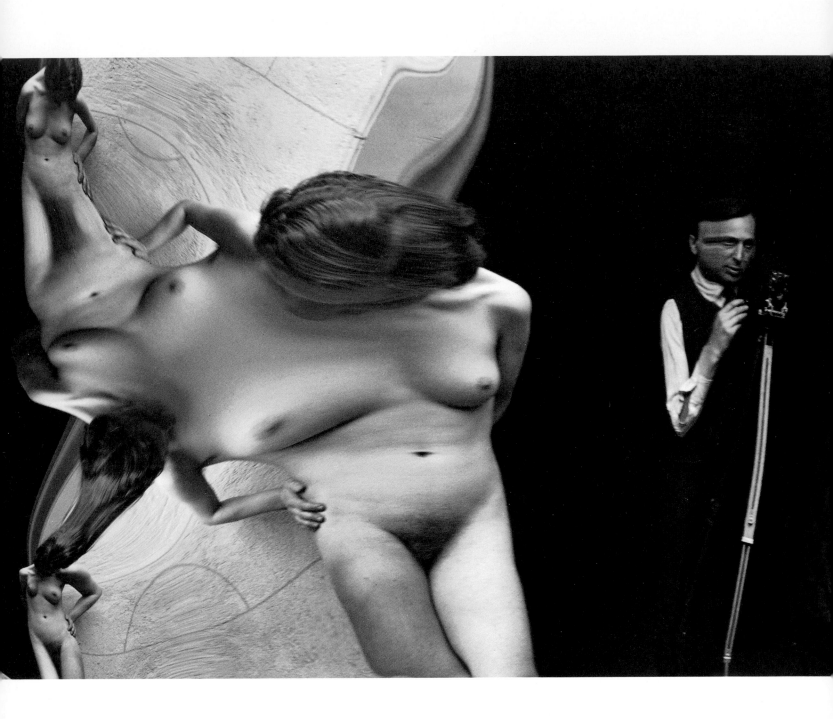

[PLATE 52]

André Kertész

1933

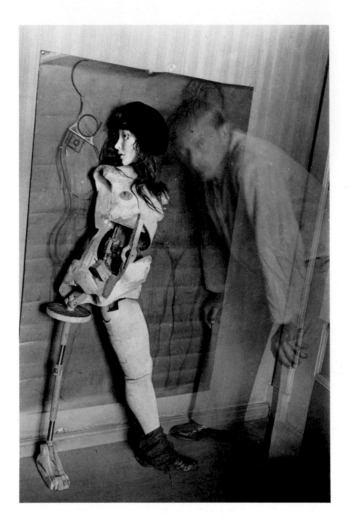

[PLATE 53]

Hans Bellmer

1934

[PLATE 54]

Carl Van Vechten

1934

[PLATE 55]

Elfriede Stegemeyer

1933

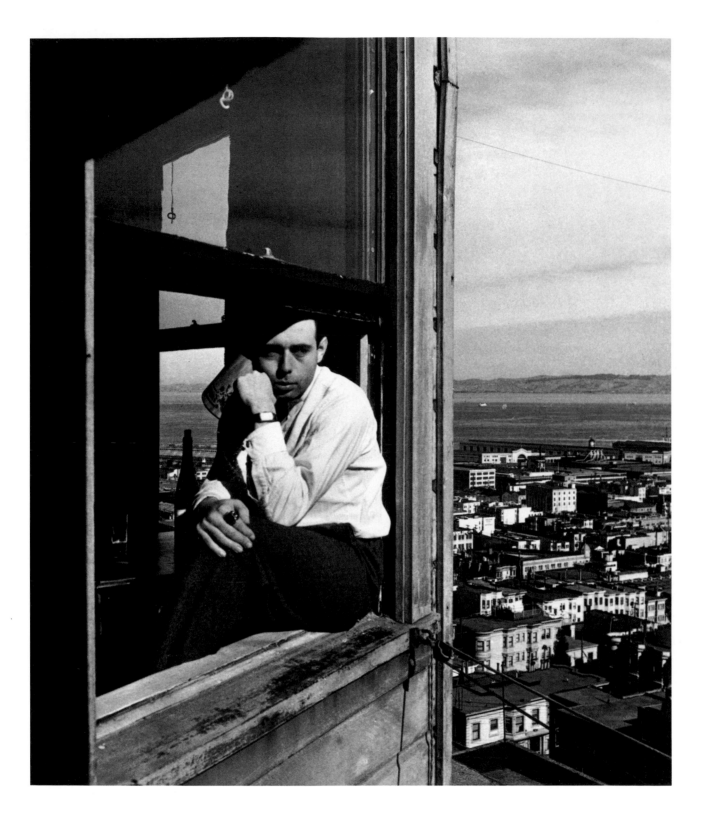

[PLATE 56]

John Gutmann

1934

[PLATE 57]

Louise Dahl-Wolfe

1935

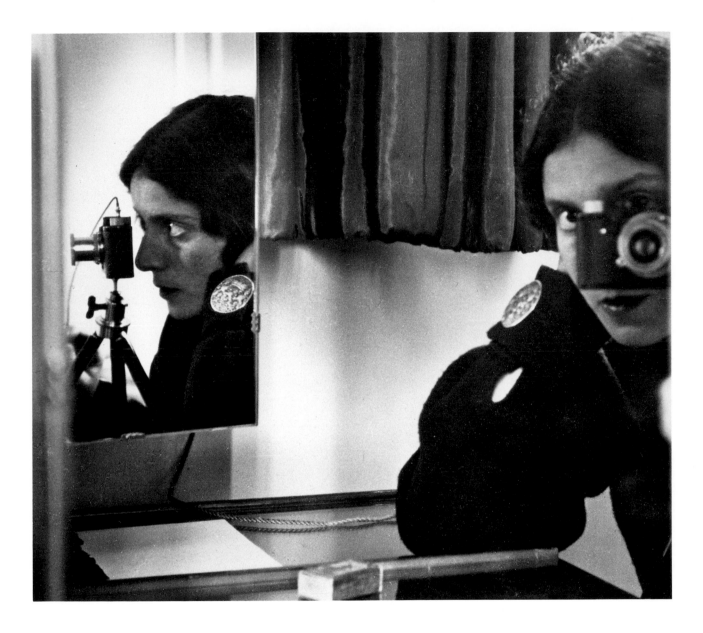

[PLATE 58]

Ilse Bing

1931

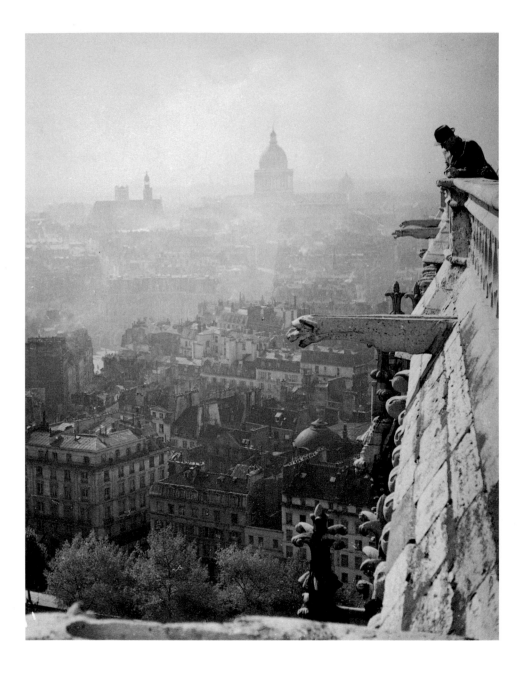

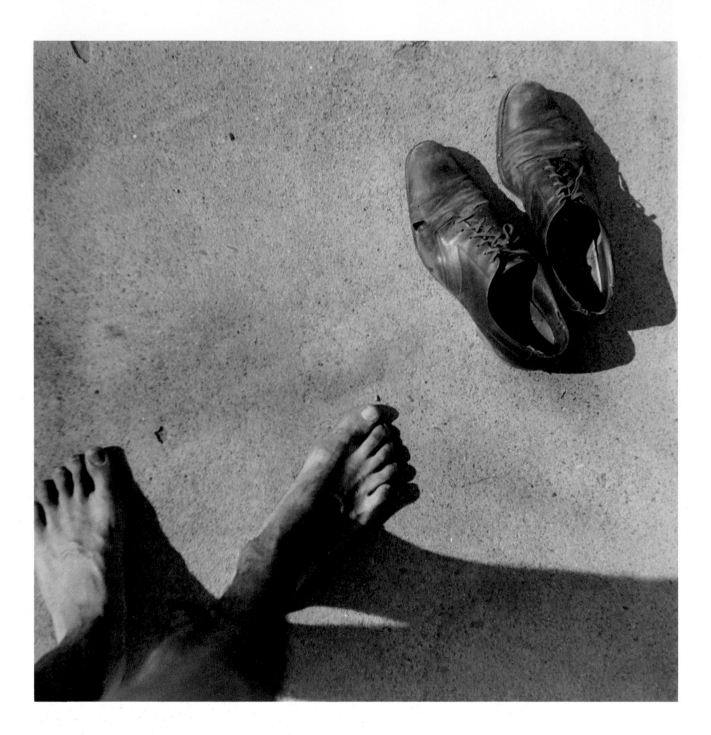

[PLATE 60]

Lou Stoumen

1935

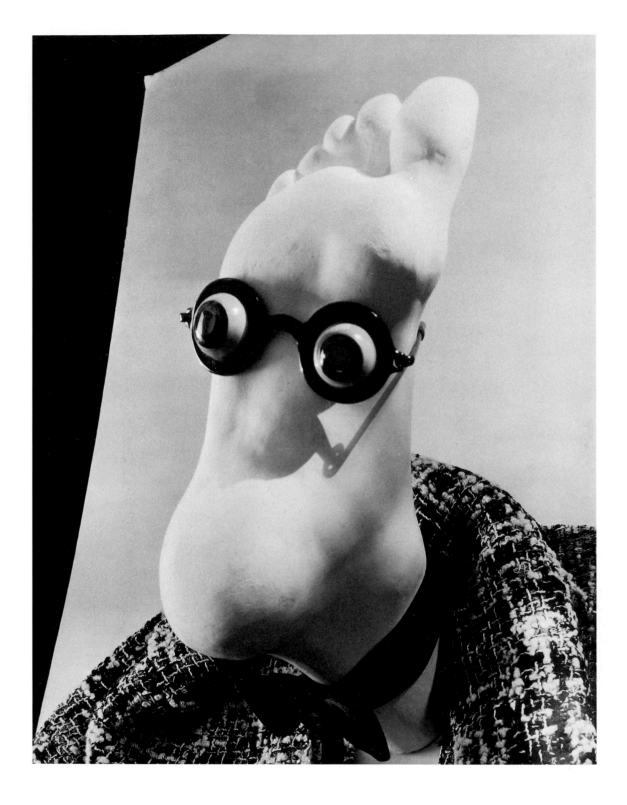

[PLATE 61]

Mehemed Fehmy Agha

C. 1935

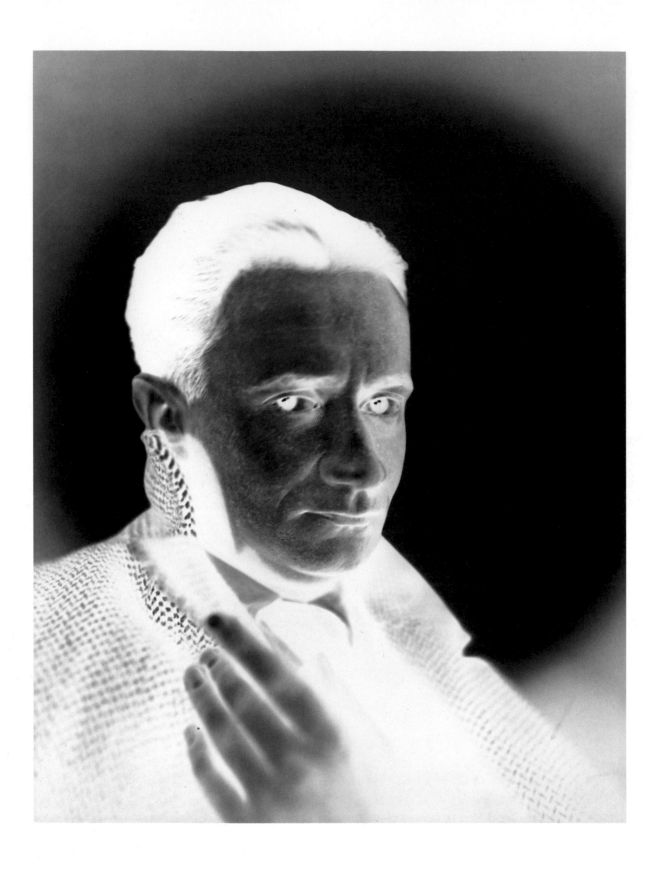

[PLATE 62]

Roger Parry

1936

[PLATE 63]

Morris Engel

1936

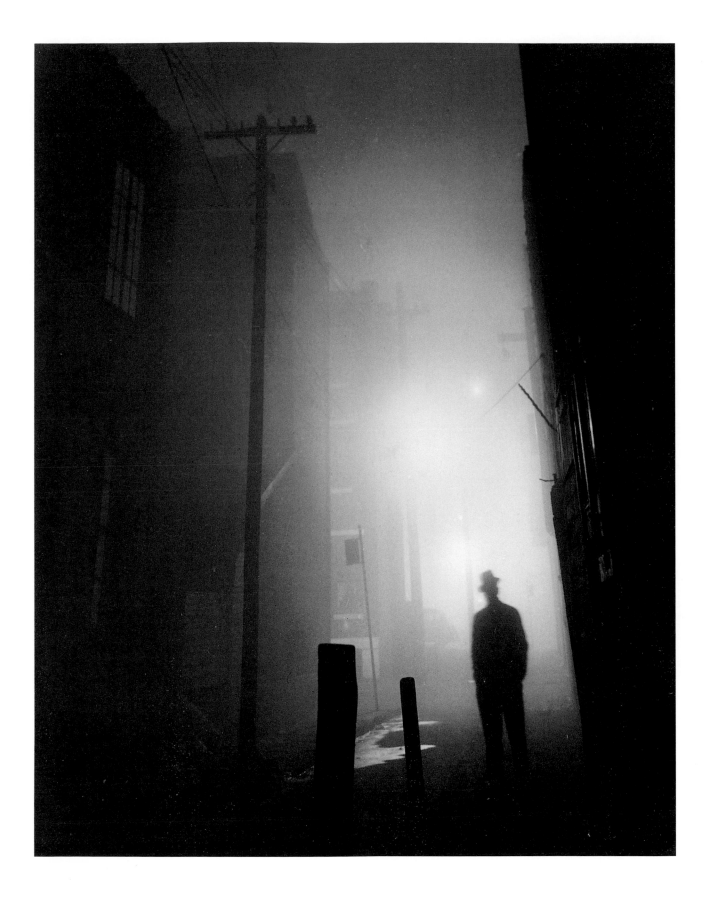

[PLATE 65]

Clarence John Laughlin

1937

[PLATE 66]

Norman Rhoads Garrett

C. 1939

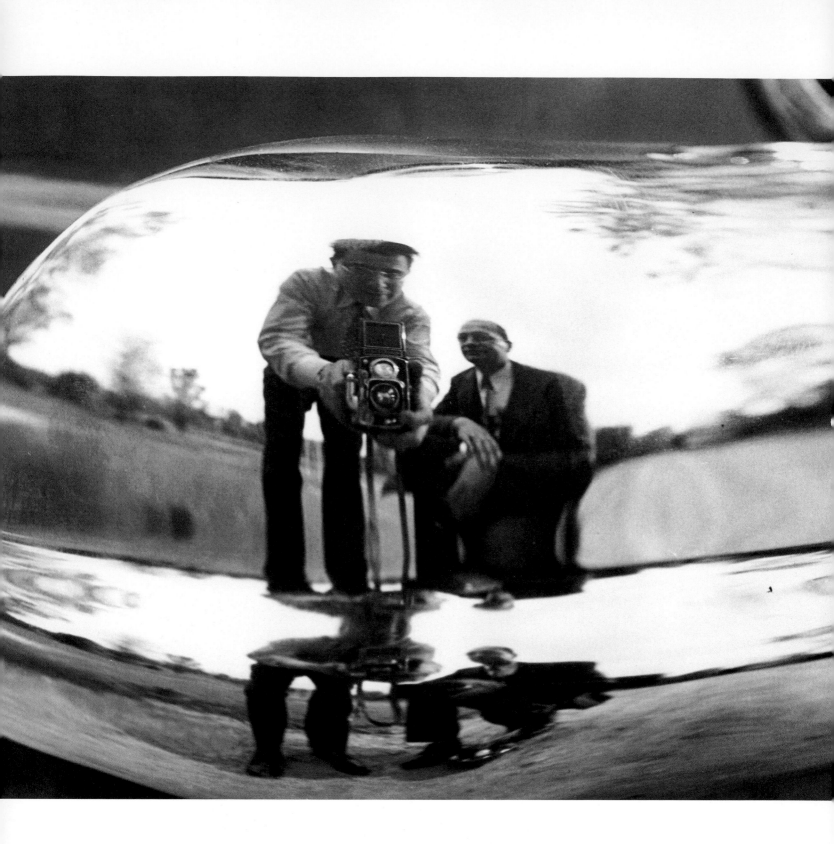

[PLATE 67]

Gordon Coster

1942

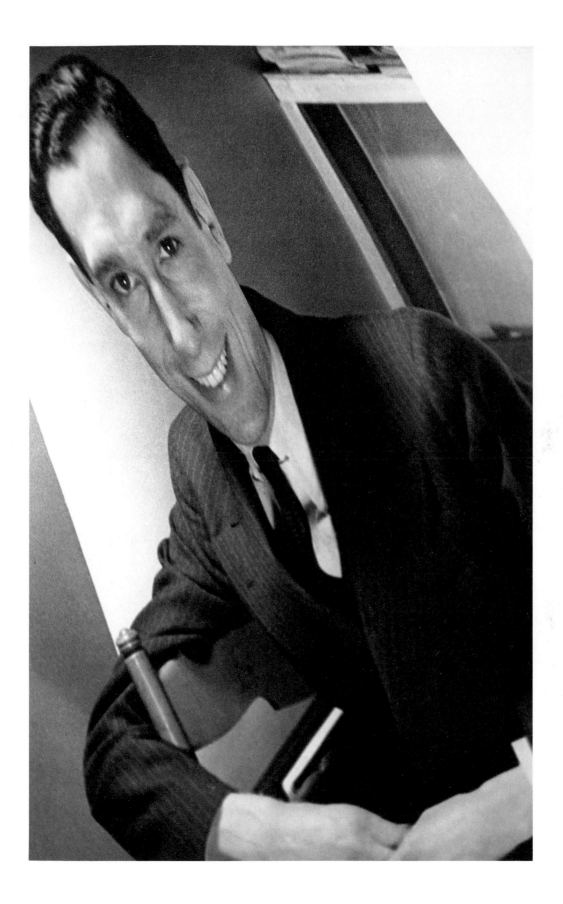

[PLATE 68]

Arthur Siegel

1937

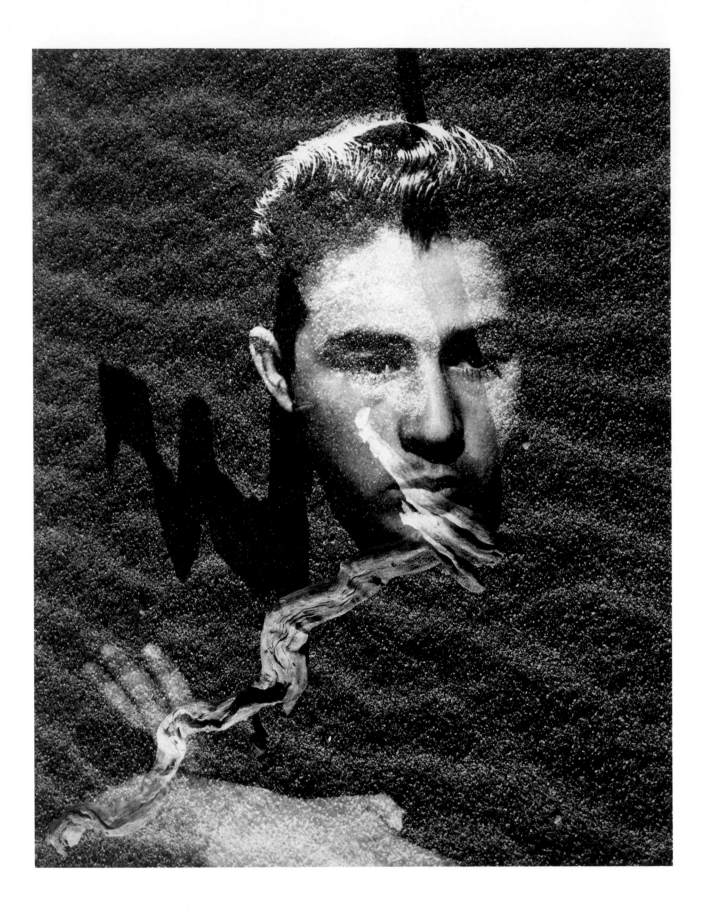

[PLATE 69]

Pedro Guerrero
1938

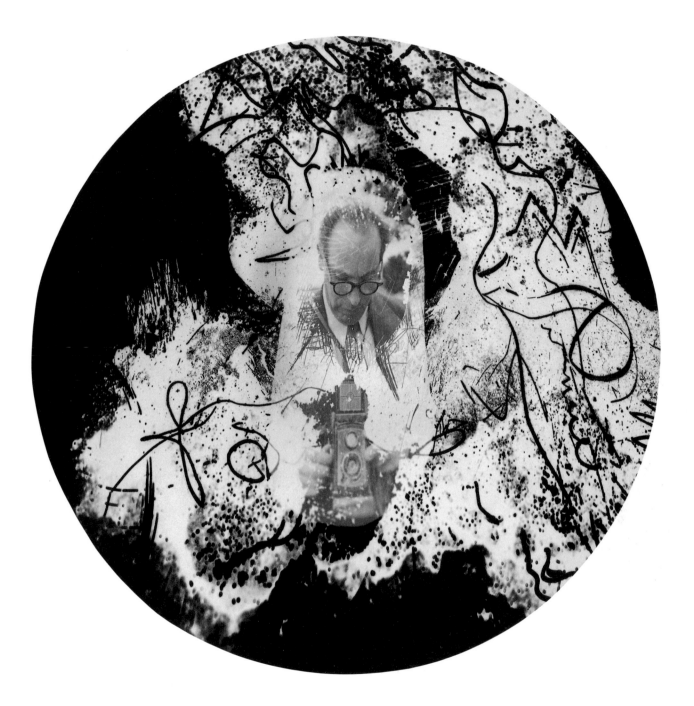

Josef Breitenbach

C. 1947

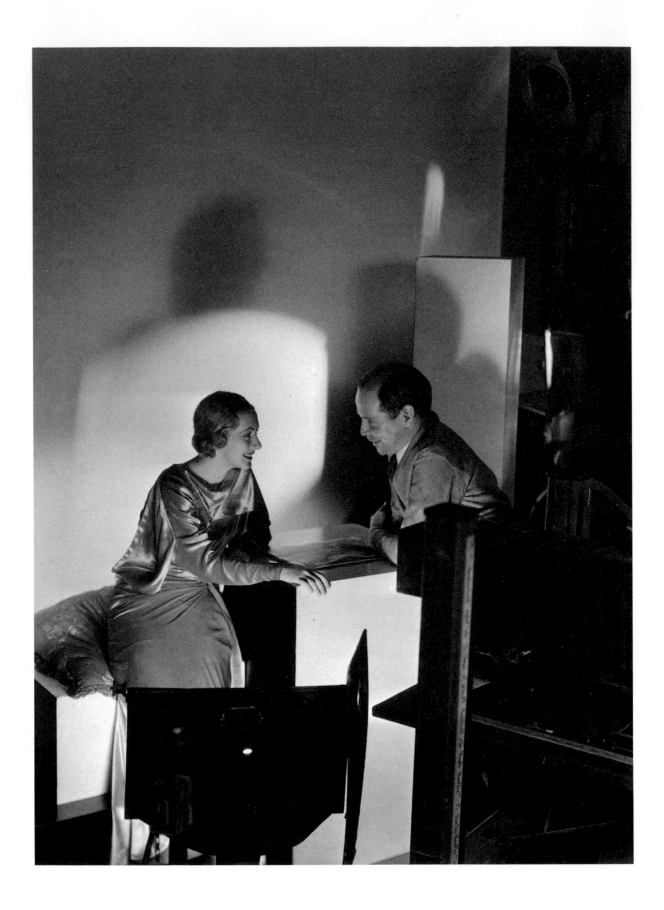

Clarence Sinclair Bull

C. 1940

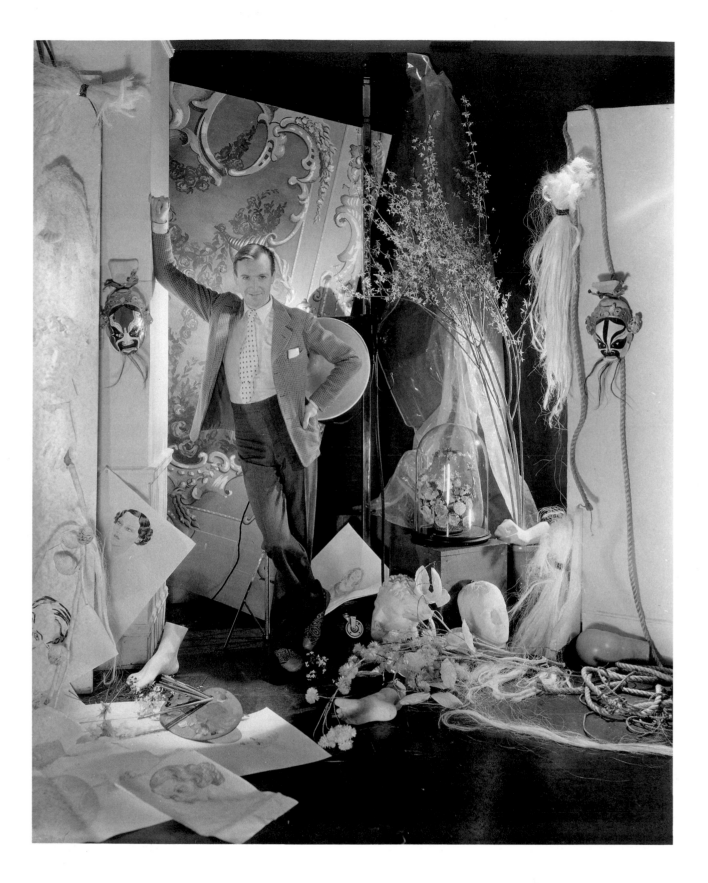

[PLATE 73]

Cecil Beaton

C. 1938

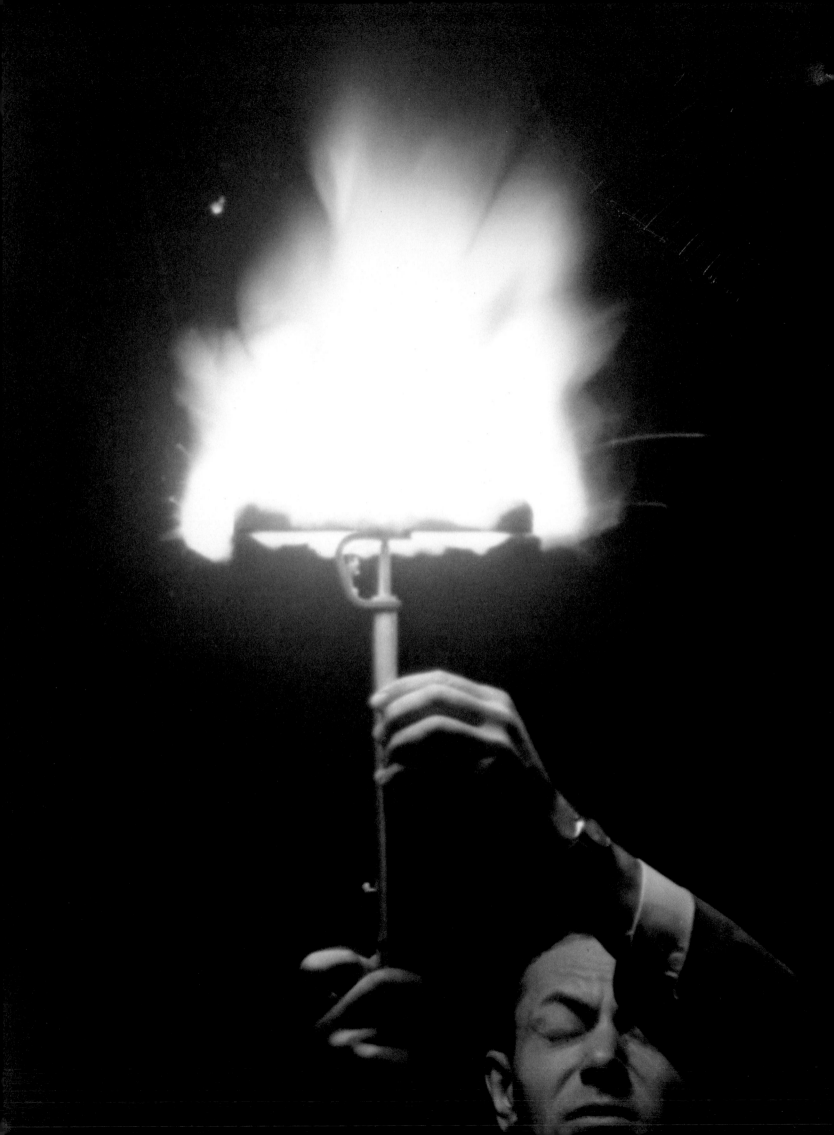

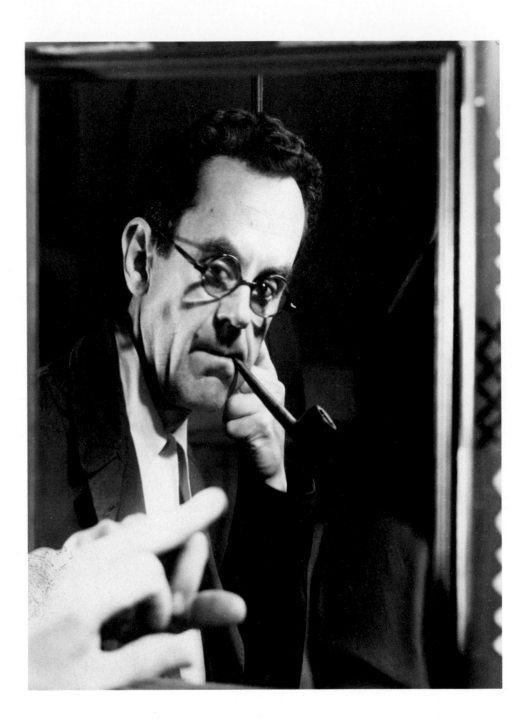

[PLATE 75]

Man Ray (Emmanuel Rudnitsky)

C. 1944

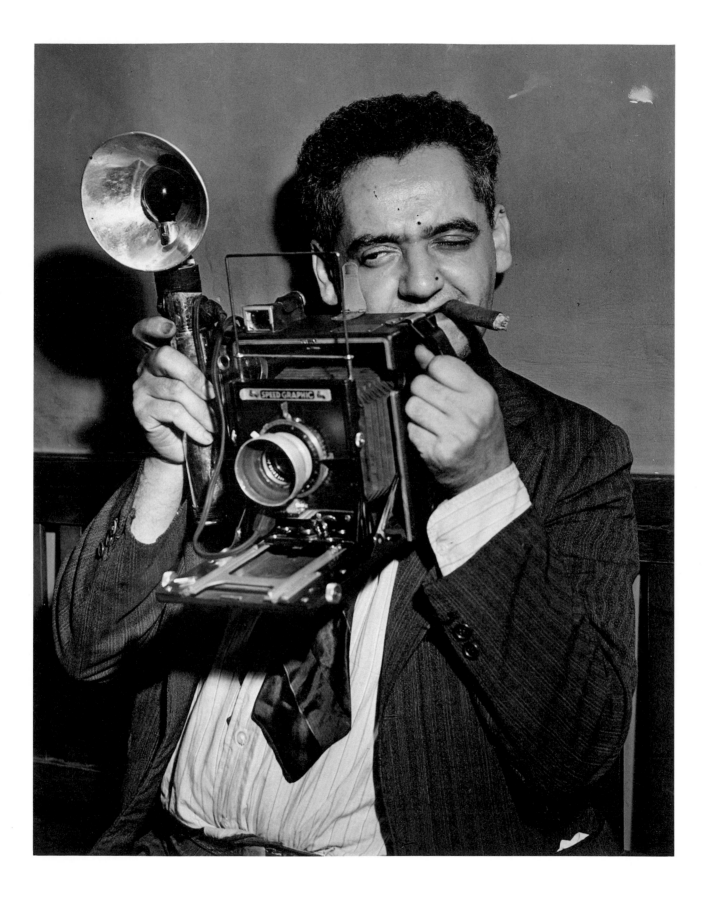

[PLATE 76]

Weegee (Arthur Fellig)

C. 1940

George Platt Lynes
1940s

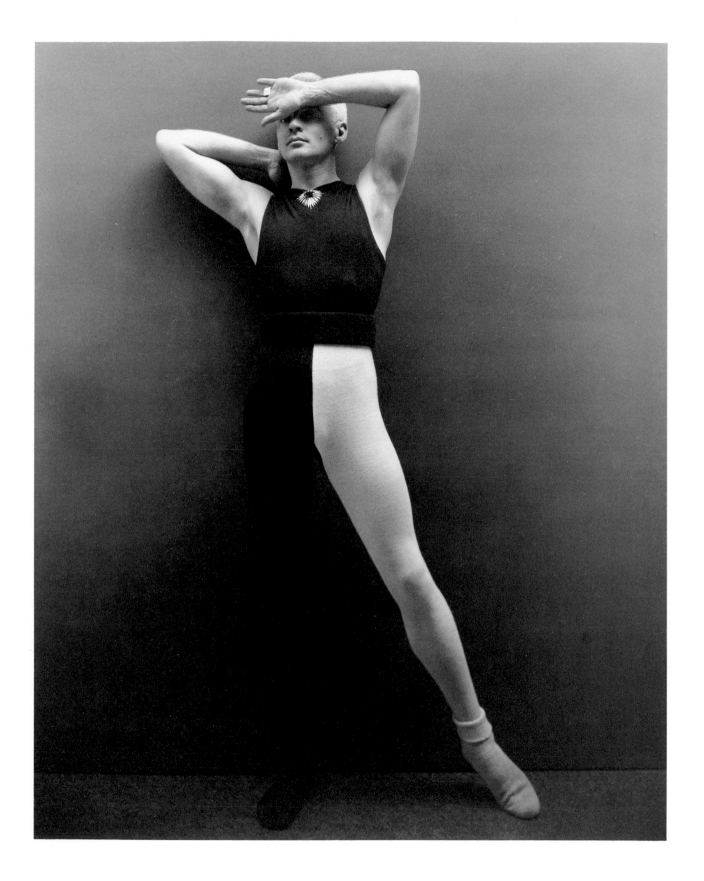

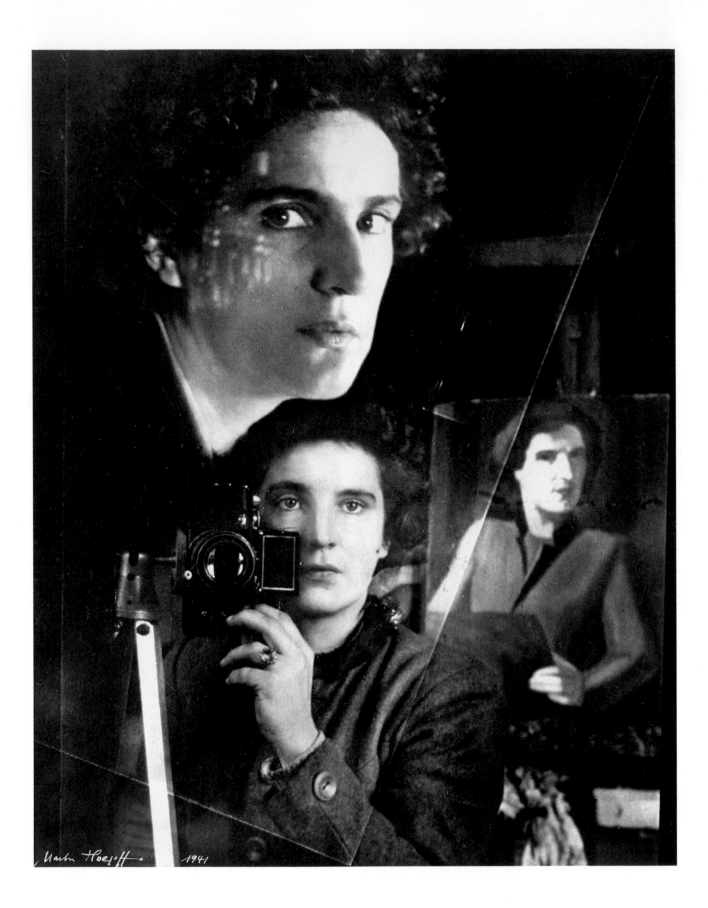

[PLATE 78]

Marta Hoepffner

1941

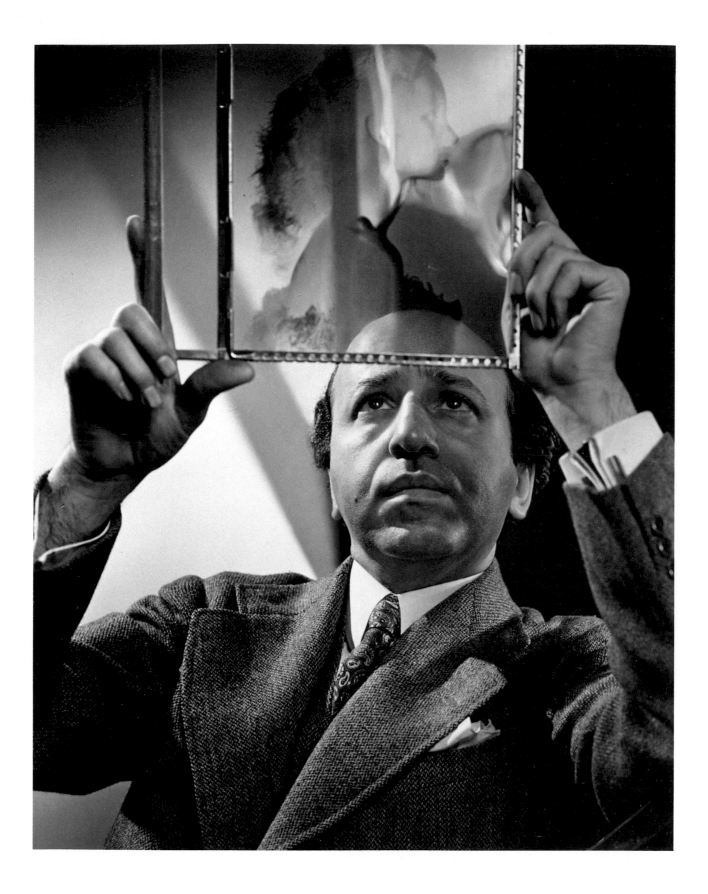

[PLATE 79]

Yousuf Karsh

1947

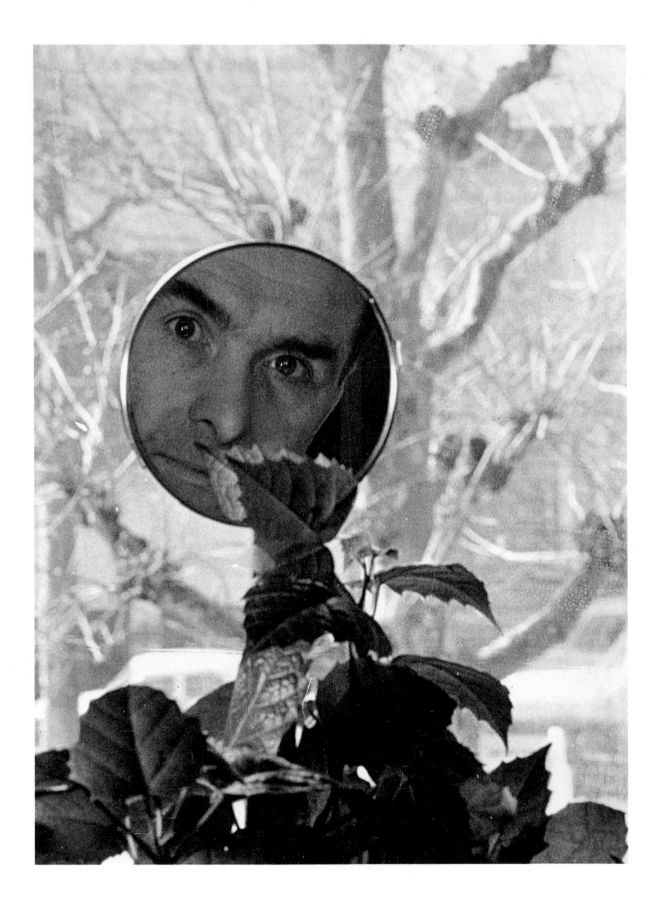

[PLATE 80]

Robert Doisneau

C. 1953

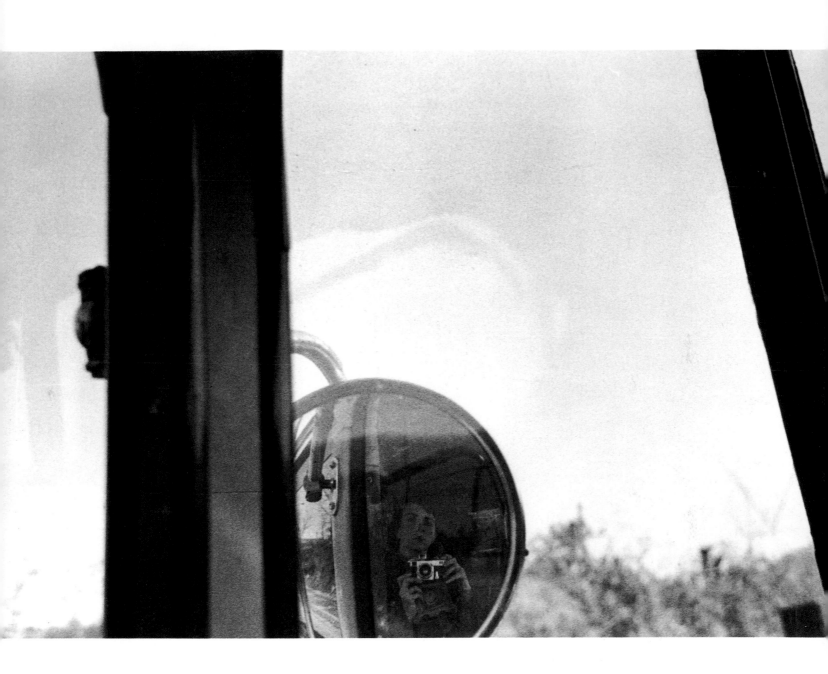

[PLATE 81]

Esther Bubley

1947

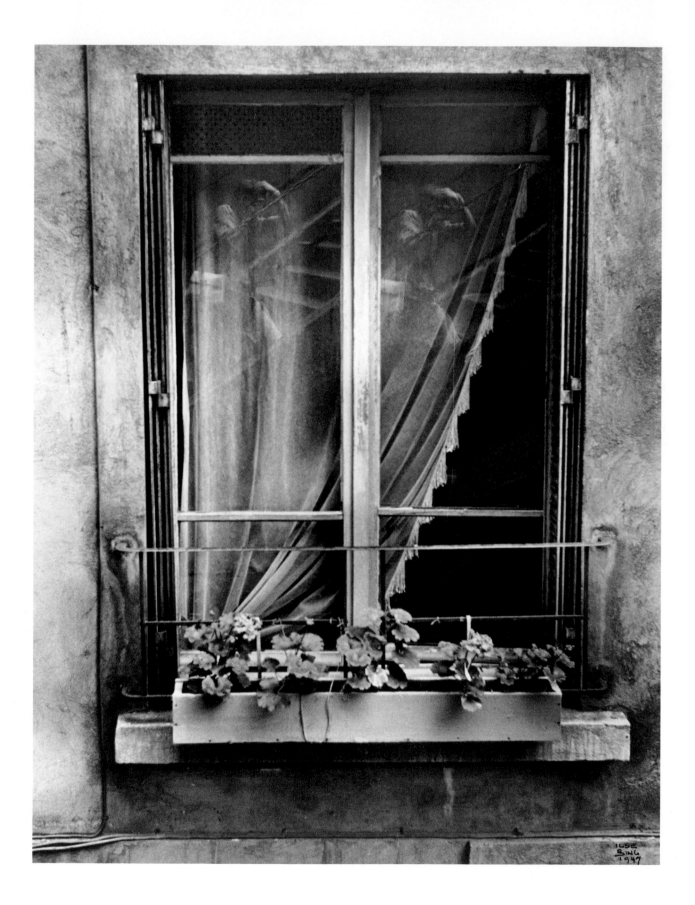

[PLATE 82]

Ilse Bing

1947

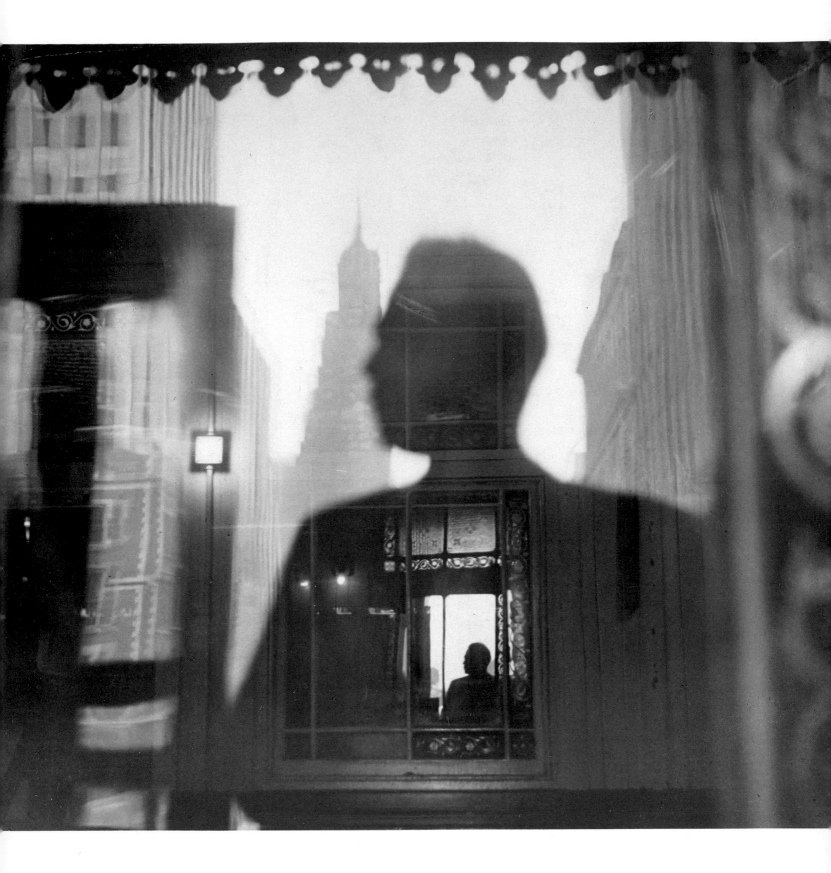

[PLATE 83]

Louis Faurer

1946

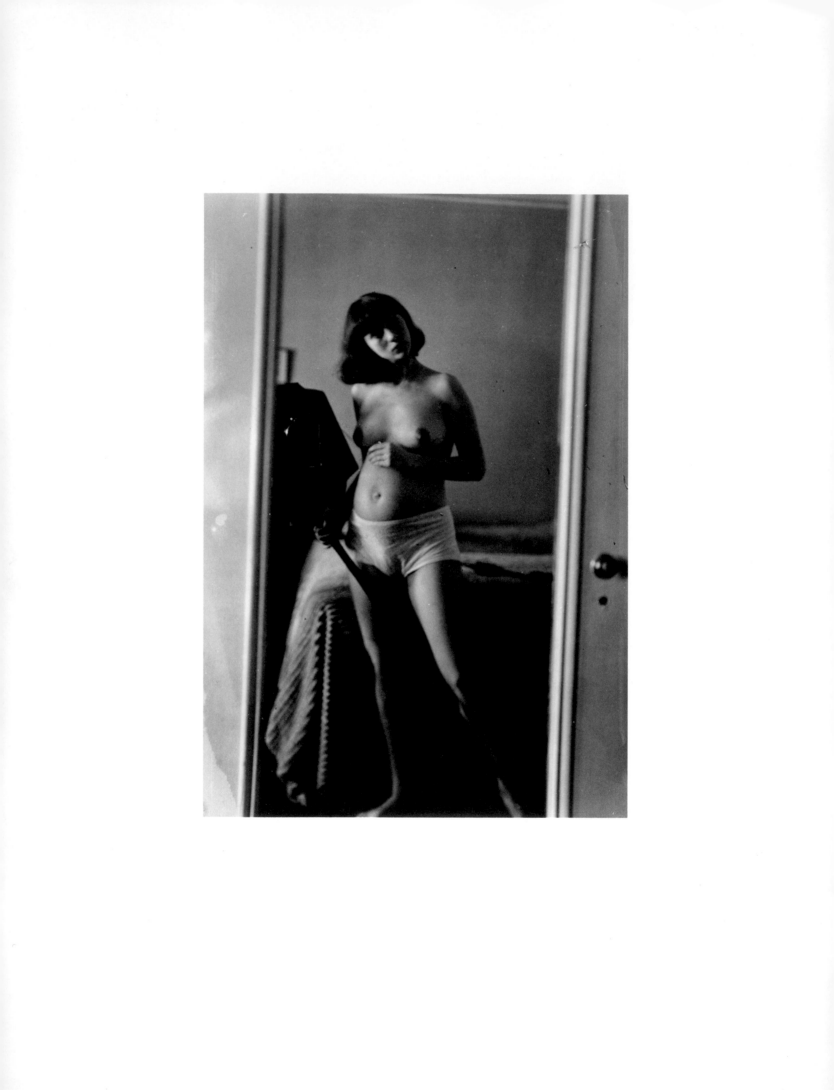

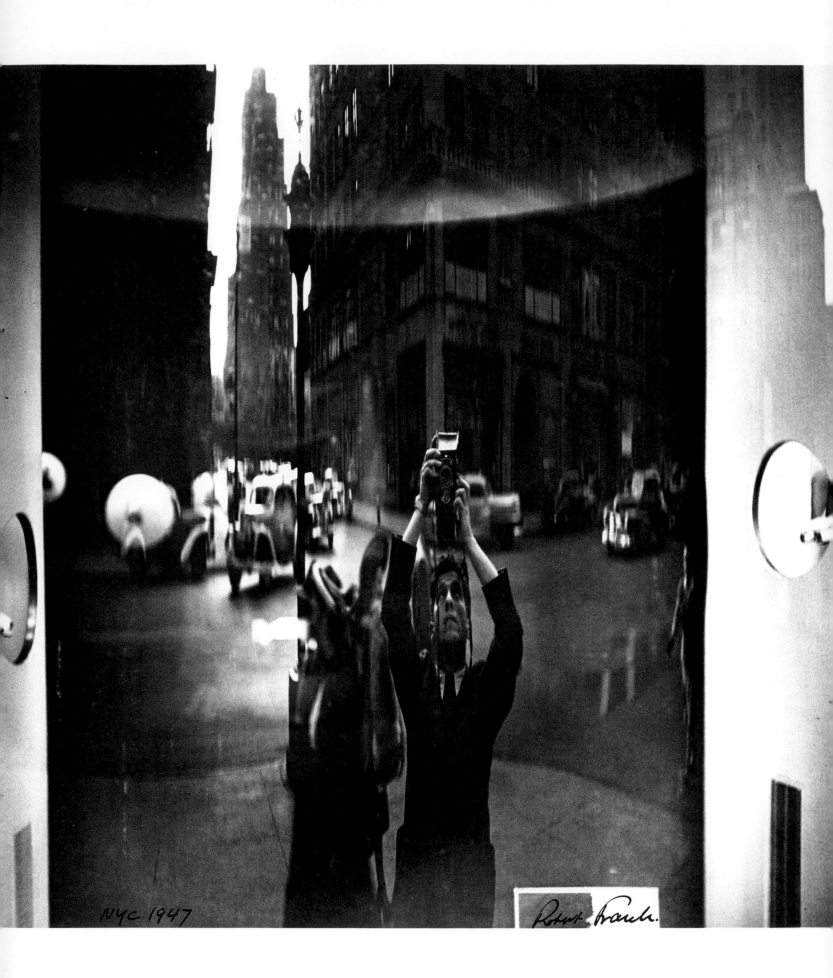

NYC 1947

Robert Frank.

[PLATE 85]

Robert Frank
1947

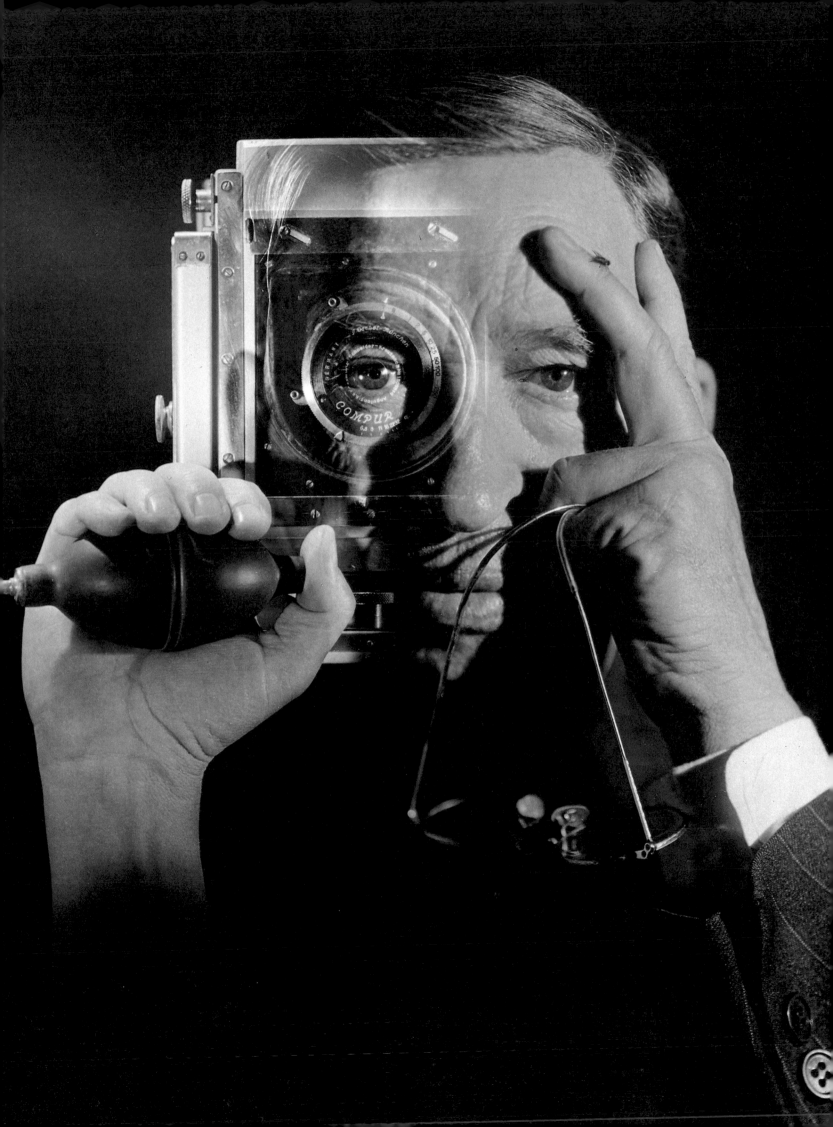

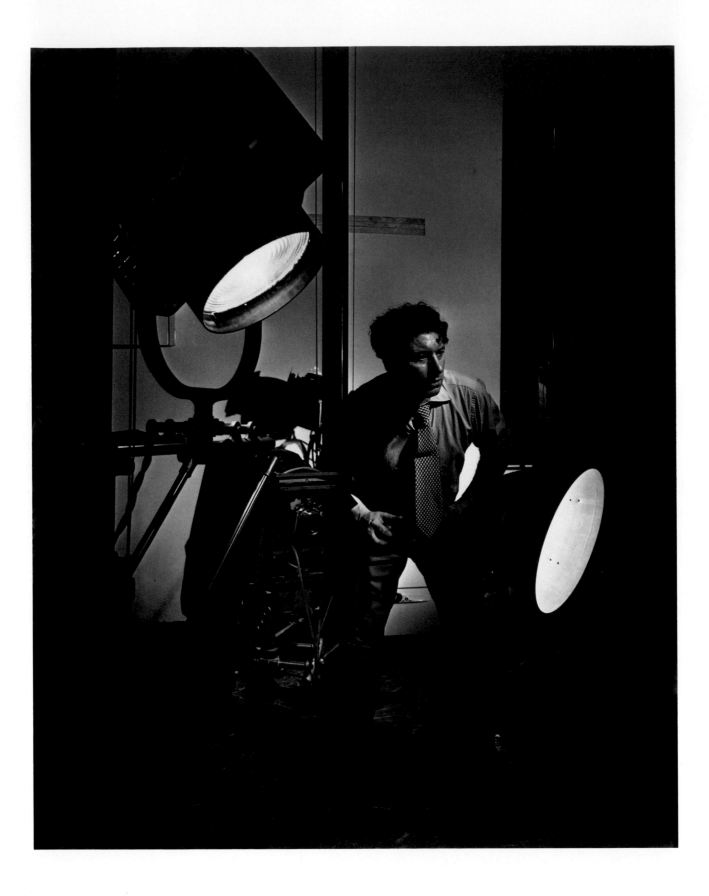

[PLATE 87]

George Hurrell

1947

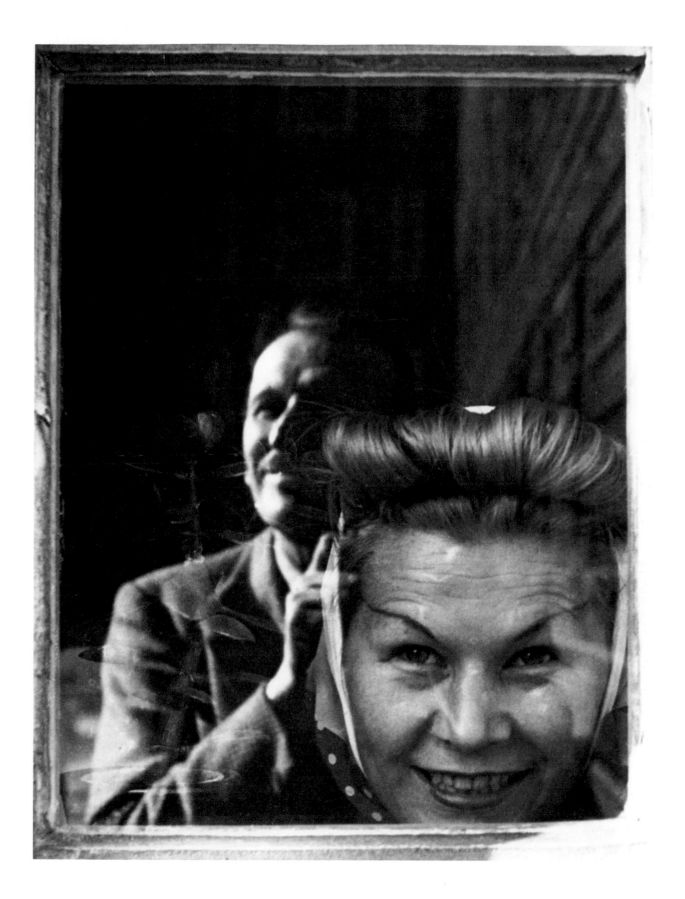

[PLATE 88]

Felix H. Man (Hans Baumann)

1947

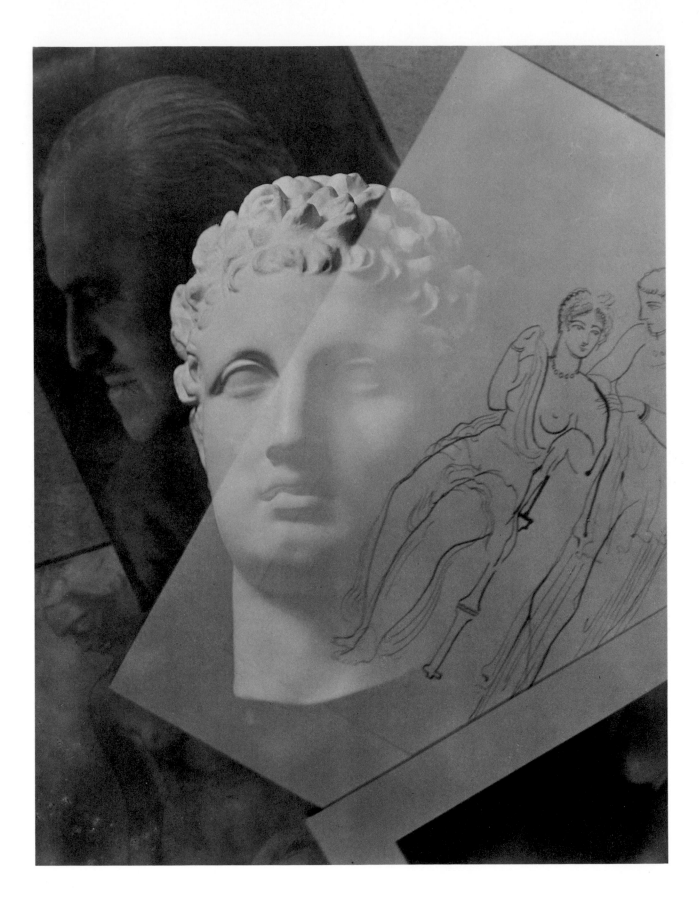

Konrad Cramer

1947

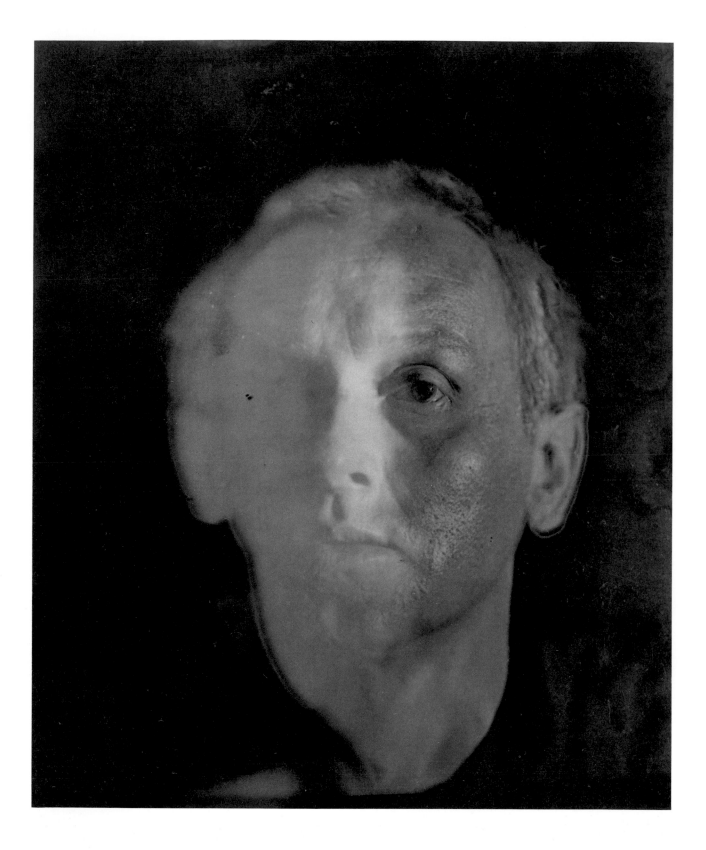

[PLATE 90]

Val Telberg

C. 1948

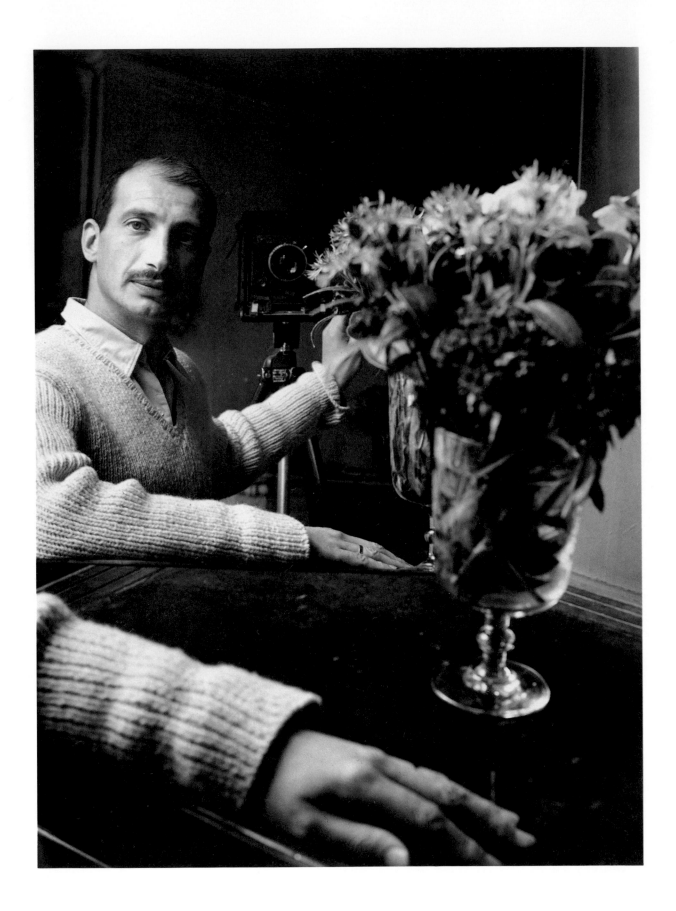

Édouard Boubat

1958

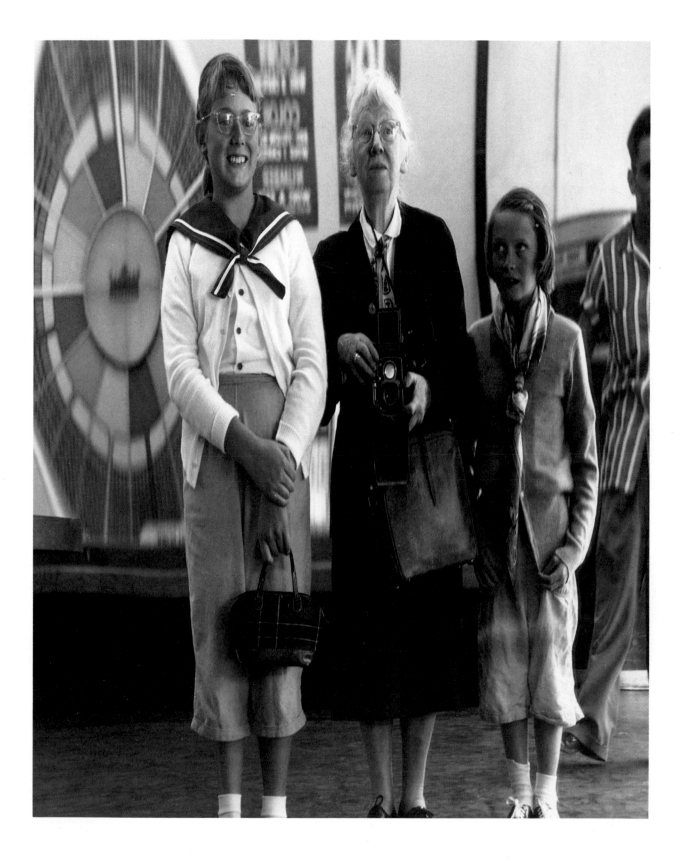

[PLATE 92]

Imogen Cunningham

1955

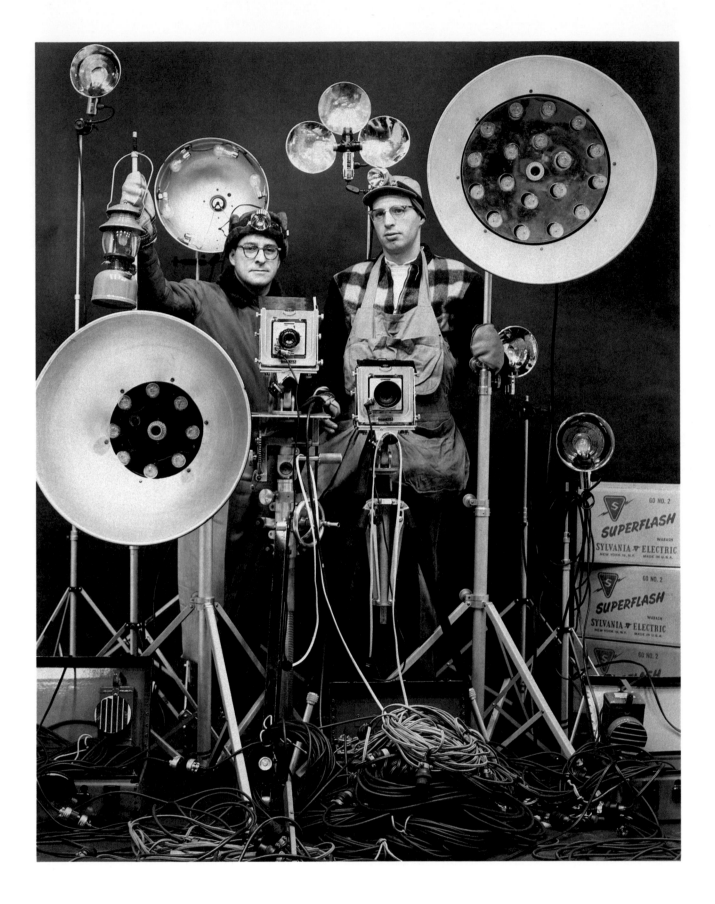

[PLATE 93]

O. Winston Link

1956

[PLATE 94]

Peter Keetman

1957

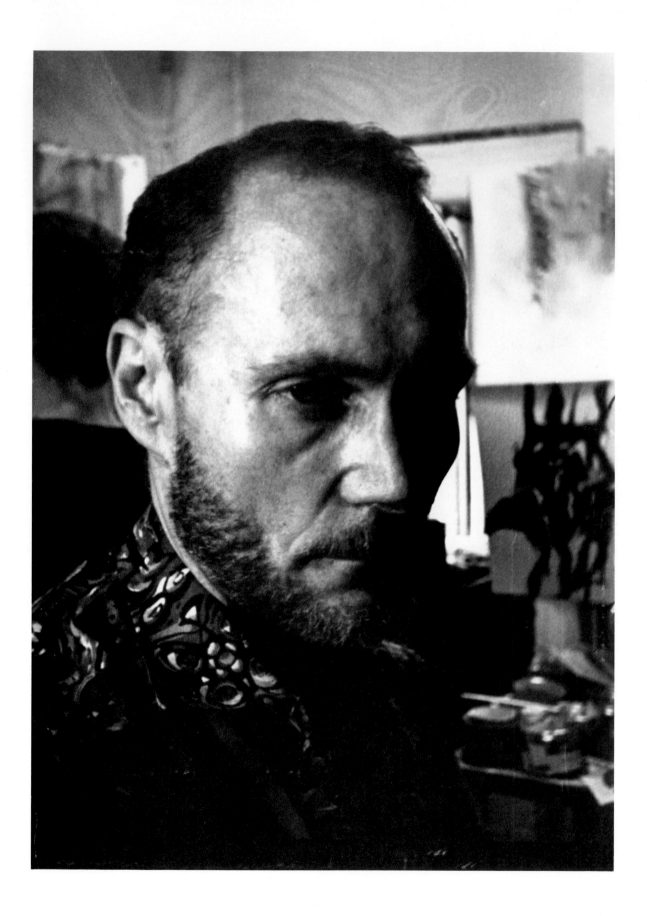

[PLATE 95]

W. Eugene Smith

C. 1968

[PLATE 96]

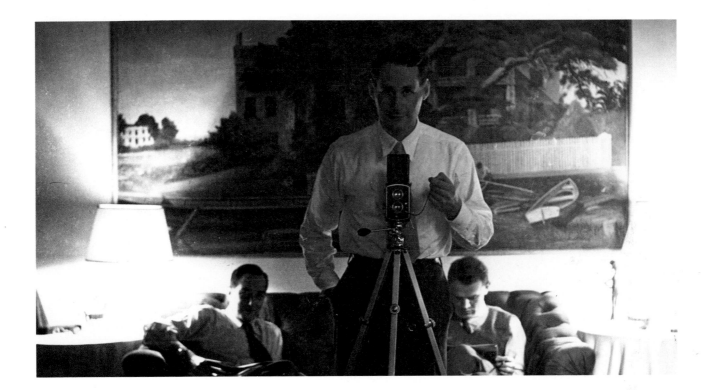

[PLATE 96]

Irving Penn

C. 1943

Andy Warhol
1964

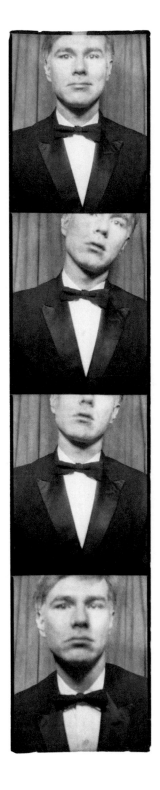

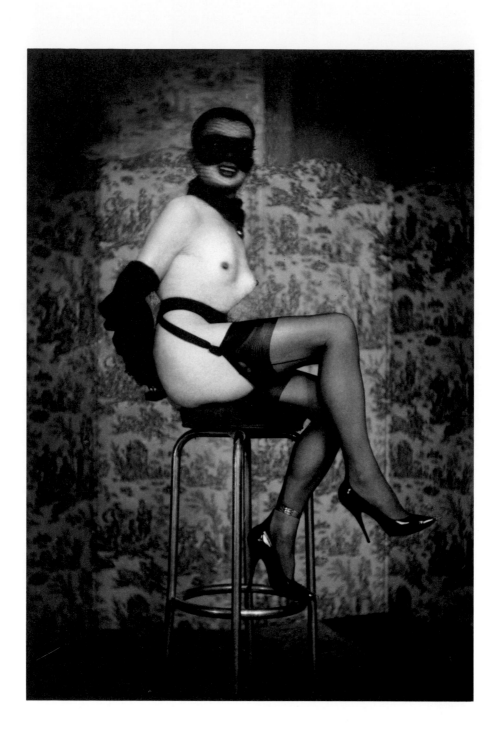

[PLATE 99]

Danny Lyon

1966

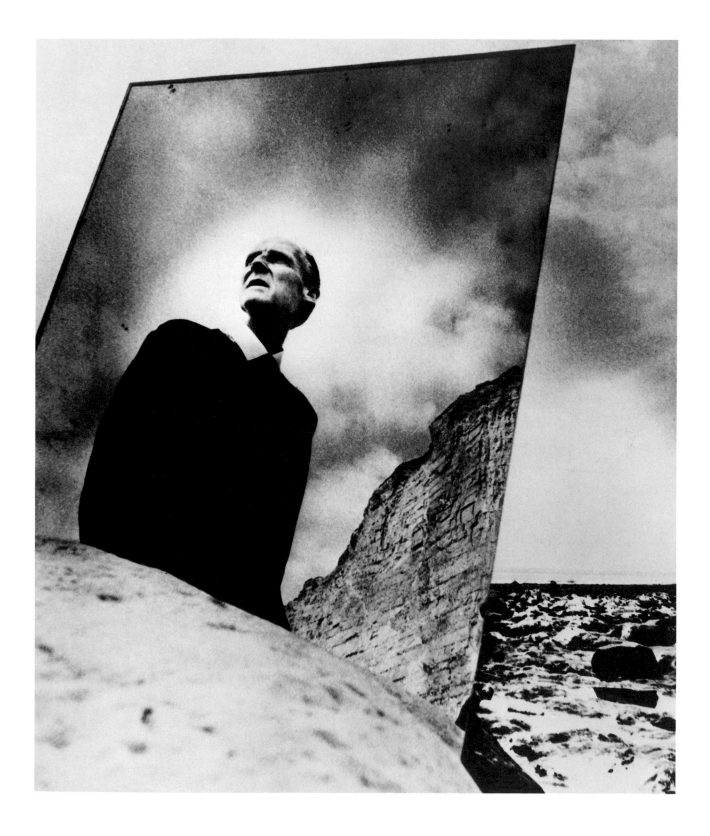

[PLATE 100]

Bill Brandt

1965

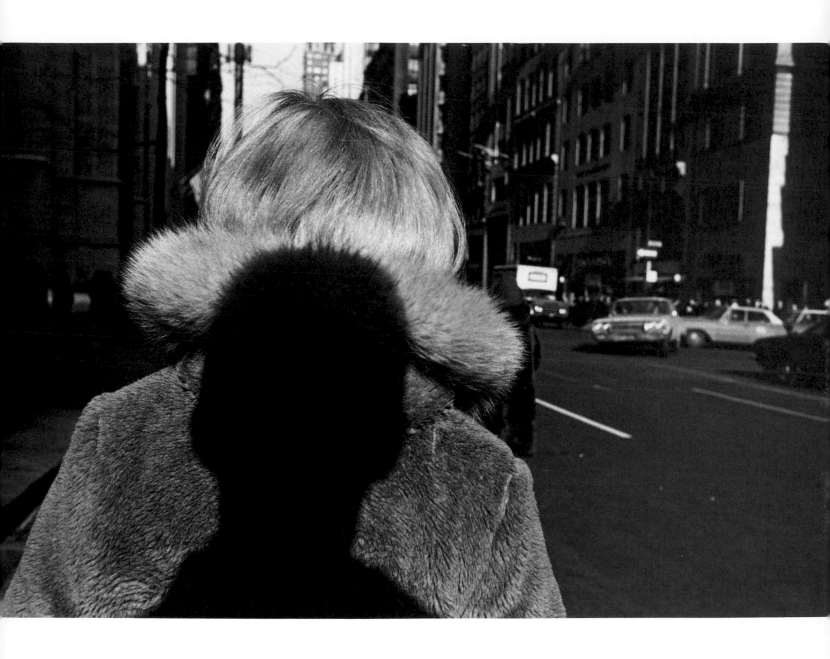

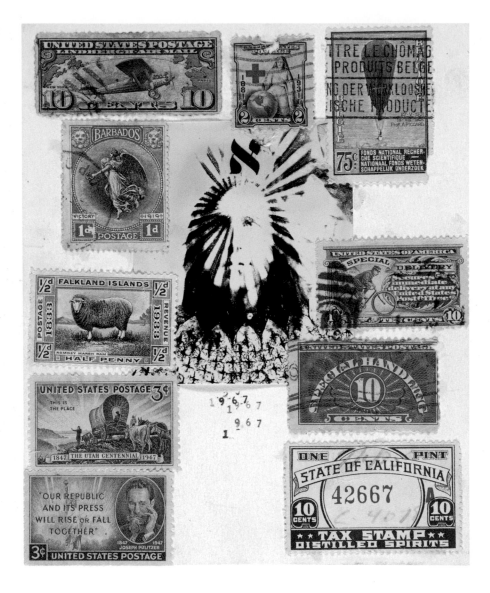

[PLATE 102]

Wallace Berman

1967

[PLATE 103]

Arnulf Rainer

1975

[PLATE 104]

Ralph Eugene Meatyard

1971

Bob & I & Other Friendly Creatures

[PLATE 105]

Jerry Uelsmann

1971

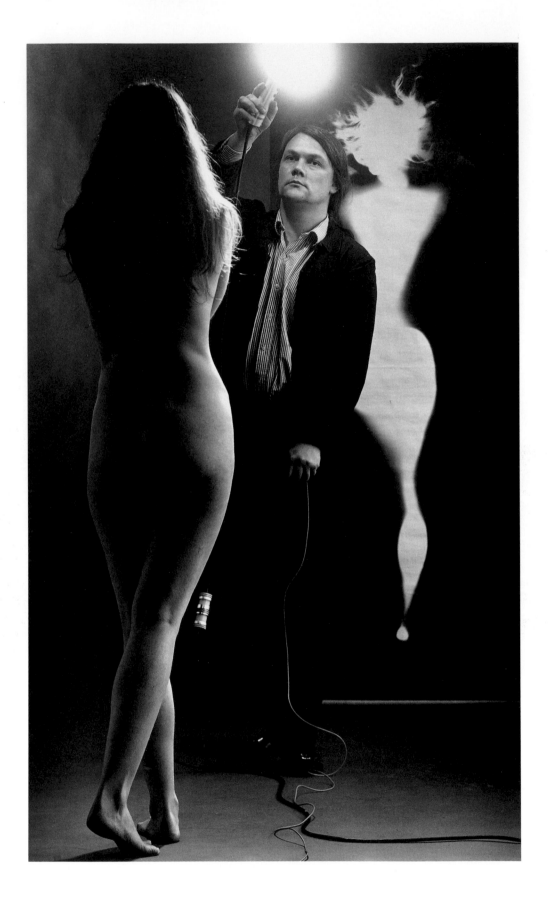

[PLATE 106]

Floris Michael Neusüss

1972

SELF PORTRAIT AS I WERE DEAD

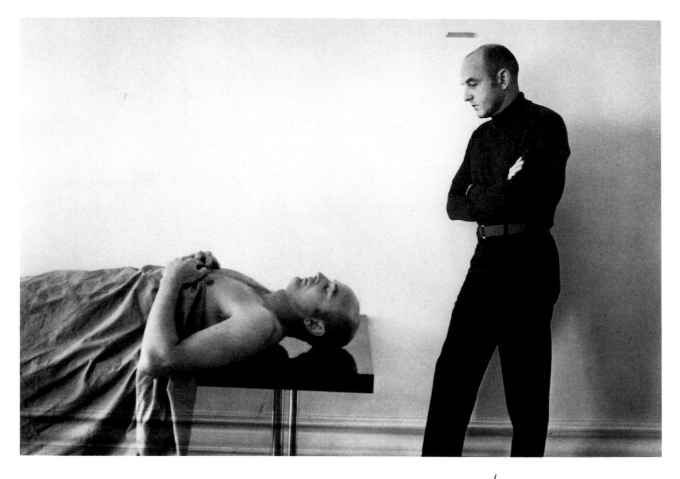

Duane Michals

1968

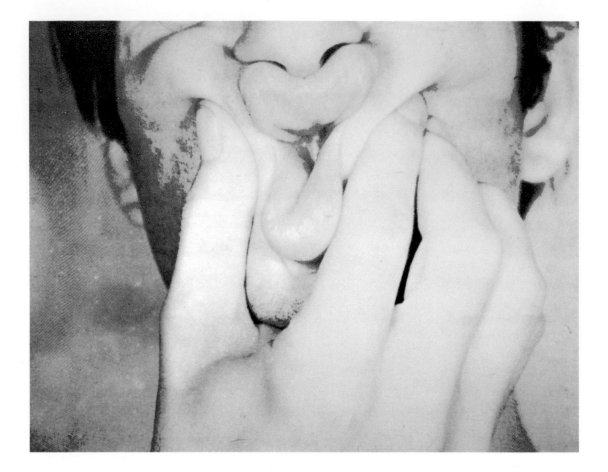

[PLATE 108]

Bruce Nauman

1970

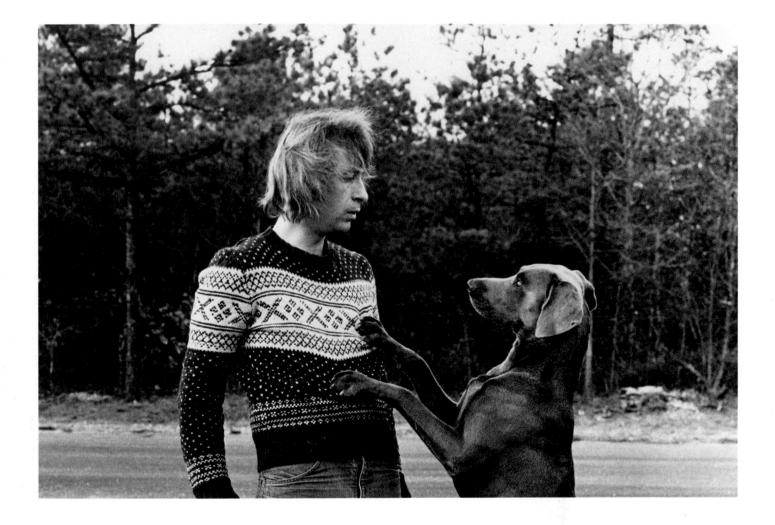

[PLATE 109]

William Wegman

1973

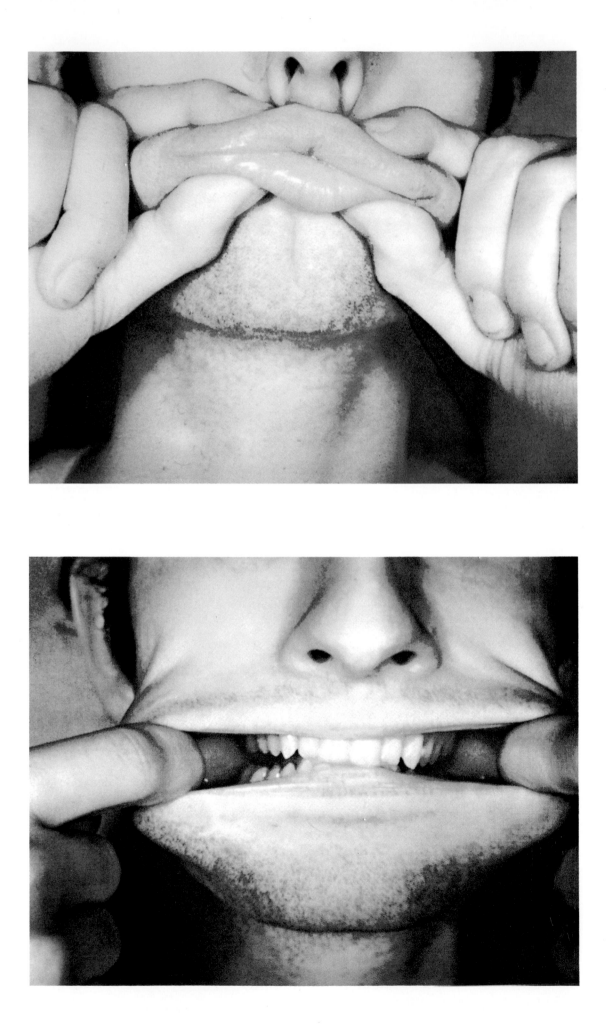

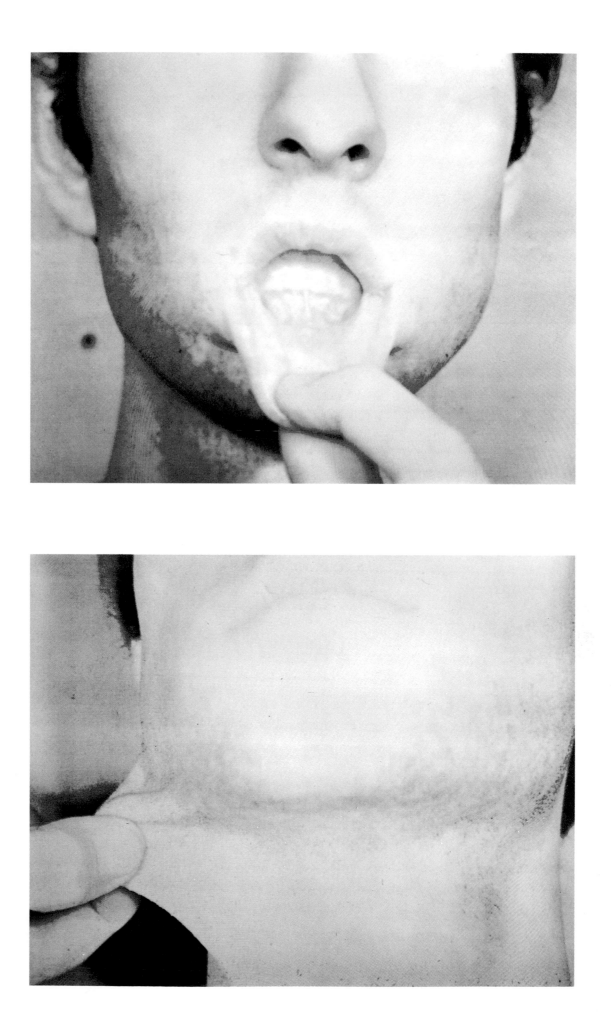

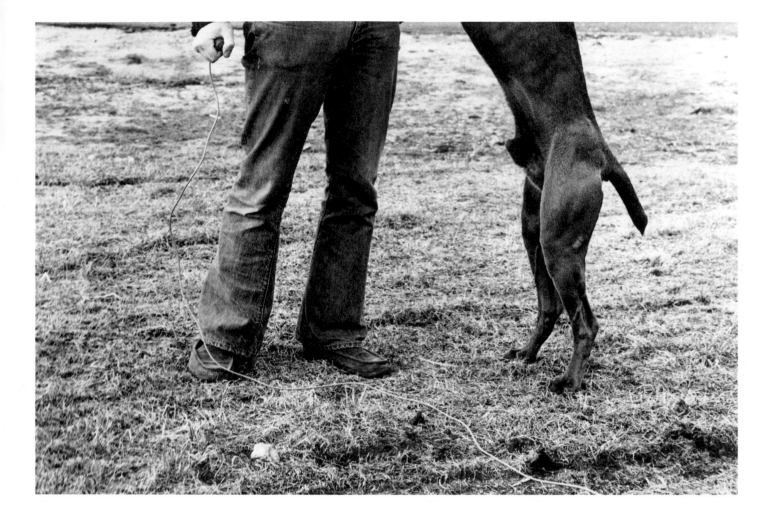

[PLATE 110]

Beaumont Newhall

1970

[PLATE 111]

Max Yavno

1977

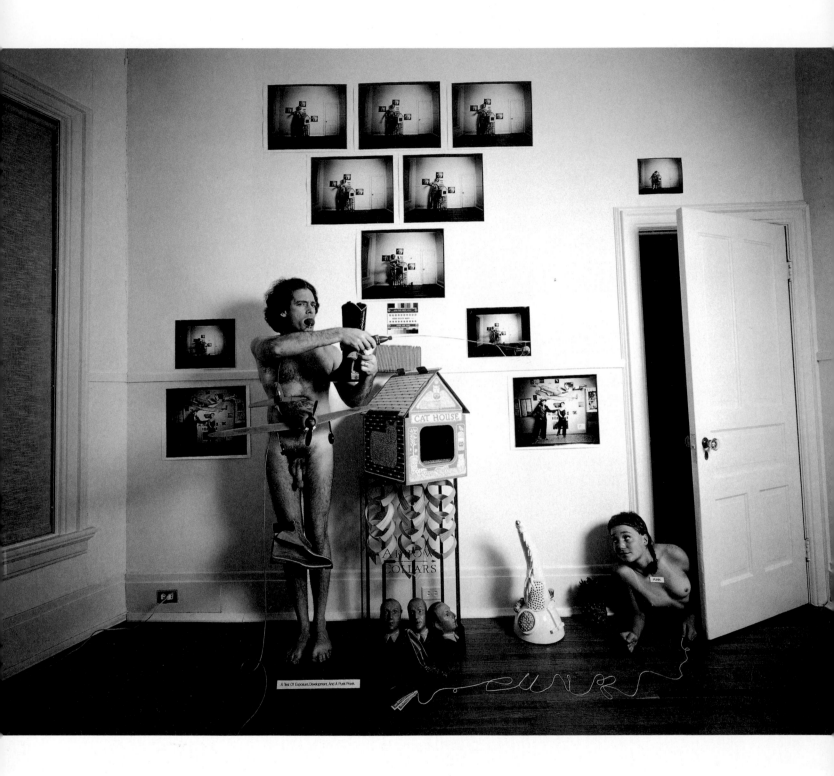

[PLATE 112]

Les Krims

1979

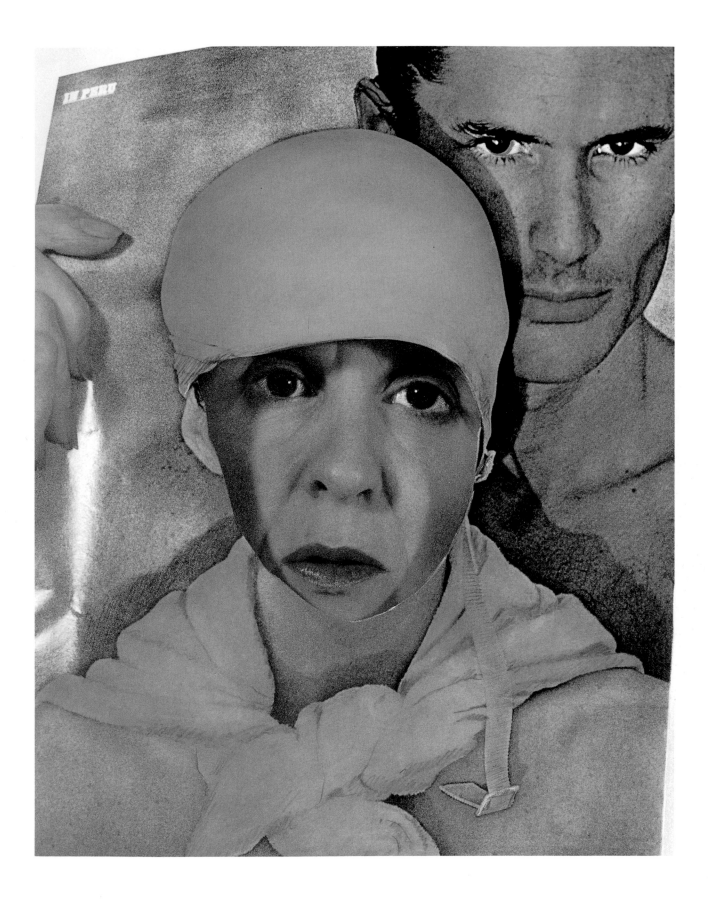

Judith Golden

1977

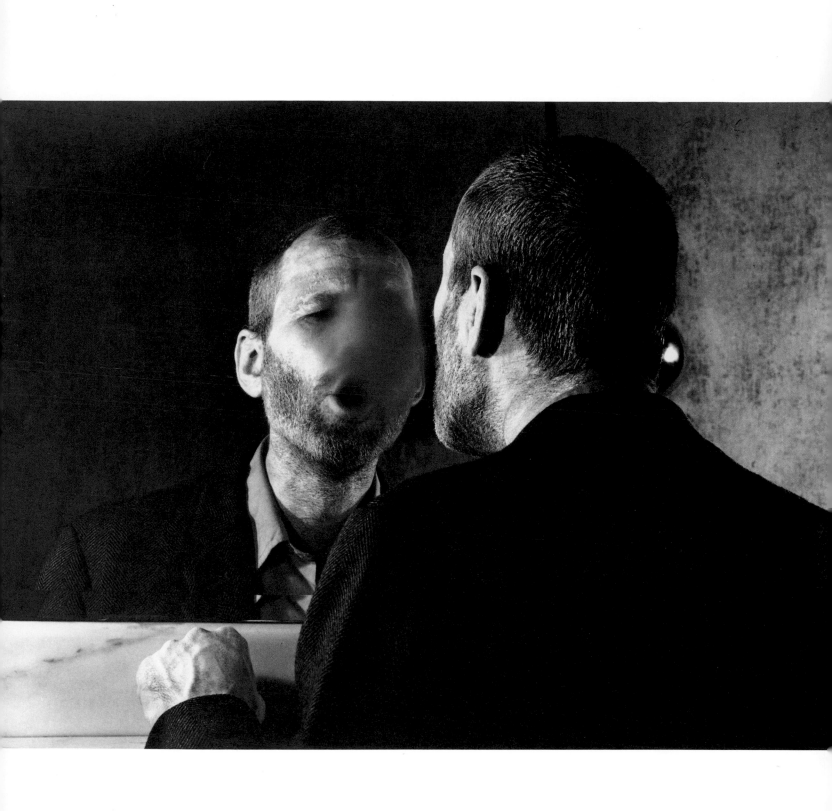

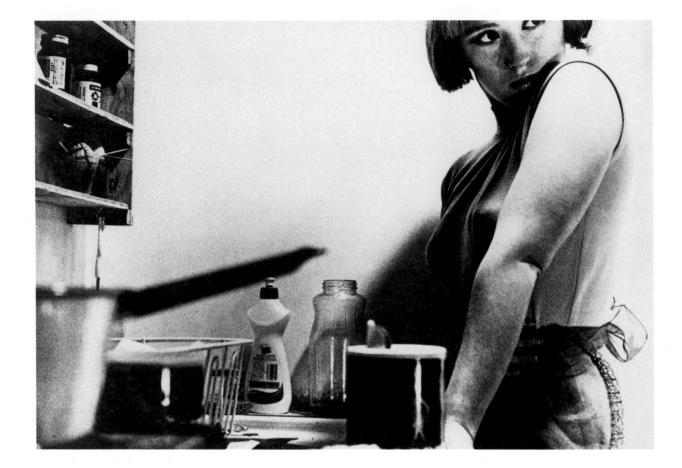

[PLATE 115]

Cindy Sherman

1977

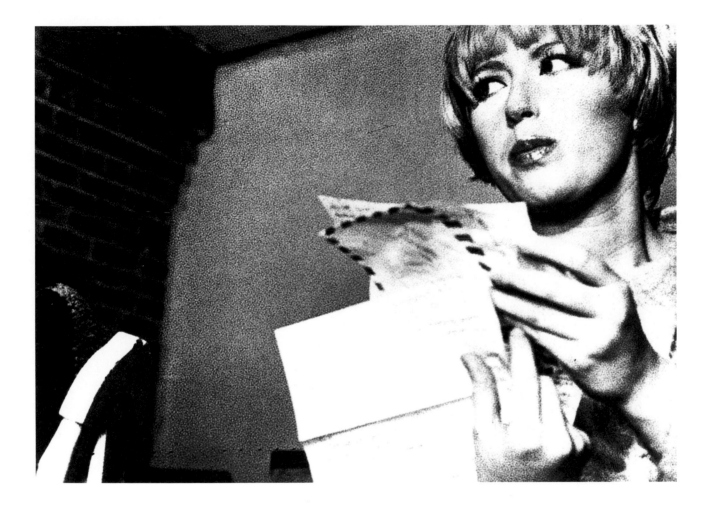

Cindy Sherman
1977

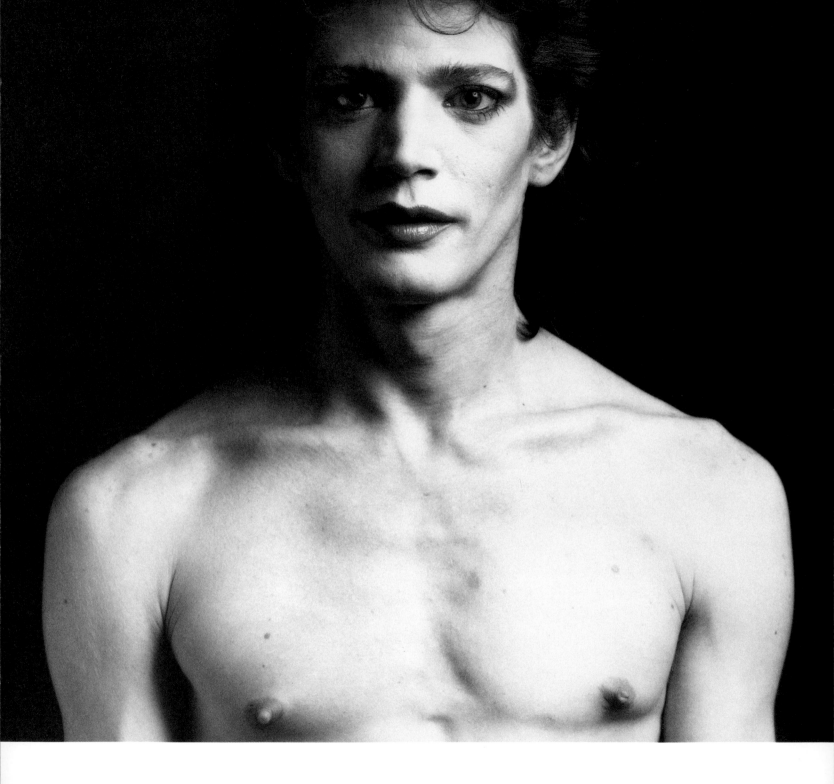

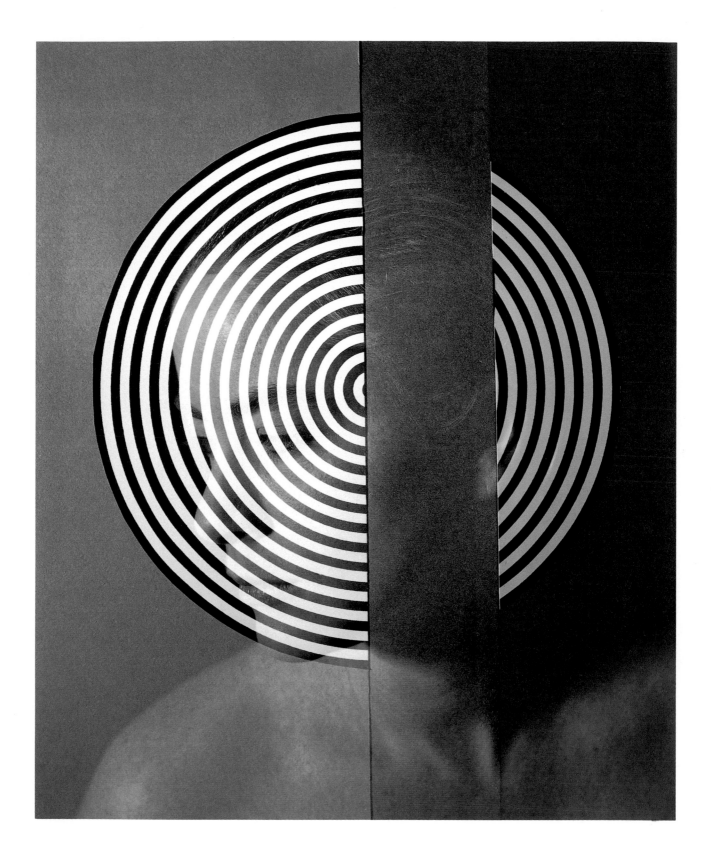

[PLATE 118]

Ellen Carey

1985

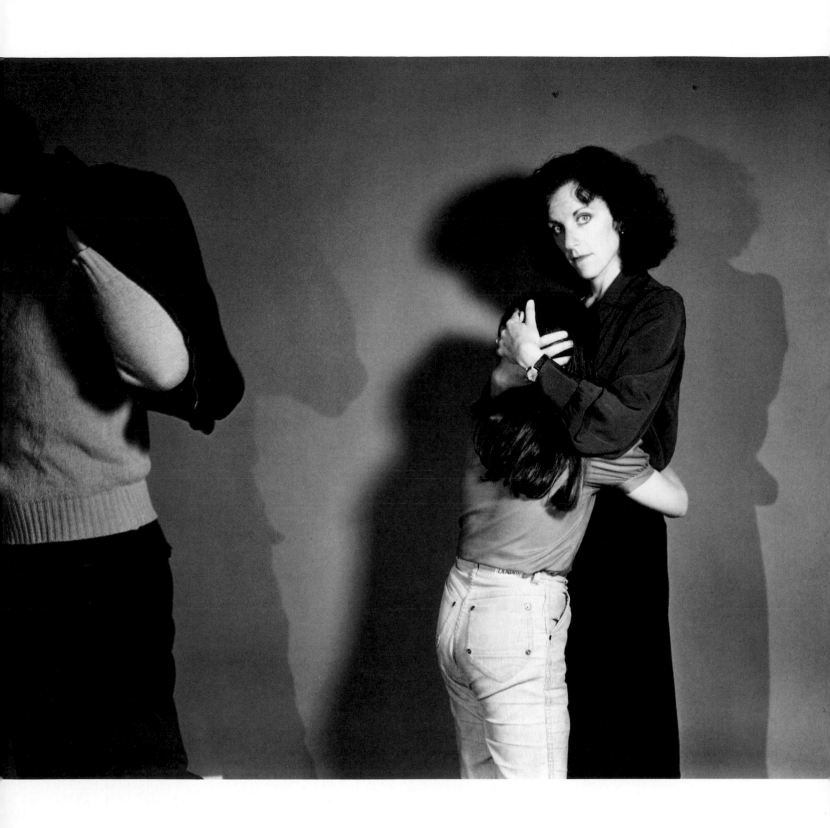

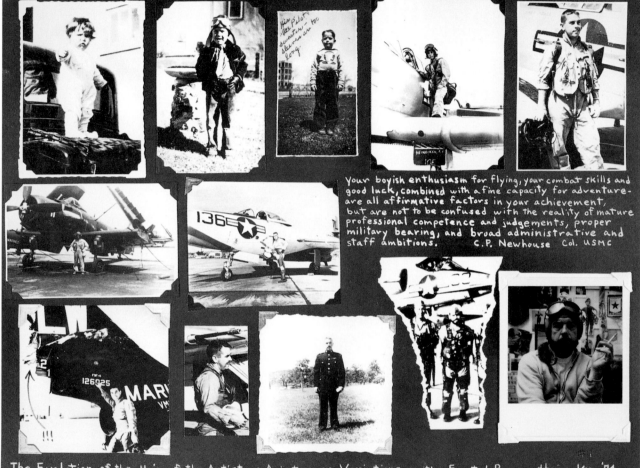

The Evolution of the Hair of the Artist as Aviator or Variations on the Frontal Pose Heinecken '74

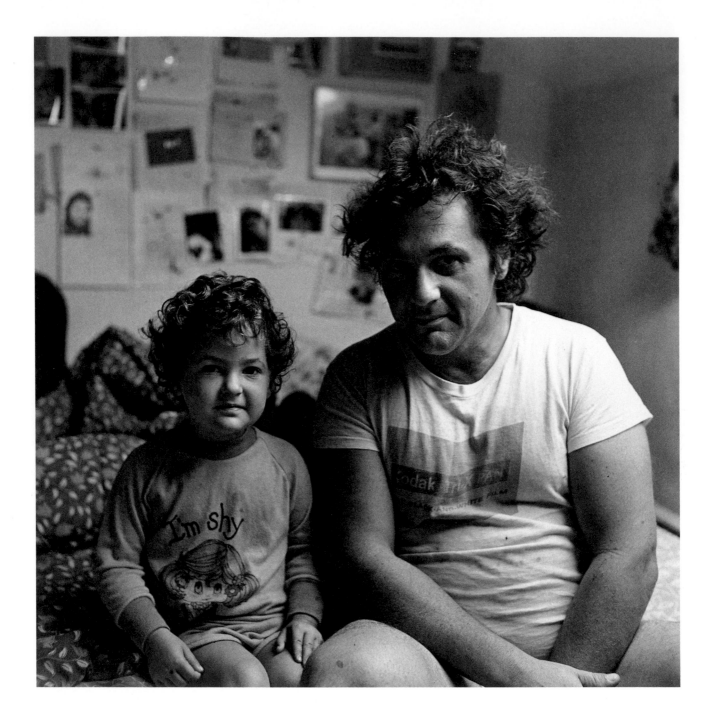

[PLATE 121]

Larry Fink

1982

We really enjoyed our one week honeymoon in Mexico.

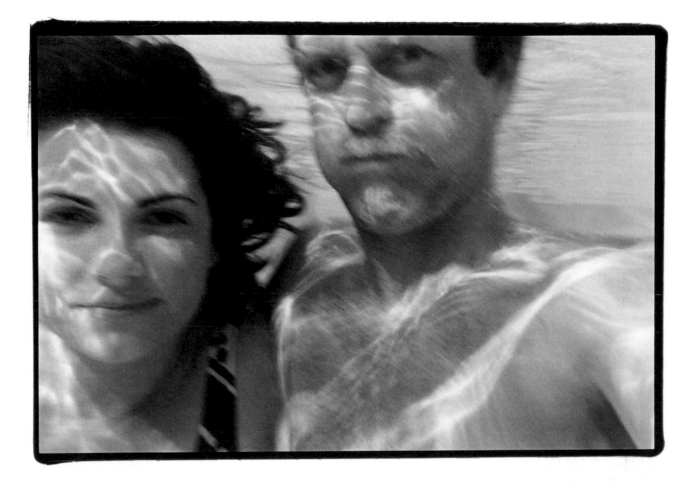

It was the first time Carmen had separated from her four-year-old son.

[PLATE 122]

Tony Mendoza
1988

Lucas Samaras

1976

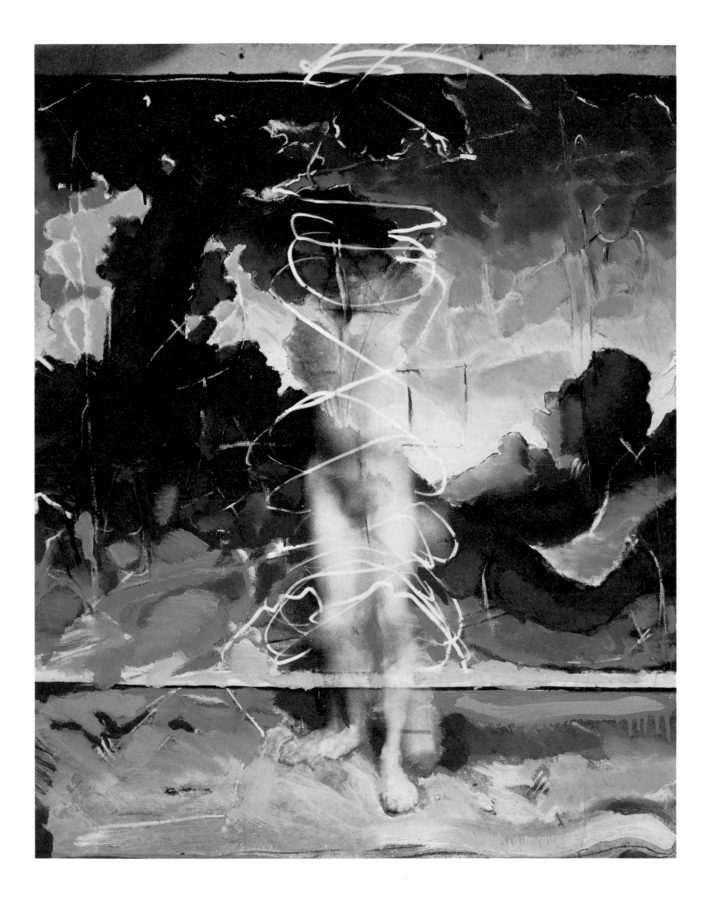

[PLATE 124]

Bayat Keerl

1982

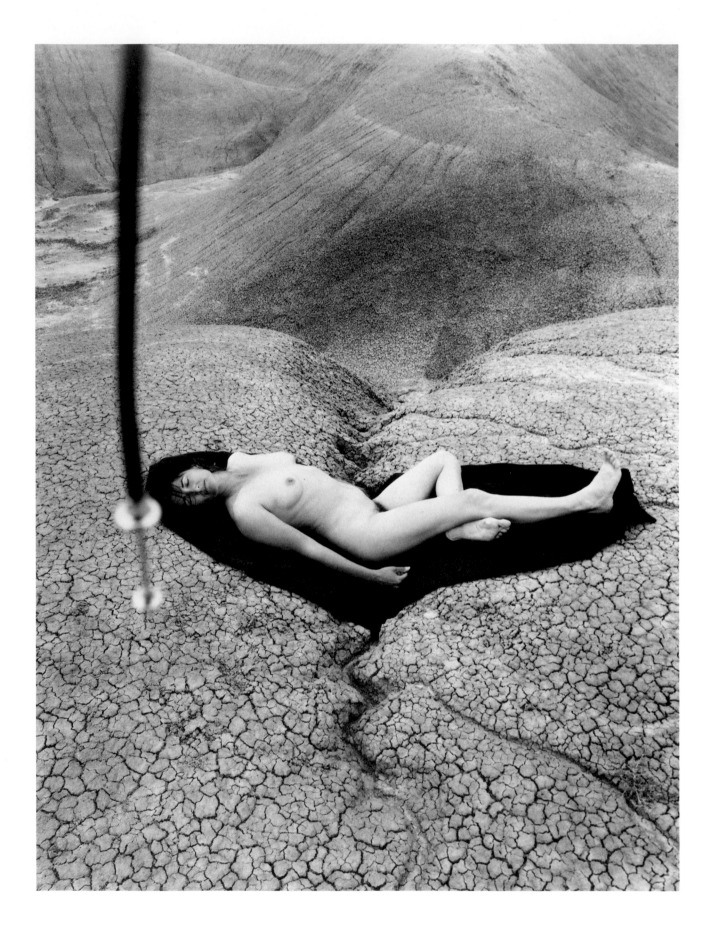

[PLATE 125]

Judy Dater
1981

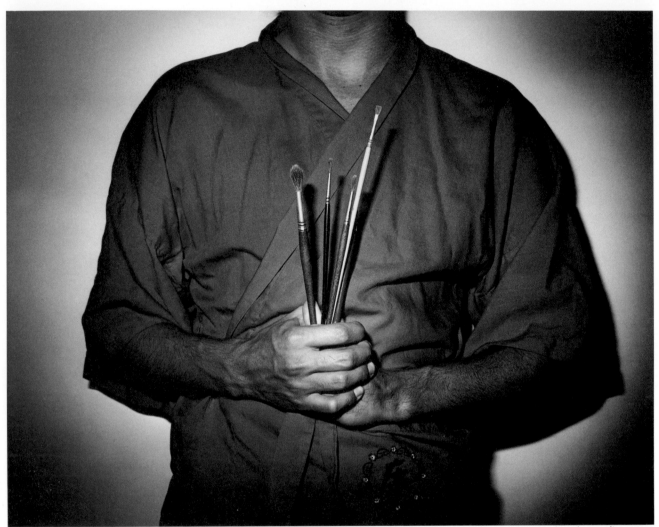

Fig. 2.11 — "In post-industrial society, he may have to deal with the issue of careers that stress financial reward and security versus those which might be more aligned with inner urges and talents. In a production-oriented culture, occupational groupings in which one develops talents instead of stressing strictly utilitarian skills are often negatively valued. His questions regarding the wisdom of his choices may leave him with a pronounced sense of anxiety."

[PLATE 126]

Lance Carlson

1982

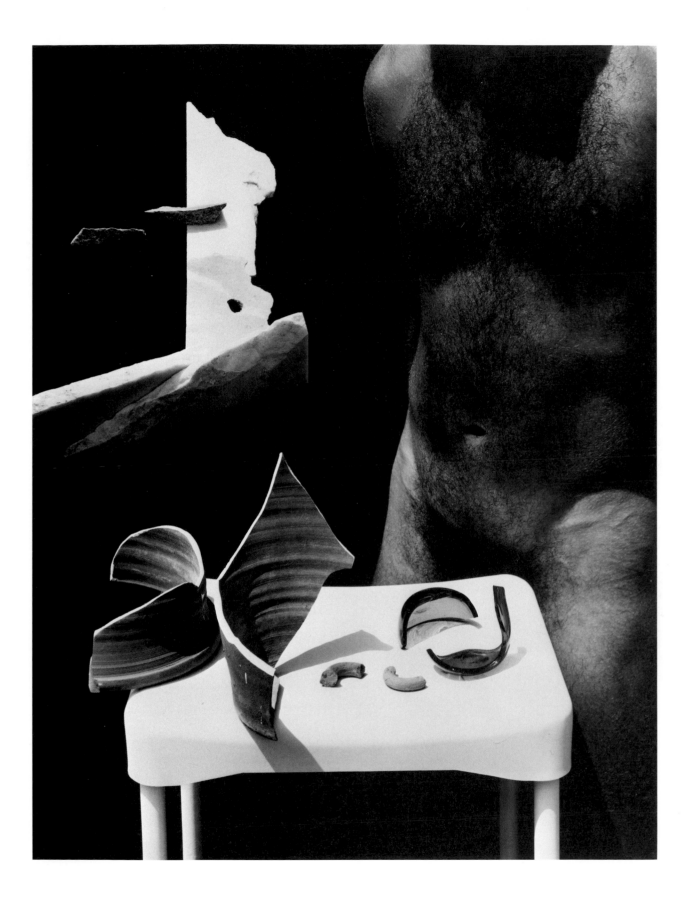

[PLATE 127]

Laurence Bach

1983

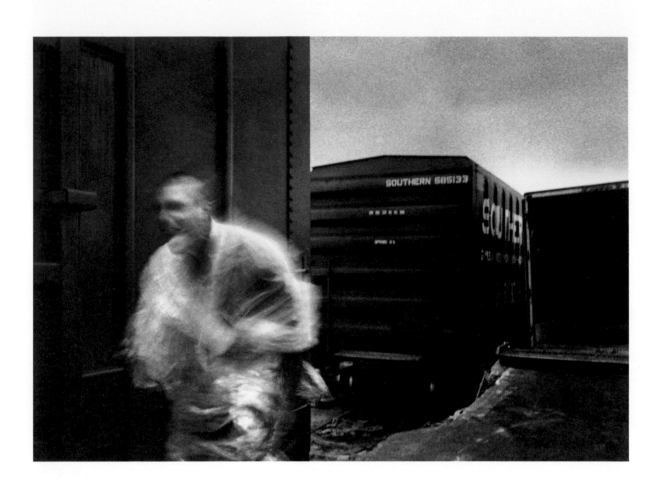

[PLATE 128]

John Brill

1981

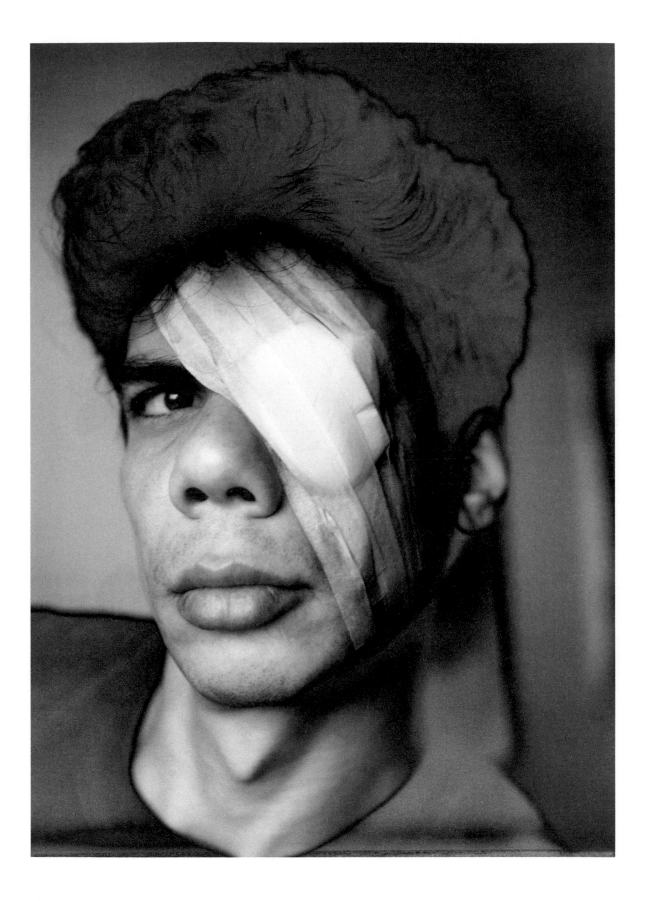

[PLATE 129]

Michael Spano

1987

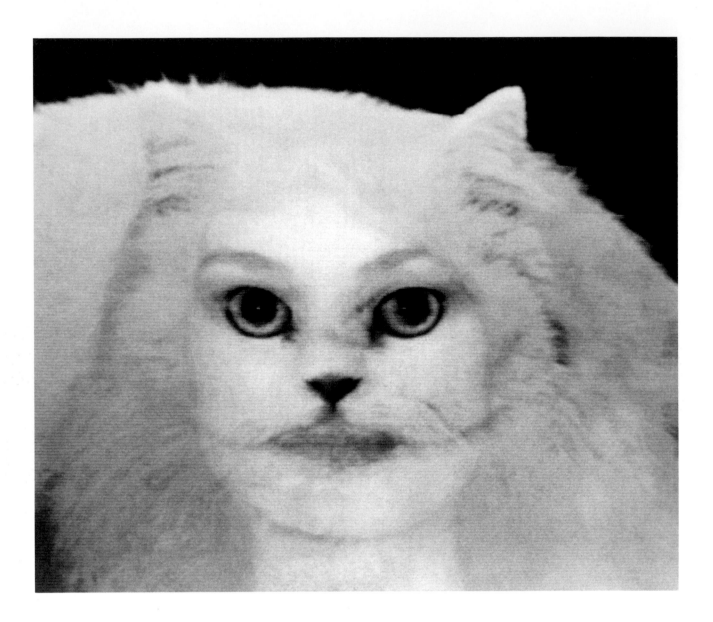

Nancy Burson
1983

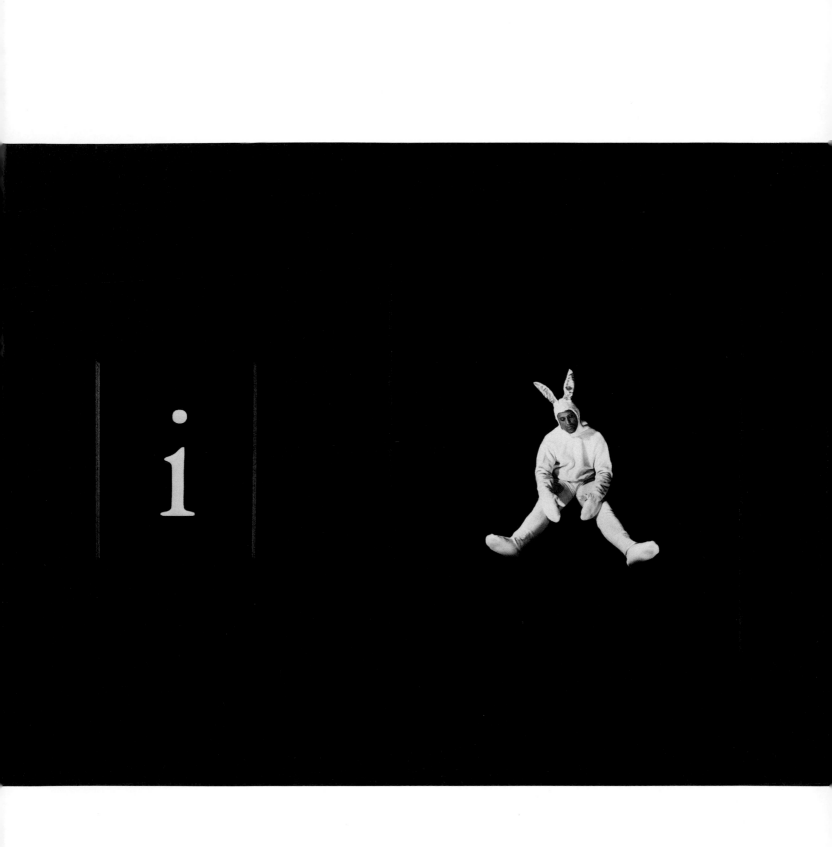

[PLATE 131]

John Boskovich

1987

[PLATE 132]

Susan Unterberg

1984

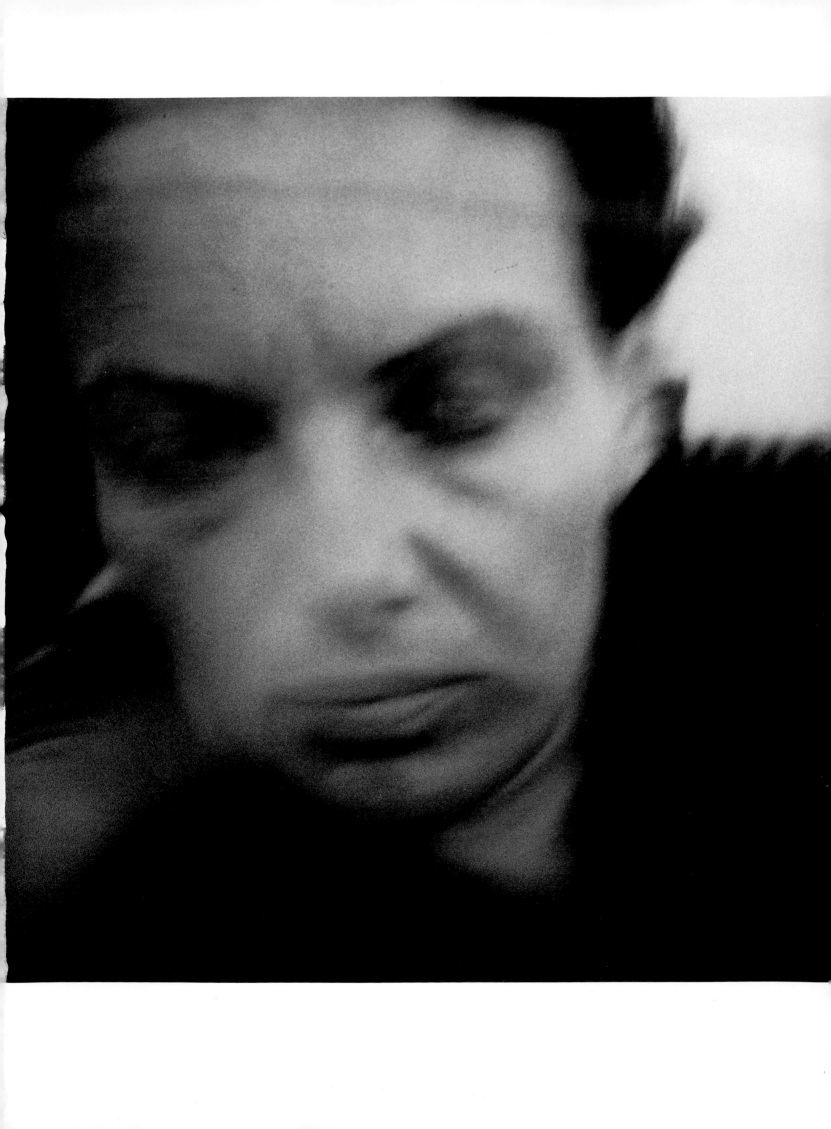

[PLATE 133]

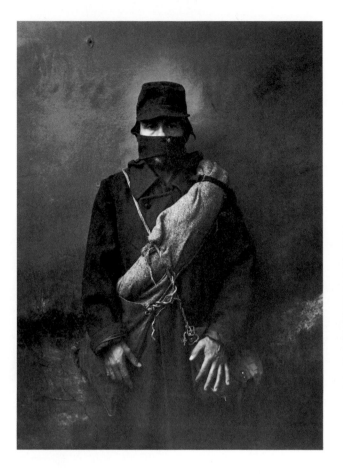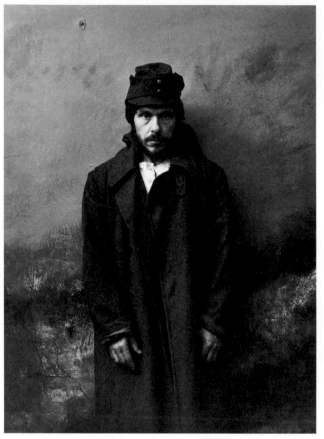

Joel-Peter Witkin

1984

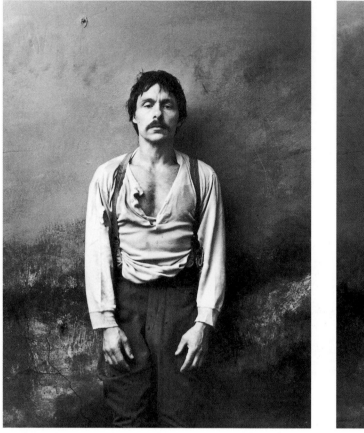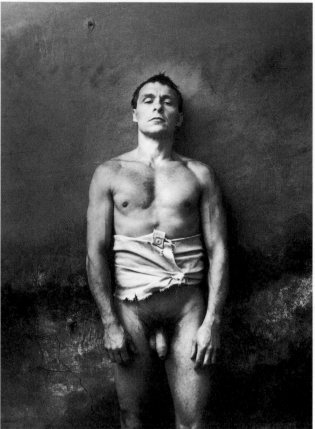

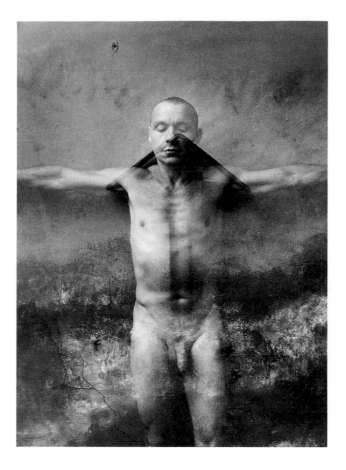

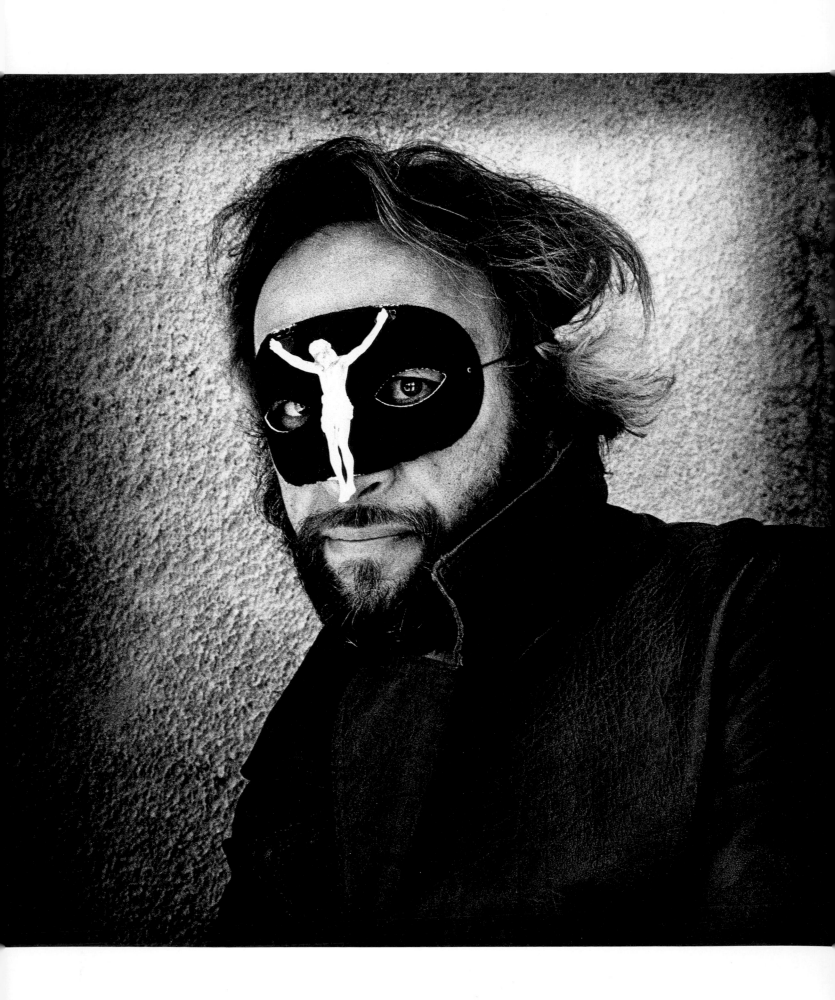

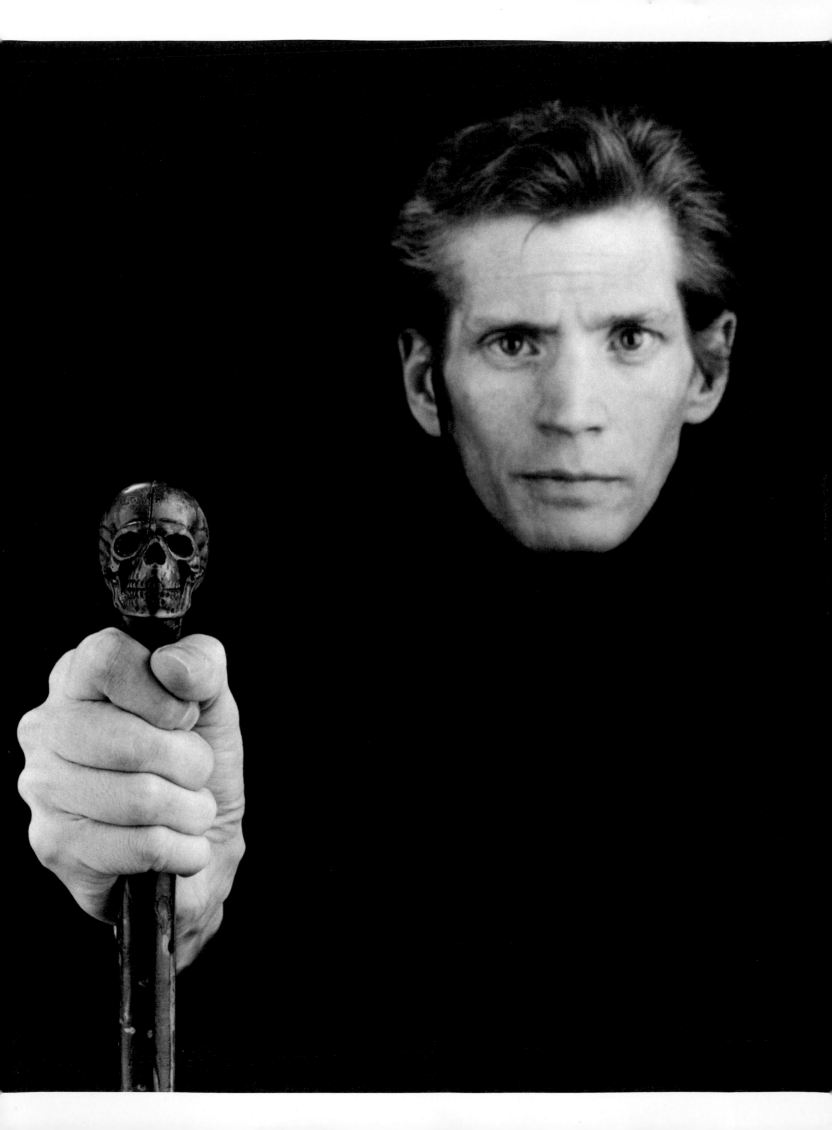

Berenice Abbott

United States, 1898–1991

Portrait of the Author as a Young Woman, c. 1930,
printed c. 1951
Gelatin-silver print
8¹³⁄₁₆ x 7⅛ in. (22.4 x 18.1 cm)
AC1992.197.1
PLATE 35

Abbott studied drawing and sculpture in New York from
1918 to 1921 and then in Paris from 1921 to 1923. While in
Paris she worked as a photographic assistant to Man Ray
from 1923 to 1925. Following the death of Eugène Atget
she was responsible for preserving his archives and cham-
pioning his art. From 1926 to 1929 Abbott established
herself as a portrait photographer, and upon returning to

Exhibition Checklist

New York in 1930, she began documenting the modern
urban scene. Under the auspices of the Federal Art Project,
she published *Changing New York* in 1939. During the
1960s her work encompassed the realms of both the scien-
tific and humanistic.

O'Neal, Hank. *Berenice Abbott, American Photographer.*
New York: McGraw-Hill, 1982.

Mehemed Fehmy Agha
Ukraine, active Germany and United States, 1896–1978

Self-Portrait, c. 1935
Toned gelatin-silver print
10 x 7¹⁵⁄₁₆ in. (25.4 x 20.2 cm)
AC1992.197.2
PLATE 61

Born in Nikolayev, Ukraine, Agha was educated in fine arts in Kiev, studied economics at the Emperor Peter the Great Polytechnic Institute, and received a degree from the National School of Oriental Languages in Paris. In 1929, while working for German *Vogue* in Berlin, Agha met Condé Nast, who persuaded him to immigrate to the United States, where he became art director for Condé Nast Publications, a position he held until 1943.

Remington, R. Roger, and Barbara J. Hodik. *Nine Pioneers in American Graphic Design.* Cambridge: MIT Press, 1989.

Dieter Appelt
Germany, b. 1935

The Spot on the Mirror Made by Exhaling, 1978
Gelatin-silver print, ed. 11/20
11⁹⁄₁₆ x 15⁷⁄₁₆ in. (29.3 x 39.2 cm)
AC1992.197.3
PLATE 114

Diane Arbus
United States, 1923–71

Self-Portrait in Mirror, 1945
Gelatin-silver print
6½ x 4⅝ in. (16.5 x 11.8 cm)
AC1992.197.4
PLATE 84

Diane Arbus began photographing in the early 1940s and worked in New York with her husband, Allan Arbus, in fashion photography. She later studied photography with Lisette Model from approximately 1955 to 1957 and around that time began to concentrate exclusively on her own work. Beginning in 1960 her portraits were seen regularly in *Esquire, Harper's Bazaar*, and other magazines. By the late 1960s she abandoned fashion photography in favor of the documentary portrait style for which she is best known. She taught photography from 1965 to 1971, first in New York at Parsons School of Design and Cooper Union and then in Providence at the Rhode Island School of Design. The year following her death the Museum of

& Biographies

Born in Niemegk, Germany, Appelt studied classical music in Leipzig and Berlin. From 1959 to 1963 he studied with the experimental photographer Heinz Hajek-Halke in Berlin. He credits the photography and films of the surrealists, the Bauhaus, and the Russian constructivists with a great influence on his work. Often alluding to mythology and ritual, Appelt's work incorporates aspects of both performance- and conceptual-art practice. His use of long exposures permits the intrusion of motion into his work, as both a means of expression and transformation.

Weinberg, Adam D., Eugenia Parry Janis, and Max Kozloff. *Vanishing Presence.* Exh. cat. Minneapolis: Walker Art Center; New York: Rizzoli, 1989.

Modern Art, New York, organized a retrospective exhibition of her work, which toured the United States until 1975. Since that time numerous exhibitions and publications have made her unique vision known throughout the world.

Arbus, Doon, and Marvin Israel, eds. *Diane Arbus: An Aperture Monograph.* Millerton, New York: Aperture, 1972.
_____. *Diane Arbus: Magazine Work, 1960–1971.* Millerton, New York: Aperture, 1984.

Fred R. Archer
United States, 1889–1963

Self-Portrait, 1946
Gelatin-silver-bromide print
14¹⁵⁄₁₆ x 12³⁄₁₆ in. (38 x 31.1 cm)
AC1992.197.5
PLATE 86

A member and director of the Camera Pictorialist Club of Los Angeles, with affiliations to the Royal Photographic Society of Great Britain, Archer exhibited in the International Salon of Photography from 1918 to 1927 held at the Los Angeles County Museum of Science, History, and Art. After working as head of the title department at Universal Studios and then as director of still photography at DeMille Studios, Archer was a portrait photographer for Warner Bros. until 1929. Archer was the director of the photography department at the Art Center School of Design and also founded his own school of photography following the end of World War II.

Archer, Fred R. *Fred Archer on Portraiture.* San Francisco: Camera Craft Publishing, 1948.

Laurence Bach
United States, b. 1947

Amphora Series #4, 1983
Gelatin-silver print
19⁷⁄₁₆ x 15¼ in. (49.4 x 38.7 cm)
AC1992.197.7
PLATE 127

Bach studied at the Philadelphia College of Art and then at the Allegemeine Gewerbeschule in Basel, Switzerland. He was an associate professor at the State University of New York College at Purchase from 1974 to 1986. Bach's extensive photographing of the Greek island of Paros resulted in the publication of *The Paros Dream Book* in 1983. He exhibited his photography until the late 1980s. Since 1986 Bach has been a professor at the Philadelphia College of Art and is currently concentrating on his work as a ceramicist.

Bach, Laurence. *The Paros Dream Book.* Rochester, New York: Visual Studies Workshop Press, 1983.

Ralph Bartholomew, Jr.
United States, 1907–85

Self-Portrait, 1940s
Gelatin-silver print
13⁵⁄₁₆ x 10⅜ in. (33.8 x 26.4 cm)
AC1992.197.8
PLATE 74

Bartholomew studied at the Clarence White School of Photography and worked as a commercial art director under Lejaren à Hiller before establishing his own commercial studio in New York in 1936. Before his retirement in 1972 Bartholomew had counted among his clients General Electric, Eastman Kodak, and Texaco.

Sobieszek, Robert A. *The Art of Persuasion: A History of Advertising Photography.* New York: Harry N. Abrams, 1988.

Herbert Bayer
Austria, active Germany and United States, 1900–1985

Self-Portrait, 1932, printed c. 1978
Gelatin-silver print
13⁷⁄₁₆ x 9¾ in. (34.2 x 24.8 cm)
AC1992.197.9
PLATE 51

Bayer studied at the Weimar Bauhaus with Wassily Kandinsky before becoming an instructor himself at the relocated Bauhaus in Dessau, where he taught typography and graphic design from 1925 to 1928. After establishing a career as a photographer, art director, and exhibition designer in Berlin, he immigrated to the United States in 1938, where he worked as an exhibition designer for the Museum of Modern Art, New York, and the Art Institute of Chicago. In 1946 Bayer moved to Aspen, Colorado. For the next thirty years his work encompassed graphic and environmental design as well as architecture. While he embraced the Bauhaus photographic ideals espoused by László Moholy-Nagy, Bayer, in his photographs, typically incorporated the strategies of surrealist representation.

Bayer, Herbert. *Herbert Bayer: Painter, Designer, Architect.* New York: Reinhold Book Division, 1967.

Cecil Beaton
England, 1904–80

Self-Portrait, c. 1938
Gelatin-silver print
9¹¹⁄₁₆ x 7⅝ in. (24.6 x 19.4 cm)
AC1992.197.10
PLATE 73

Self-taught, Beaton began his career as a freelance portrait and fashion photographer. Soon, however, he was working under contract with Condé Nast Publications, setting the stylistic tone for the pages of *Vogue* from 1930 until the mid-1950s. During World War II he was also a photographer for the Ministry of Information in London and documented the ravages of the German blitzkrieg as well as the Allied operations in North Africa and the Pacific. During the 1950s and 1960s Beaton placed a greater emphasis on his portrait photography, though he also worked in both theatrical and cinematic design. Beaton was knighted in 1972.

Vickers, Hugo. *Cecil Beaton: A Biography*. Boston: Little, Brown and Company, 1985.

Hans Bellmer
Germany, 1902–75

Self-Portrait with Doll, 1934
Gelatin-silver print
4⅝ x 3¹⁄₁₆ in. (11.8 x 7.8 cm)
AC1992.197.11
PLATE 53

A draftsman and sculptor as well as a photographer, Bellmer studied with artist George Grosz in Berlin. Self-taught as a photographer, he primarily used photography as a means of documenting the evolving ideas and facets of his sculptural work *La Poupée* (The doll). Increasingly his photographic explorations developed as a means of expression independent of his sculpture, as typified by his continuing series of female nudes of the 1940s and 1950s.

Prokopoff, Stephen S., and Maarten van de Guchte. *Hans Bellmer, Photographs*. Exh. cat. Urbana-Champaign: Krannert Art Museum, University of Illinois, 1991.

Henry Hamilton Bennett
United States, 1843–1908

Self-Portrait with Son Ashley and Daughters Harriet and Nellie, c. 1887
Toned albumen print
17¼ x 21¼ in. (43.8 x 54 cm)
AC1992.197.12
PLATE 8

Born in Vermont, Bennett moved to Wisconsin in 1857. After being severely wounded during the Civil War, he opened a photographic studio in 1865. Though producing portraits as his primary means of support, he soon came to specialize in landscape photography. He was an innovator in the development and use of the photographic shutter and in the production of oversized panoramas. Bennett became well known for his documentary panoramas of the city of Milwaukee and the Wisconsin Dells as well as for his portraits of the Winnebago Indians and their environment.

Sandweiss, Martha A., ed. *Photography in Nineteenth-Century America*. Exh. cat. Fort Worth: Amon Carter Museum, 1991.

Wallace Berman
United States, 1926–76

Self-Portrait, 1967
Gelatin-silver print collage with ink and postal stamps
5⁹⁄₁₆ x 4⅝ in. (14 x 11.8 cm)
AC1992.197.13
PLATE 102

Berman studied at the Chouinard and Jepson art schools in Los Angeles and was instrumental in the development of the arts community in Los Angeles during the Beat era of the 1950s. In 1955 he began publishing *Semina* magazine, producing nine issues over the next nine years. Berman is credited with instigating the beginnings of the assemblage movement and was one of the core group of artists to exhibit at Ferus Gallery in Los Angeles. He liberally incorporated photography into his assemblage work and continued to use photography late into his career, creating a series of Verifax collages in the 1960s and 1970s.

Lipschutz-Villa, Eduardo, et al. *Wallace Berman: Support the Revolution*. Exh. cat. Amsterdam: Institute of Contemporary Art, 1992.

Ilse Bing
Germany, active United States, b. 1899

Self-Portrait in Mirrors, 1931, printed 1941
Gelatin-silver print
10⁷⁄₁₆ x 12¹⁵⁄₁₆ in. (26.5 x 32.3 cm)
AC1992.197.14
PLATE 58

Super Self-Portrait in Window, Paris, 1947
Gelatin-silver print
13⅜ x 10¼ in. (34 x 26 cm)
AC1992.197.15
PLATE 82

Bing relinquished her doctoral studies in art history to pursue a career as a photojournalist. In 1930 she moved to Paris, where, in addition to journalism, she produced magazine illustration, fashion, portrait, and architectural photography. She immigrated to the United States in 1941 and continued to photograph until 1959, when she abandoned the medium to concentrate on poetry, painting, and collage in New York.

Barrett, Nancy C. *Ilse Bing: Three Decades of Photography.* Exh. cat. New Orleans: New Orleans Museum of Art, 1985.

John Boskovich
United States, b. 1956

Self-Portrait, 1987
Gelatin-silver print, gouache, and photostat
18 x 23 in. (45.7 x 58.4 cm)
AC1992.197.16
PLATE 131

After earning a degree in philosophy at the University of Southern California, Boskovich received his master of fine arts degree from the California Institute of the Arts in Valencia, California, and in 1985 a law degree from Loyola Law School in Los Angeles. In 1986 he collaborated with Sandra Bernhard in writing *Without You I'm Nothing* and directed the ensuing productions. He began exhibiting autobiographical assemblage portraits in 1987 and held his first solo exhibition in Los Angeles the following year.

Gardner, Colin. "Boskovich and I." *Artforum* 26, no. 9 (May 1988): 132–33.

Édouard Boubat
France, b. 1923

Self-Portrait, 1958, printed 1976
Gelatin-silver print
13¾ x 10³⁄₁₆ in. (34.9 x 25.8 cm)
AC1992.197.17
PLATE 91

Boubat studied printing, typography, and design at the École Estienne in Paris from 1938 to 1942 and, following World War II, began a career as a photographer. He eventually joined the staff of *Réalités* magazine in Paris, where he worked until 1968. Boubat is currently an independent photojournalist and portraitist.

George, Bernard. *Édouard Boubat.* Trans. Maureen Oberli-Turner. New York: Macmillan, 1973.

Margaret Bourke-White
United States, 1904–71

Self-Portrait with Camera, c. 1933
Toned gelatin-silver print
13 x 8¹⁵⁄₁₆ in. (33 x 22.7 cm)
AC1992.197.18
PLATE 48

After receiving her bachelor of arts degree from Cornell University in 1927, Bourke-White turned to photography as a career. She built a portfolio that earned her the first staff-photographer position on Henry Luce's *Fortune* magazine and then, in 1936, employment as a member of the core group of staff photographers for *Life*, where she produced the cover image for the premier issue. She later covered Europe during World War II, the Indian subcontinent during the partition, and the beginnings of the Korean conflict.

Goldberg, Vicki. *Margaret Bourke-White: A Biography.* New York: Harper and Row, Publishers, 1986.

Renata Bracksieck
Germany, b. 1900

Untitled, 1920s
Four gelatin-silver prints, mounted together
Overall: 8⅜ x 2⅞ in. (21.3 x 7.3 cm)
AC1992.197.19
PLATE 31

Bracksieck's interest in photography began after meeting Werner Rohde in 1920. A fashion designer, Bracksieck specialized in exotic gowns and costumes patterned after the Parisian couturiers, and Rohde would photograph her work and her models. She, however, became the subject and inspiration of a large body of Rohde's photographs. They were married in 1937. Bracksieck was active as a photographer herself in the late 1920s and early 1930s, and her work was included in the seminal Stuttgart exhibition *Film und Foto* in 1929 as well as the 1930 Munich photographic exhibition *Das Lichtbild*.

Taubhorn, Ingo, and Ferdinand Brüggemann. *Werner Rohde: Fotografien 1925–37*. Exh. cat. Essen: Museum Folkwang; Berlin: Nishen, 1992.

Bill Brandt
England, 1904–83

Self-Portrait with Mirror, East Sussex Coast, 1965, printed 1970s
Gelatin-silver print
13½ x 11½ in. (34.3 x 29.2 cm)
AC1992.197.20
PLATE 100

Educated in Germany and Switzerland, Brandt was largely self-taught as a photographer and worked as an assistant to Man Ray in Paris from 1929 to 1930. A freelance documentary photographer during the 1930s, he worked for *Weekly Illustrated*, *Picture Post*, and *Verve* in London. During World War II he worked for *Lilliput* magazine in addition to serving the Home Office in London and photographing for the National Buildings Record. Following the war Brandt, as an independent photographer, contributed to periodicals internationally. He is known for his portraits, landscapes, and an extended series of exaggerated or distorted nude studies.

Mellor, David. *Bill Brandt, Behind the Camera: Photographs, 1928–1983*. New York: Aperture, 1985.

Brassaï (Gyula Halász)
Hungary, active France, 1899–1984

Brassaï Photographing Paris at Night, 1932
Gelatin-silver print
10 x 7¹¹⁄₁₆ in. (25.4 x 19.5 cm)
AC1992.197.21
PLATE 49

Educated in Budapest and Berlin, Halász adopted the name Brassaï (literally meaning "from [the town of] Brasso") the year following his immigration to Paris in 1924. He worked as a painter, sculptor, and journalist until 1930, associating closely with Picasso, Braque, and their circle. From 1930 to 1940 Brassaï worked as a freelance photographer for such publications as *Minotaur*, *Verve*, and *Harper's Bazaar*. He abandoned his career during the German occupation of Paris, working only in Picasso's studio, photographing his sculpture and writing *Conversations avec Picasso*. He resumed his photographic career after World War II in addition to creating theatrical designs for the ballet. In 1976 Brassaï became a chevalier de la Légion d'Honneur.

Brassaï. *The Artists of My Life*. Trans. Richard Miller. New York: Viking Press, 1982.

Josef Breitenbach
Germany, active United States, 1896–1984

Self-Portrait, N.Y., c. 1947
Gelatin-silver print
Diameter: 10⁵⁄₁₆ in. (26.2 cm)
AC1992.197.22
PLATE 70

After studying under the eminent art historian Heinrich Wöfflin in Munich, Breitenbach began photographing in 1924, concentrating primarily on landscape. He established himself as a portrait photographer in Munich and then in Paris before he was incarcerated in a French internment camp. His escape from the camp and immigration to the United States in 1941 allowed him to resume his career as a portrait photographer and photojournalist in New York. He taught at Cooper Union and the New School for Social Research and in 1951 became chief photographer for the United Nations Korean Reconstruction Program, which marked the beginning of extensive travels and photodocumentation throughout the Far East.

Holborn, Mark. *Joseph Breitenbach: Photographer*. New York: Temple Rock Company, 1986.

John Brill
United States, b. 1951

Self-Portrait, Paterson, New Jersey, 1981
Gelatin-silver print
4⁹⁄₁₆ x 6½ in. (11.6 x 16.5 cm)
AC1992.197.23
PLATE 128

Brill received a bachelor of science degree in physiological psychology from Colgate University, Hamilton, New York, in 1973 and is self-taught as a photographer. He worked on an extended series of photographic self-portraits from 1981 to 1987 and produced natural history and scientific photographs of fish, about which he also writes. Brill works as an independent photographer in Essex County, New Jersey, and has received fellowships from the New Jersey State Council on the Arts.

Coleman, A. D. "Blurred Works Swim into Focus." *New York Observer*, 29 October 1990.

Esther Bubley
United States, b. 1921

Self-Portrait, Bus Story, 1947
Gelatin-silver print
6⅜ x 9⅜ in. (16.2 x 23.9 cm)
AC1992.197.24
PLATE 81

Born in Wisconsin, Bubley developed an interest in photography while studying painting at the Minneapolis School of Design. In 1941 she began working with the Farm Security Administration as a lab technician under the direction of Roy Stryker and began to receive photographic assignments as Stryker and his team moved to the Office of War Information. Bubley's documentary photographs of small-town life in Texas during the 1940s brought her wide attention. She worked for *Life* magazine in the late 1940s and began a freelance career as a photojournalist in 1972.

Fisher, Andrea. *Let Us Now Praise Famous Women: Women Photographers for the U.S. Government, 1935 to 1944.* New York: Pandora Press, 1987.

Clarence Sinclair Bull
United States, 1895–1979

Self-Portrait with Karen Morley, c. 1940
Gelatin-silver print
11½ x 8½ in. (29.2 x 21.6 cm)
AC1992.197.25
PLATE 72

Bull was educated at the University of Michigan and afterward relocated to Hollywood, California, in 1918. He was working as an assistant cinematographer for Metro Pictures when, in 1920, he was hired by Samuel Goldwyn as a studio still-photographer. His association with MGM Studios lasted until his retirement in 1961. Bull held the distinction of being the exclusive portrait photographer to Greta Garbo during her years at MGM.

Pepper, Terrence, and John Kobal. *The Man Who Shot Garbo: The Hollywood Photographs of Clarence Sinclair Bull.* Exh. cat. London: National Portrait Gallery, 1989.

Nancy Burson
United States, b. 1948

Catwoman, 1983
Gelatin-silver print
8⅞ x 10⁵⁄₁₆ in. (22.5 x 26.2 cm)
AC1992.197.26
PLATE 130

A painter and conceptual artist, Burson studied at Colorado Women's College before moving in 1968 to New York, where she began to use photography and computer-generated images in her work. She became affiliated with Experiments in Art and Technology in an effort to interact with computer scientists and further the development of her computer imagery. Burson ultimately received a patent for her "aging machine" in 1981 and started her work with computer-assisted composite images the following year. Her computer images have spawned the interactive "composite machine," whereby a viewer's features are selectively combined with those of a roster of celebrities. In 1991 Burson began to explore issues of beauty and normalcy through straight photographic images of children suffering from severe craniofacial disorders and premature aging.

Burson, Nancy. *Composites: Computer-Generated Portraits.* New York: Beech Tree Books, 1986.

Claude Cahun (Lucy Schwob)
France, 1894–1954

I.O.U. (Self-Pride), 1929–1930
Gelatin-silver print
6 x 4¹⁄₁₆ in. (15.2 x 10.3 cm)
AC1992.197.27
PLATE 38

Born in Nantes to a wealthy family, Cahun was a follower
of surrealism during the 1920s and met André Breton while
a member of the Association des Écrivains et Artistes
Révolutionnaires. She was also active in Contre-Attaque,
a group formed to oppose the rise of Hitler and the spread
of fascism in France. By 1936 Cahun had moved to the Isle
of Jersey, where her continued resistance activities led to
her subsequent imprisonment by the Nazis. Her surreal
and often androgynous imagery consistently raises issues of
gender and identity.

Leperlier, François. *Claude Cahun: L'Écart et la métamor-
phose*. Paris: Jean Michel Place, 1992.

Ellen Carey
United States, b. 1952

Untitled, 1985
Dye-diffusion transfer (SX-70 Polaroid) print
27⅝ x 22 in. (70.2 x 55.9 cm)
AC1992.197.28
PLATE 118

Born in New York, Carey studied printmaking at the
Kansas City Art Institute in Missouri and earned a master
of fine arts degree in photography at the State University of
New York College at Buffalo in 1978. She is an indepen-
dent photographer who typically uses overpainting,
multiple exposures, and other manipulations in her large-
format color work.

Miami University Art Museum, Oxford, Ohio. *Reflections:
Woman's Self-Image in Contemporary Photography*. Exh.
cat., 1988.

Lance Carlson
United States, b. 1954

Self-Portrait, 1982
Toned gelatin-silver print with text
7⅜ x 9⅜ in. (18.7 x 23.9 cm)
AC1992.197.29
PLATE 126

Educated at California State University, Fullerton and Los
Angeles, Carlson was a student of Eileen Cowin. A critic
and editor as well as a photographer, Carlson served on the
board of the Los Angeles Center for Photographic Studies
from 1977 to 1983 and has taught at Rio Hondo College
in Whittier, California, the Art Institute of Chicago, and
in the California State University system. Carlson is a con-
tributor to *Afterimage*, *Artweek*, *Art Issues*, and *High
Performance*. His recent photographic work has incorpo-
rated collage, appropriation, and rephotographing.

Hugunin, James R. "Bachelors, Even." *Afterimage* 15, no. 6
(January 1988): 19–20.

Henri Cartier-Bresson
France, b. 1908

Italy, 1932
Gelatin-silver print
6¼ x 9¼ in. (15.9 x 23.5 cm)
AC1992.197.30
PLATE 47

After studying painting in Paris, Cartier-Bresson began his
photographic career in 1931. He also studied filmmaking
with Paul Strand while working as a freelance photogra-
pher in New York in 1935, serving as an assistant director
under Jean Renoir the following year. Confined in
Württemberg, Germany, as a prisoner of war from 1940
until his escape in 1943, he spent the remainder of the war
years working with the French underground and docu-
menting the Occupation and the eventual liberation of
Paris. After the war Cartier-Bresson worked as an indepen-
dent photographer based in Paris and New York and, along
with Robert Capa and David Seymour, was one of the
founders of Magnum Photos cooperative agency. During
the 1950s and 1960s he worked throughout Europe, Asia,
and the Americas. Cartier-Bresson's work is often summed
up as the recognition and documentation of (in his own
oft-quoted phrase) "the decisive moment."

Galassi, Peter. *Henri Cartier-Bresson: The Early Work*. Exh.
cat. New York: Museum of Modern Art, 1987.

John F. Collins

United States, 1888–1991

Self-Portrait Frame-in-Frame, 1935
Gelatin-silver print
13⅝ x 10⁹⁄₁₆ in. (34.6 x 26.8 cm)
AC1992.197.31
PLATE 24

Collins worked as a solar printer for William Rau at the Saint Louis World's Fair (the *Louisiana Purchase Exposition*) in 1904. He went on to work as a photojournalist, cinematographer, and commercial photographer in Ohio, Florida, and New York until establishing an advertising-photography studio in Syracuse in 1919. After eleven years he began to work as a photographer for the Eastman Kodak Company, an affiliation that was to last until 1974.

Carey, Marty. *John F. Collins: Photographs 1904–1946.* Exh. cat. New York: Photofind Gallery, 1987.

Gordon Coster

United States, 1906–88

Self-Portrait, 1942
Gelatin-silver print
7½ x 9¹⁄₁₆ in. (19.1 x 23 cm)
AC1992.197.32
PLATE 67

Coster was a photojournalist and commercial photographer in Chicago during the 1920s. By the end of the decade he was working in New York with Lejaren à Hiller at Underwood and Underwood Commercial. Returning to Chicago, he taught at the New Bauhaus (later the Institute of Design) under László Moholy-Nagy.

Sobieszek, Robert A. *The Art of Persuasion: A History of Advertising Photography.* New York: Harry N. Abrams, 1988.

Eileen Cowin

United States, b. 1947

Untitled, 1981
From the series *Family Docu-drama*
Gelatin-silver print
19⅞ x 23⅞ in. (50.5 x 60.6 cm)
AC1992.197.33
PLATE 119

Educated at the State University of New York College at New Paltz and the Illinois Institute of Technology, Cowin studied with both Aaron Siskind and Arthur Siegel. Her narrative stagings explore the dramas of interpersonal and family relations in images that are evocative of classic film noir and television melodrama. Since 1975 she has been teaching at the California State University in Fullerton and is currently concentrating on video work.

Gauss, Kathleen McCarthy. *New American Photography.* Exh. cat. Los Angeles: Los Angeles County Museum of Art, 1985.

Konrad Cramer

Germany, active United States, 1888–1963

Portrait of the Artist as a Young Man, 1947
Gelatin-silver print
13⁹⁄₁₆ x 10⁹⁄₁₆ in. (34.5 x 26.8 cm)
AC1992.197.34
PLATE 89

Cramer studied painting in Germany with Ludwig Schmidt-Reutte and Ernest Schurth and was influenced by the group of artists who would later come to be known collectively as the Blaue Reiter (Blue rider). He immigrated to the United States in 1911 and cofounded the Woodstock School of Art in 1933. Cramer began working as an independent photographer in 1935. His work typically took the forms of photomontage, solarization prints, and photograms.

Riehlman, Frank, and Tom Wolf. *Konrad Cramer: 1917–1963.* Exh. cat. Annandale-on-Hudson, New York: Edith C. Blum Art Institute, 1981.

Imogen Cunningham
United States, 1883–1976

Self-Portrait, c. 1908
Toned platinum print
4⅞ x 3¼ in. (12.4 x 8.3 cm)
AC1992.197.35
PLATE 16

With Grandchildren at the Fun House, 1955, printed 1965
Gelatin-silver print
8⅛ x 6⁷⁄₁₆ in. (20.6 x 16.3 cm)
AC1992.197.36
PLATE 92

Cunningham studied chemistry at the University of Washington in Seattle and photographic chemistry at the Technische Hochschule in Dresden. She worked in the photographic studio of Edward S. Curtis in Seattle from 1907 to 1909 and then established her own studio, specializing in portraiture and pictorialist imagery. Relocating to San Francisco in 1917, she was a founding member of Group f/64 along with Edward Weston, Ansel Adams, Sonya Noskowiak, Willard Van Dyke, Henry Swift, and John Paul Edwards. Cunningham concentrated primarily on portrait and still-life photography from 1935 to 1965.

Dater, Judy. *Imogen Cunningham: A Portrait*. Boston: New York Graphic Society, 1979.

Edward Sheriff Curtis
United States, 1868–1954

Self-Portrait, 1899, printed c. 1930
From the series *The North American Indian*, 1907–30
Photogravure
10¹⁄₁₆ x 6¹⁵⁄₁₆ in. (25.5 x 17.6 cm)
AC1992.197.37
PLATE 11

Self-taught as a photographer, Curtis is known for his documentation of the lives and customs of Native American tribes west of the Mississippi. He began work as a photographic assistant in Wisconsin before migrating to Seattle, where he eventually opened his own studio. He was part of a survey expedition to Alaska in 1896 and there began his consuming documentation of Native Americans, which was ultimately published (in twenty volumes with twenty supplementary portfolios) as *The North American Indian* from 1907 to 1930.

Davis, Barbara A. *Edward S. Curtis: The Life and Times of a Shadow Catcher*. San Francisco: Chronicle Books, 1985.

Louise Dahl-Wolfe
United States, 1895–1989

Self-Portrait, 1935
Gelatin-silver positive transparency
3⅝ x 3⅜ in. (9.2 x 8.6 cm)
AC1992.197.38
PLATE 57

Dahl-Wolfe studied design and painting at the San Francisco Institute of Art from 1914 to 1917. She was largely self-taught as a photographer, working in San Francisco from 1930 to 1932 and then in Tennessee until 1933. Dahl-Wolfe worked as a freelance advertising and fashion photographer in New York, contributing to *Harper's Bazaar*, *Vogue*, and *Women's Home Companion* from 1933 until her retirement in 1960.

Dahl-Wolfe, Louise. *A Photographer's Scrapbook*. New York: St. Martin's/Marek, 1984.

Judy Dater
United States, b. 1941

Self-Portrait with Cable Release, 1981
Gelatin-silver print
18⅝ x 14⁷⁄₁₆ in. (47.3 x 36.7 cm)
AC1992.197.39
PLATE 125

Dater studied painting and drawing at the University of California, Los Angeles, and then photography at San Francisco State University. Dater has been an independent photographer, producing distinctive psychological portrait studies, since 1967. She also has been teaching photography at the University of California, San Francisco, Extension and at the San Francisco Art Institute.

Dater, Judy. *Cycles*. Tokyo: Kodansha, 1992.

213

Jack Delano
Russia, active United States and Puerto Rico, b. 1914

Self-Portrait, 1947
Gelatin-silver print
13¹⁵⁄₁₆ x 11 in. (35.4 x 27.9 cm)
AC1992.197.41
PLATE 64

Jack Delano immigrated to the United States from Russia in 1923. He studied music at the Settlement Music School in Philadelphia from 1925 to 1933 and also attended the Pennsylvania Academy of the Fine Arts in Philadelphia. Delano began work as a photographer with the Works Progress Administration and then with Roy Stryker at the Farm Security Administration and the Office of War Information. Since 1946 he has resided in Puerto Rico, where has been a photographer, arts administrator, film-maker, composer, teacher, and designer.

Delano, Jack. *Puerto Rico Mio: Four Decades of Change.* Washington, D.C.: Smithsonian Institution Press, 1990.

Baron Adolph de Meyer
France, active England and United States, 1868–1946

Self-Portrait, 1905
Platinum print
7½ x 3½ in. (19.1 x 8.9 cm)
AC1992.197.42
PLATE 17

Self-Portrait, c. 1920s, printed c. 1938
Gelatin-silver print
9⅜ x 7⁷⁄₁₆ in. (23.9 x 18.8 cm)
AC1992.197.43
PLATE 26

Reared in Paris, de Meyer was subsequently educated in Dresden. By 1895 he was a member of the British pictorial-ist group the Linked Ring and was considered the most influential portrait photographer of Edwardian London. De Meyer worked as a fashion photographer for *Vogue* magazine from 1914 to 1922, at which time he began an association with *Harper's Bazaar* that lasted until 1934. De Meyer also produced a substantial amount of portrait work in New York, Paris, and later in Hollywood.

Brandau, Robert. *De Meyer.* New York: Alfred Knopf, 1976.

André-Adolphe-Eugène Disdéri
France, 1818–89

Self-Portrait, c. 1860
Toned albumen print (carte de visite)
3⅜ x 2⅛ in. (8.6 x 5.4 cm)
AC1992.197.44
PLATE 4

Disdéri began as a daguerreotypist working in Brest and then in Nîmes. By 1854 he had opened a portrait studio in Paris. Disdéri is credited with the popularization, if not the invention, of the carte de visite. An inventor as well as a portraitist, he devised methods and equipment that allowed him to obtain multiple exposures and poses, thereby dramatically increasing his productivity as well as his profitability. By 1861 he had been appointed official photographer to the imperial courts of Spain, France, England, and Russia.

McCauley, Elizabeth Anne. *A. A. E. Disdéri and the Carte de Visite Portrait Photograph.* New Haven: Yale University Press, 1985.

Robert Doisneau
France, 1912–94

Self-Portrait, c. 1953
Gelatin-silver print
9½ x 7 in. (24.1 x 17.8 cm)
AC1992.197.45
PLATE 80

Doisneau initially studied lithography but has worked as a photographer since 1930. He served as a photographic assistant to André Vigneau from 1931 to 1933 and as an industrial photographer for Renault from 1934 to 1938. Since 1940 he has been a photojournalist and magazine photographer for such periodicals as *Vogue*, *Life*, *Paris-Match*, *Fortune*, and *Point de vue* as well as for the Mission Photographique de la DATAR, sponsored by the French government.

Chevrier, Jean-François. *Robert Doisneau.* Paris: P. Belfond, 1973.

214

Pierre Dubreuil
France, 1872–1944

Myself, 1929
Gelatin-silver print
9¾ x 7⅝ in. (24.8 x 19.4 cm)
AC1992.197.46
PLATE 30

Self-taught as a photographer, Dubreuil was a member of the Photo-Club de Paris by 1896 and was elected a member of the British pictorialist group the Linked Ring in 1903. In 1910 six of his photographs were exhibited at the Albright-Knox Museum in Buffalo, New York, in the *International Exhibition of Pictorialist Photography*, organized by Alfred Stieglitz.

Jacobson, Tom. *Pierre Dubreuil: Photographs 1896–1935.* San Diego: Dubroni Press, 1987.

Morris Engel
United States, b. 1918

Self-Portrait, 1936
Gelatin-silver print
9⁹⁄₁₆ x 7⅝ in. (24.2 x 19.4 cm)
AC1992.197.47
PLATE 63

Initially influenced by Paul Strand and the members of New York's Photo League, Engel later served as a member of the United States Navy's combat photography team, headed by Edward Steichen. After World War II he began a career as an independent photographer. Engel is best known for his photographic essays on urban life in New York, where his work was regularly seen in the pages of the newspaper *PM*.

Documentary Photography. New York: Time-Life Books, 1972.

Frederick H. Evans
England, 1853–1943

Self-Portrait, c. 1900
Platinum print
7⁷⁄₁₆ x 2¹⁄₁₆ in. (18.9 x 5.2 cm)
AC1992.197.48
PLATE 13

Evans devoted himself to photography after his retirement from a successful bookselling career in 1898. Though he produced some portrait images, Evans is primarily known for his architectural photography documenting the cathedrals of both England and France. He was a contributor to *Photogram, Country Life*, and Alfred Stieglitz's *Camera Work*. By 1900 he was a member of the British pictorialist group the Linked Ring and was named an honorary fellow of the Royal Photographic Society in 1925.

Hammond, Anne. *Frederick H. Evans: Selected Texts and Bibliography.* Boston: G. K. Hall, 1992.

Walker Evans
United States, 1903–75

Silhouette Self-Portrait, 1927
Gelatin-silver print
5⅜ x 3⅜ in. (13.6 x 8.5 cm)
AC1992.197.49
PLATE 28

Evans was educated at Williams College, Williamstown, Massachusetts, and the Sorbonne, Paris. Principally self-taught, he began taking photographs in 1927. For inspiration he turned to the work of Paul Strand and the intellectual stimulation provided by friends such as Ben Shahn, James Agee, and Lincoln Kirstein. His work during this period was primarily concerned with urban, architectural, and art documentation, along with literary illustration. In 1935 he began a two-year assignment with the Farm Security Administration as a staff photographer under Roy Stryker. In 1938 his work from this period was exhibited at the Museum of Modern Art, New York, and served as the basis for his publications *American Photographs* and *Let Us Now Praise Famous Men*. Evans resumed his freelance career but then, in 1945, became affiliated with *Fortune* magazine, where he was a photographer and associate editor until retiring in 1965.

Mora, Gilles, and John T. Hill. *Walker Evans: The Hungry Eye.* New York: Harry N. Abrams, 1993.

215

Louis Faurer
United States, b. 1916

Self-Portrait, 42nd Street El Station Looking towards "Tudor City," 1946
Gelatin-silver print
10½ x 13½ in. (26.7 x 34.3 cm)
AC1992.197.50
PLATE 83

Faurer worked as a commercial photographer in New York from 1947 to 1969; he contributed to Time-Life and Hearst publications, *Harper's Bazaar*, *Vogue*, and *Fortune* magazines. While living in London and Paris from 1969 to 1974, he was an independent photographer, a practice he continued after returning to New York; there he taught at Parsons School of Design. Faurer's work was included in the Museum of Modern Art's landmark exhibition *Family of Man* in 1955.

Harrison, Martin. *Louis Faurer*. Paris: Centre National de la Photographie, 1992.

T. Lux (Theodore Lukas) **Feininger**
Germany, active Germany and United States, b. 1910

Self-Portrait as Charlie Chaplin, 1927
Gelatin-silver print
3⁵⁄₁₆ x 2½ in. (8.4 x 6.4 cm)
AC1992.197.51
PLATE 29

The son of Lyonel Feininger and brother of Andreas, T. Lux Feininger studied at the Bauhaus from 1926 to 1932 under Paul Klee, Wassily Kandinsky, Josef Albers, and Oskar Schlemmer. During the late 1920s and early 1930s Feininger's photographs appeared in magazines as well as in the Stuttgart exhibition *Film und Foto* (1929). He lived in Paris from 1932 to 1935 and, after returning to Germany for a year, immigrated to the United States, where he concentrated increasingly on his career as a teacher, painter, and designer.

Fiedler, Jeannine, ed. *Photography at the Bauhaus*. Cambridge: MIT Press, 1990.

Roger Fenton
England, 1819–69

Zouave 2nd Division [Self-portrait in collaboration with Marcus Sparling], 1855, printed 1856
Salted-paper print
7⅛ x 5⅞ in. (18.1 x 14.9 cm)
AC1992.197.52
PLATE 2

Educated at University College in London, Fenton studied painting in the early 1840s with Charles Lucy. He was producing photographs using waxed-paper and collodion negatives by 1852 and was among the founding members of the Royal Photographic Society (then called the Photographic Society of London) the following year. Fenton's government-commissioned photographs of the Crimean War presented visual testimony of the conflict to the British public.

Hannavy, John. *Roger Fenton of Crimble Hall*. London: Gordon Fraser Gallery, 1975.

Larry Fink
United States, b. 1941

Self and Molly, 1982
Gelatin-silver print
14⅞ x 14¹⁵⁄₁₆ in. (37.8 x 37.9 cm)
AC1992.197.53
PLATE 121

Fink studied photography with Lisette Model in New York. He began his career in the 1950s with a photodocumentary on the "beatniks." In addition to being a freelance photographer, he has taught at Parsons School of Design and Cooper Union, New York, Lehigh University, Bethlehem, Pennsylvania, and Bard College, Annandale-on-Hudson, New York. His work continues to document urban life and attitudes.

Levin, Eric. "The Art of Empathy." *American Photographer* 23, no. 9 (September 1989): 26–36.

Louis Fleckenstein
United States, 1866–1943

Self-Portrait, c. 1910
Toned gelatin-silver print
10⅝ x 6¹⁵⁄₁₆ in. (27 x 17.6 cm)
AC1992.197.54
PLATE 20

After gaining national recognition for his pictorialist photography in 1903, Fleckenstein was instrumental in the formation of a national alliance of photography clubs, which led to the First American Salon in Chicago in 1905. Arriving in Los Angeles in 1914, he was a founding member of the Camera Pictorialists of Los Angeles, serving as director until 1922. He was a regular exhibitor at the International Salon of Photography at the Los Angeles County Museum of Science, History, and Art between 1918 and 1927. Following his move to Long Beach in 1924 Fleckenstein was appointed the city's first art commissioner.

White, Stephen. *Louis Fleckenstein.* Exh. cat. Los Angeles: Stephen White Gallery, 1978.

Robert Frank
Switzerland, active United States and Canada, b. 1924

NYC, 1947, 1947, printed c. 1980
Gelatin-silver print
10½ x 10⁷⁄₁₆ in. (26.7 x 26.5 cm)
AC1992.197.55
PLATE 85

Frank apprenticed in Zurich under photographers Michael Wolgesinger and H. Segesser, in Geneva under Victor Bouverat, and in Basel under Herman Eidenbenz. Immigrating to the United States in 1947, he worked as a freelance photographer for such publications as *Harper's Bazaar, Fortune, Life,* and *Look* until shifting the focus of his efforts to filmmaking in 1969, at which time he moved to Canada. Frank's best-known and most influential work, *The Americans,* was produced under the auspices of a Guggenheim Foundation grant and published in France in 1958 and in the United States the following year.

Tucker, Anne Wilkes, ed. *Robert Frank: New York to Nova Scotia.* Exh. cat. Houston: Museum of Fine Arts, 1986.

Lee Friedlander
United States, b. 1934

New York City, 1966, 1966, printed 1970
Gelatin-silver print
7⁷⁄₁₆ x 11⅛ in. (18.8 x 28.3 cm)
AC1992.197.56
PLATE 101

Friedlander studied photography with Edward Kaminski at the Art Center School in Los Angeles from 1953 to 1955. His work as a freelance photographer has been seen in the pages of *Esquire, Art in America, Collier's, McCall's,* and many others since 1955. He has taught at the University of Minnesota and the University of California, Los Angeles. In 1967 the work of Friedlander, along with that of Diane Arbus and Garry Winogrand, was featured in the seminal Museum of Modern Art, New York, exhibition *New Documents,* curated by John Szarkowski. Since then Friedlander's work has been included in exhibitions internationally. In 1990 he was the recipient of a MacArthur Foundation award.

Malle, Loic. *Lee Friedlander.* New York: Pantheon Books, 1988.

Francis Frith
England, 1822–98

Portrait, Turkish Summer Costume, 1857, printed c. 1862
Toned albumen print
7¼ x 5¹¹⁄₁₆ in. (oval) (18.4 x 14.4 cm)
AC1992.197.57
PLATE 3

217

Frith began photographing by the mid-nineteenth century and was a founding member of the Liverpool Photographic Society in 1853. He made three photo expeditions to the Middle East between 1856 and 1860. Subsequently, he produced albums of collectible images, such as the eight-volume *Views of Sinai, Egypt, Palestine, and Ethiopia,* which enjoyed both critical and commercial success and for which he is best known.

Seiberling, Grace. *Amateurs, Photography, and the Mid-Victorian Imagination.* Chicago: University of Chicago Press, 1986.

Dallett Fuguet
United States, 1868–1933

A Brown Study, 1895
Toned gelatin-silver print
4⅜ x 3⁷⁄₁₆ in. (11.1 x 8.7 cm)
AC1992.197.58
PLATE 10

A photographer, critic, poet, and humorist, Fuguet was a member of Alfred Stieglitz's Photo-Secession. He served as a contributor and associate editor for *Camera Work* for the run of its publication, having previously worked with Stieglitz on the New York Camera Club's *Camera Notes*.

Kiefer, Geraldine W. "The Leitmotifs of Camera Notes, 1897–1902." *History of Photography* 14, no. 4 (October–December 1990): 349–60.

Norman Rhoads Garrett
United States, 1896–1981

Photographer's License, c. 1939
Toned gelatin-silver print
9⁹⁄₁₆ x 13¼ in. (24.2 x 33.7 cm)
AC1992.197.59
PLATE 66

While residing in Prescott, Arizona, Garrett was a member of a pictorialist photographers' group with affiliations to the Royal Photographic Society. A prolific exhibitor, during the 1930s he participated in up to twenty-three different photographic salons in a single season.

Arnold Genthe
Germany, active United States, 1869–1942

Self-Portrait, c. 1906, printed c. 1930
Gelatin-silver print
9⁷⁄₁₆ x 7¹⁄₁₆ in. (23.6 x 18 cm)
AC1992.197.60
PLATE 21

Born in Germany, Genthe was educated in Berlin and Paris. He immigrated to the United States in 1896, establishing a portrait-photography studio in San Francisco and then in Carmel, California. He is best remembered for his documentation of the devastating aftermath of the 1906 San Francisco earthquake and resulting fires. In 1911 Genthe relocated to New York and opened a photography studio, where he specialized in portraits of theater and dance personalities.

Tchen, John Kuo Wei. *Genthe's Photographs of San Francisco's Old Chinatown*. New York: Dover Publications, 1984.

Tim N. Gidal
Germany, active United States and Israel, b. 1909

Self-Portrait, 1930
Photogram
9 x 4⅛ in. (22.9 x 10.5 cm)
AC1992.197.61
PLATE 43

After attending school in Munich and Berlin, Gidal received a doctorate from the University of Basel in 1935. Immigrating to Palestine in 1936, then to the United States in 1947, he finally returned to Israel, where he was naturalized in 1975. Gidal worked as a photojournalist in Berlin, Palestine, Jerusalem, and London from 1929 to 1948. His work has been seen in *Müncher Illustrierte Presse*, *Picture Post*, *Look*, and *Life*. He worked as writer, photographer, lecturer, and editorial consultant in New York from 1950 through 1970 and then as a lecturer and professor at the Hebrew University in Jerusalem from 1971.

Gidal, Tim N. *Modern Photojournalism: Origin and Evolution, 1910–1933*. New York: Collier Books, 1973.

Judith Golden
United States, b. 1934

In Peru, 1977
Hand-colored gelatin-silver print
13¹⁵⁄₁₆ x 10¹⁵⁄₁₆ in. (35.4 x 27.7 cm)
AC1992.197.62
PLATE 113

Golden received her bachelor of arts degree from the Art Institute of Chicago and her master of fine arts degree from the University of California, Davis. She began working as a photographer in 1973. After having lectured at the University of California, Los Angeles and Davis, and the California College of Arts and Crafts, Oakland, she accepted an associate professorship at the University of Arizona, Tucson, in 1981. Golden's explorations of roles and identities have resulted in a succession of photographic series including *Cycles*, 1972; *Magazine Makeovers*, 1976; *Ode to Hollywood*, 1977; *Forbidden Fantasies*, 1979; *Relationships*, 1985; and *Elements*, 1986.

Judith Golden: *Cycles, a Decade of Photographs*. San Francisco: Friends of Photography, 1988.

Pedro Guerrero
United States, b. 1917

Self-Portrait, 1938
Gelatin-silver print
13¼ x 10½ in. (33.7 x 26.7 cm)
AC1992.197.63
PLATE 69

Born in Arizona, Guerrero studied photography at the Art Center School in Los Angeles from 1937 to 1939. He joined Frank Lloyd Wright's Taliesin Fellowship as a photographer the following year and continued to document Wright's life and work until the architect's death in 1959. A photo technician during World War II, Guerrero started his professional career in New York in 1946. Concentrating primarily on architectural photography, he also documented the work of Alexander Calder and Louise Nevelson. Guerrero is currently living and working in Connecticut.

Guerrero, Pedro E. *Picturing Wright*. Rohnert Park, California: Pomegranate Artbooks, 1994.

John Gutmann
Germany, active United States, b. 1905

Self-Portrait, San Francisco, 1934, printed later
Gelatin-silver print
8¾ x 7¾ in. (22.2 x 19.7 cm)
AC1992.197.64
PLATE 56

Gutmann received his bachelor's degree from the Staatliche Akademie für Kunst und Kunstgewerbe, Breslau, in 1927. The following year he earned a master's degree from Preussisches Schulkollegium für Höhere Erziehung, Berlin. While doing postgraduate work at the Berliner Akademie der Bildenden Künste, he began exhibiting his paintings and drawings. In reaction to Hitler's rise to power he immigrated to the United States in 1933. Settling in San Francisco, he worked as a photojournalist, documenting life in the West for Presse-Photo in Berlin until 1936. He continued as a freelance photographer based in San Francisco, where he also began to produce independent films after 1949. Gutmann was an instructor and professor at San Francisco State University from 1936 to 1973.

Sutnik, Maia-Mari. *Gutmann*. Exh. cat. Toronto: Art Gallery of Ontario, 1985.

Otto Hagel
Germany, active United States, 1909–73

Self-Portrait, New York, 1931
Gelatin-silver print
13⅛ x 9³⁄₁₆ in. (33.3 x 24.9 cm)
AC1992.197.65
PLATE 46

Hagel, who began his career as a freelance photographer in California working with his wife, Hansel Meith, moved to New York in 1929. From 1936 to 1972 he was employed by Time, Inc., and in 1955 participated in the *Family of Man* exhibition at the Museum of Modern Art, New York.

Fels, Thomas Weston, Therese Heyman, and David Travis. *Watkins to Weston: 101 Years of California Photography*. Exh. cat. Santa Barbara: Santa Barbara Museum of Art in cooperation with Roberts Rinehart Publishers, 1992.

Robert Heinecken

United States, b. 1931

The Evolution of the Hair of the Artist as Aviator or Variations on the Frontal Pose (#11), 1979
Gelatin-silver print with dye-diffusion transfer
(SX-70 Polaroid) print adhered
12⅞ x 17⅜ in. (32.7 x 44.1 cm)
AC1992.197.66
PLATE 120

Heinecken studied at the University of California, Los Angeles, from 1951 to 1953 and from 1958 to 1960. A Los Angeles-based photographer and multimedia artist, he was a professor at UCLA from 1960 until 1992. His work, which typically combines popular-culture images in juxtapositions that convey an uneasy commentary on modern life, including issues of gender and sexual identity, was the focus of a retrospective at the International Museum of Photography at George Eastman House in 1976.

Enyeart, James, ed. *Heinecken*. Carmel, California: Friends of Photography, 1980.

Florence Henri

United States, active France, 1895–1982

Self-Portrait (Artist Seated at Table with Window Reflection), 1928
Gelatin-silver print
6⅜ x 4⁹⁄₁₆ in. (16.2 x 11.6 cm)
AC1992.197.67
PLATE 27

After studying music (under Egon Petri and Ferruccio Busoni) and painting (under Kurt Schwitters) in Berlin, then going to Paris to study with Fernand Léger, Henri attended the Bauhaus in Dessau, where she studied painting with Josef Albers and photography with László Moholy-Nagy. Henri established herself as a freelance portrait, advertising, and fashion photographer in Paris in 1929 while also producing a significant body of work exploring mirror abstractions. In 1963 she relocated near the Normandy region of France, where she worked exclusively as a painter. In 1990 her work was the subject of a retrospective at the San Francisco Museum of Modern Art.

Du Pont, Diana C. *Florence Henri: Artist-Photographer of the Avant-Garde*. Exh. cat. San Francisco: San Francisco Museum of Modern Art, 1990.

Lejaren à Hiller

United States, 1880–1969

Bean Soup, c. 1930
Gelatin-silver print
9⁷⁄₁₆ x 7½ in. (24 x 19.1 cm)
AC1992.197.68
PLATE 39

A student at the Art Institute of Chicago before moving to New York in 1902, Hiller worked as a commercial illustrator and painter. After a brief period in Paris he returned to New York to work for *Life* and *Mumsey's*. Hiller began working as a photographer with Underwood and Underwood Commercial in 1929 and was the first photographer to have his work incorporated as illustration within a magazine story. Hiller became well known for his theatrical sense of design and composition as evident in his series *Surgery through the Ages*, begun in 1927.

Sobieszek, Robert A. *The Art of Persuasion: A History of Advertising Photography*. New York: Harry N. Abrams, 1988.

Marta Hoepffner

Germany, b. 1912

Self-Portrait in Mirror, 1941
Gelatin-silver print
14 x 11⁵⁄₁₆ in. (35.6 x 28.8 cm)
AC1992.197.69
PLATE 78

Hoepffner studied painting, graphics, and photography under Willi Baumeister in Frankfurt from 1929 to 1933. Opening a studio in 1934, she worked as a portrait and advertising photographer. Her personal emphasis, however, lay in the experimental work she was producing using photomontage and photograms. Following the wartime destruction of her studio she moved to Hofheim in 1944, establishing a private photography school five years later. By 1958 she had turned her efforts toward experimental color work using polarized light. In 1971 she relocated her school to Kressbronn, Lake Constance, where she lives and works.

Eisele, Jupp. *Marta Hoepffner: Das fotografische und lichtkinetische Werk*. Exh. cat. Ravensburg, Germany: Städtische Galerie Altes Theater, 1982.

Emil Otto Hoppé
Germany, active England, 1878–1972

Self-Portrait, 1910
Gelatin-silver print
9¹³⁄₁₆ x 9⅞ in. (24.9 x 25.1 cm)
AC1992.197.70
PLATE 14

Born in Germany, Hoppé was educated in Paris and Vienna
and immigrated to England in 1900. Primarily self-taught
as a photographer, he established himself as a portraitist in
London and New York while also working as a freelance
fashion, theater, and travel photographer. In 1910 he was a
founding member of the London Salon of Photography and
then became a member of the Royal Photographic Society.
Although he still produced portraits, Hoppé specialized in
travel and landscape photography after 1925.

Pepper, Terrence. *Camera Portraits by E. O. Hoppé*. Exh. cat.
London: National Portrait Gallery, 1978.

George Hurrell
United States, 1904–92

Self-Portrait, 1947
Toned gelatin-silver print
10 x 8 in. (25.4 x 20.3 cm)
AC1992.197.71
PLATE 87

Hurrell studied painting and drawing at the Art Institute
of Chicago before working as an assistant to portrait
photographer Eugene Hutchinson in 1922. Moving to
Los Angeles, he opened a photography studio in 1927,
producing portrait and commercial work. He was hired by
MGM as a portrait photographer, then worked indepen-
dently before moving in 1935 to New York, where he spent
a year concentrating on fashion photography and portrai-
ture. Returning to California, Hurrell began working
for Warner Bros. and then Columbia Pictures before again
establishing himself as an independent specializing in
glamour photographs, celebrity portraits, and production-
still photography.

Hurrell, George. *Hurrell Hollywood*. New York: St. Martin's
Press, 1992.

Lotte Jacobi
Germany, active United States, 1896–1991

Self-Portrait, Berlin, c. 1930, printed c. 1980
Platinum print
13¹¹⁄₁₆ x 9¹⁵⁄₁₆ in. (34.8 x 25.3 cm)
AC1992.197.72
PLATE 41

Born into a family of photographers, Jacobi attended the
Bavarian State Academy of Photography in Munich while
also studying art history at the University of Munich. For a
time Jacobi worked as a portrait photographer in Berlin,
but in 1935 she immigrated to the United States, where she
continued her career in New York. In 1955 she relocated to
Manchester, New Hampshire, where she proceeded with
her photographic work, founded the Currier Gallery of Art,
and taught at the University of New Hampshire, Durham.

Wise, Kelly, ed. *Lotte Jacobi*. Danbury, New Hampshire:
Addison House, 1978.

Yousuf Karsh
Armenia, active Canada, b. 1908

Self-Portrait, 1947
Gelatin-silver print
9½ x 7⅝ in. (24.1 x 19.4 cm)
AC1992.197.73
PLATE 79

After immigrating to Canada in 1924, Karsh worked as a
photographic assistant to his uncle until 1928. He studied
photography under the Boston portraitist John H. Garo
from 1928 to 1931, establishing his own portrait studio
the following year. While perhaps best known for his
insightful and elegant portrait photography—his portrait
of Sir Winston Churchill was featured on the cover of *Life*
magazine in 1941—he also worked as an industrial photog-
rapher, educator, arts consultant, and administrator.

Borcoman, James, et al. *Karsh: The Art of the Portrait*. Exh.
cat. Ottawa: National Gallery of Canada, 1989.

André Kertész

Hungary, active France and United States, 1894–1985

Self-Portrait with "Distortion #91," 1933, printed c. 1980
Toned gelatin-silver print
7 x 9¾ in. (17.8 x 24.8 cm)
AC1992.197.77
PLATE 52

Kertész began photographing in his native Hungary with limited success and encouragement. Determined to make photography his career, he moved to Paris, where he worked as an independent from 1925 to 1935. Kertész was an innovator in the use of the 35mm camera, which offered him the flexibility and immediacy his work required. As French picture magazines began to gain popularity, Kertész began to be a regular contributor to *Vu*, *Variétés*, and *Art et Médecine*. After immigrating to the United States in 1936, he worked as a freelance photographer until earning a contract position with Condé Nast Publications in New York. He remained with Condé Nast until 1962, when he returned to his personal photographic explorations.

Harder, Susan, with Hiroji Kubota. *André Kertész: Diary of Light, 1912–1975*. New York: Aperture in association with the International Center of Photography, 1987.

Bayat Keerl

Switzerland, active United States, b. 1948

Anableps II, 1982
Gelatin-silver print with applied oil pigment
24⅝ x 19¾ in. (62.6 x 50.2 cm)
AC1992.197.75
PLATE 124

Keerl received his bachelor of arts degree in 1970 from the Layton School of Art, Milwaukee, and his master of fine arts degree in 1972 from Rutgers University, New Brunswick, New Jersey. Keerl characteristically manipulates his finished photographs using traditional oil pigments, resulting in the questioning of the spatial correspondance and materiality of both media.

Risatti, Howard. "Exhibition Review." *Artforum* 27, no. 4 (December 1988): 127.

Peter Keetman

Germany, b. 1916

1001 Faces, 1957
Gelatin-silver print
11⁹⁄₁₆ x 9¹⁄₁₆ in. (29.4 x 23 cm)
AC1992.197.76
PLATE 94

Keetman studied photography under Hans Schreiner at the Bayerische Staatslehranstalt für Photographie in Munich from 1935 to 1937 and from 1947 to 1948. He worked as an industrial photographer until his service in the German army during World War II. Following the war he was a founding member of the Fotoform group in Stuttgart. His experimental work with this group was supplemented by work as both a landscape and industrial photographer.

Keetman, Peter. *Volkswagen: A Week at the Factory*. San Francisco: Chronicle Books, 1992.

Edmund Kesting

Germany, 1892–1970

Self-Portrait, c. 1925
Gelatin-silver print
11¹³⁄₁₆ x 9⅛ in. (30 x 23.2 cm)
AC1992.197.78
PLATE 32

Kesting, who studied art and painting in Dresden before World War I and then briefly worked with artists Richard Müller and Otto Gussmann after the war, was fundamentally self-taught in photography. He experimented with photograms and photomontage before becoming a portrait and dance photographer in 1930. His work shows a strong sense of cubist fracturing and an expressive formalism. Because of his links with the German avant-garde, Kesting was prohibited from exhibiting during the Third Reich. During the 1950s and 1960s, as both teacher and photographer, he increasingly made use of graphic design elements, painterly applications of chemicals, and photomontage.

Coke, Van Deren. *Avant-Garde Photography in Germany: 1919–1939*. Munich: Schirmer/Mosel, 1982.

Anne Königer
Germany, active United States, twentieth century

Self-Portrait, 1913
Platinum print
4¹⁵⁄₁₆ x 6¹⁵⁄₁₆ in. (12.6 x 17.6 cm)
AC1992.197.79
PLATE 19

Königer was active in New York in the first two decades of this century and is represented in the collections of the New Orleans and Los Angeles County museums of art.

Les Krims
United States, b. 1943

A Test of Exposure, Development, and a Punk Prank, 1979
Toned gelatin-silver print
15³⁄₁₆ x 17¾ in. (38.5 x 45.1 cm)
AC1992.197.80
PLATE 112

Krims studied at Cooper Union in New York and the Pratt Institute in Brooklyn, where he received his master of fine arts degree in 1967. He has been working as a photographer and educator since then. His work typically incorporates elaborate props and staging used to produce often-wry commentaries on modern life, culture, and identities.

Krims, Les. *Fictcryptokrimsographs*. Buffalo: Humpy Press, 1975.

Clarence John Laughlin
United States, 1905–85

The Eye (No. 1), 1937, printed 1938
Varnished gelatin-silver print
13¹¹⁄₁₆ x 10⅜ in. (34.7 x 26.4 cm)
AC1992.197.81
PLATE 65

Laughlin served as a photographer for the United States Engineer Corps and then in the photographic division of the United States Army Signal Corps and Office of Strategic Services until 1946. He was a freelance documentary and architectural photographer, incorporating a "Southern Gothic" sensibility in his work, until retiring in 1974. His personal work often involved the use of multiple negatives in the production of psychologically probing and often surreal images.

Davis, Keith F. *Clarence John Laughlin: Visionary Photographer*. Kansas City, Missouri: Hallmark Cards, 1990.

O. Winston Link
United States, b. 1914

Link and Thom with Night Flash Equipment, March 16, 1956, 1956, printed 1984
Gelatin-silver print
19½ x 15½ in. (49.5 x 39.4 cm)
AC1992.197.82
PLATE 93

Schooled as a civil engineer at the Polytechnic Institute of Brooklyn, Link transformed his photographic hobby into a career, eventually becoming chief photographer for a New York public relations firm in 1937. During World War II Link worked with the Columbia University Division of War Research, where he experimented with multiple-flash night-photography techniques. He established himself as a commercial photographer in New York after the war.

Link, O. Winston. *Ghost Trains: Railroad Photographs of the 1950s*. Exh. cat. Norfolk, Virginia: Chrysler Museum, 1983.

George Platt Lynes
United States, 1907–55

Self-Portrait, 1940s
Gelatin-silver print
9¼ x 7⅜ in. (23.5 x 18.7 cm)
AC1992.197.84
PLATE 77

A self-taught photographer, Lynes worked as a portrait photographer in both New York and Paris from 1928 until establishing a permanent studio in New York in 1932. His professional portraits of the New York elite of the 1930s and 1940s defined the glamour and sophistication of the period, while his personal studies explored the eroticism and sensuality of the male body. In 1946 he moved to Hollywood and served as head of *Vogue* studios for two years. He returned to New York in 1948 and resumed his work in fashion and portraiture.

Woody, Jack. *George Platt Lynes: Photographs, 1931–1955.* Los Angeles: Twelvetrees Press, 1980.

Danny Lyon
United States, b. 1942

Self-Portrait, Chicago, 1966
Gelatin-silver print
4¾ x 4¾ in. (12 x 12 cm)
AC1992.197.83
PLATE 99

Educated at the University of Chicago, Lyon, a self-taught photographer, began working as an independent documentary photographer while still a student. In his diverse body of work, which derives from his personal experience and involvement with his subjects, he has documented such subjects as the civil-rights struggle (*The Movement*, 1964), a Chicago-area motorcycle club (*The Bikeriders*, 1968), the plight of the American city (*The Destruction of Lower Manhattan*, 1969), and the Texas prison system (*Conversations with the Dead*, 1971). Lyon's work was the subject of a 1991 retrospective organized by the Center for Creative Photography, Tucson.

Newport Harbor Art Museum. *Danny Lyon: Ten Years of Photographs.* Exh. cat., 1973.

Felix H. Man (Hans Baumann)
Germany, active Germany and England, 1893–1985

Surrealistic Self-Portrait, 1947
Gelatin-silver print
15⁹⁄₁₆ x 11¹¹⁄₁₆ in. (39.5 x 29.7 cm)
AC1992.197.85
PLATE 88

Man studied fine arts and art history in Berlin from 1912 to 1914 and in Munich from 1918 to 1921. He began producing documentary photographs in 1915 during his service as a German officer in World War I. Following the war he worked as a freelance documentary photographer in Berlin and Munich until immigrating to England in 1934. While situated in London, he contributed to the *Daily Mirror*, *Picture Post*, *Harper's Bazaar*, Time-Life publications, and the *Sunday Times*. In 1958 he stopped photographing professionally and moved to Lugano, Switzerland, where he pursued his interest in the graphic arts. He relocated to Rome in 1972.

Man, Felix H. *Man with Camera: Photographs from Seven Decades.* New York: Schocken Books, 1984.

Man Ray (Emmanuel Rudnitsky)
United States, active United States and France, 1890–1976

Self-Portrait, c. 1944
Gelatin-silver print
6¹³⁄₁₆ x 5¹⁄₁₆ in. (17.3 x 12.8 cm)
AC1992.197.86
PLATE 75

Born in Philadelphia, Man Ray studied art in New York and was self-taught as a photographer. From 1921 to 1940 he lived in Paris working as a painter, sculptor, photographer, and filmmaker collaborating with Marcel Duchamp, Fernand Léger, and Hans Richter. After moving to Los Angeles in 1940, he worked as a freelance fashion photographer. In addition to his straight photography, Man Ray also explored cameraless photography ("Rayograms"), solarization, and hand-coloring of black-and-white photographs. He is one of the preeminent modern pioneers of photographic abstraction. By 1951 he had returned to Europe, dividing his time between Paris and Cadaqués, Spain, working as both painter and photographer.

Foresta, Merry A., et al. *Perpetual Motif: The Art of Man Ray.* Exh. cat. Washington, D.C.: National Museum of American Art, Smithsonian Institution, 1988.

Robert Mapplethorpe
United States, 1946–89

Self-Portrait, 1980
Gelatin-silver print, ed. 5/15
13⅞ x 13¹⁵⁄₁₆ in. (35.2 x 40.2 cm)
AC1992.197.87
PLATE 117

Self-Portrait, 1988
Gelatin-silver print, ed. 2/10
23⅛ x 19¼ in. (58.7 x 48.9 cm)
AC1992.197.88
PLATE 135

Mapplethorpe attended the Pratt Institute, Brooklyn, from 1963 to 1970. For five years, beginning in 1965, he was involved in the production of underground films. After working in collage and assemblage, Mapplethorpe in 1972 began to concentrate his creative efforts in photography. He explored the boundaries of his classical photographic vision in both black-and-white and color, using erotic imagery, floral and anatomical still lifes, and portraiture.

Kardon, Janet. *Robert Mapplethorpe: The Perfect Moment.* Exh. cat. Philadelphia: Institute of Contemporary Art, University of Pennsylvania, 1988.

Angus McBean
Wales, active England, 1904–90

Self-Portrait aloft with Umbrella, 1938
Gelatin-silver print
9⁹⁄₁₆ x 7⁹⁄₁₆ in. (25.2 x 19.3 cm)
AC1992.197.89
PLATE 40

Self-taught as a photographer, McBean worked as a photographic assistant to Hugh Cecil in London from 1934 to 1935; he then established his own studio, specializing in portrait and theatrical photography. His later work is most noteworthy for its surreal, often humorous, stagings. He based his career in London until relocating his studio to Debenham, Suffolk, in 1983.

Woodhouse, Adrian. *Angus McBean.* New York: Quartet Books, 1982.

Ralph Eugene Meatyard
United States, 1925–72

Untitled, 1971
Gelatin-silver print
7³⁄₁₆ x 7⅜ in. (18.3 x 18.7 cm)
AC1992.197.90
PLATE 104

Meatyard, an optician, studied photography with Van Deren Coke at the University of Kentucky, Lexington, from 1954 to 1955 and then with Minor White and Henry Holmes Smith at the University of Indiana, Bloomington, in 1956. He founded and successfully operated an optical business in Lexington while producing work as an independent photographer from 1953 until his death.

Hall, James Baker, ed. *Ralph Eugene Meatyard: An Aperture Monograph.* Millerton, New York: Aperture, 1974.

Tony Mendoza
Cuba, active United States, b. 1941

We Really Enjoyed Our One Week Honeymoon in Mexico, 1988
From the series *Short Stories*
Gelatin-silver print
15⅞ x 19¹⁵⁄₁₆ in. (40.3 x 50.6 cm)
AC1992.197.91
PLATE 122

Mendoza earned an undergraduate degree in engineering at Yale University and then received a master's degree in architecture from the Harvard Graduate School of Design in 1968. In 1973 he devoted himself to photography and studied with Minor White. An independent photographer whose work combines autobiographical text and images, Mendoza was an instructor at the International Center of Photography in New York from 1982 until 1985, at Florida International University, Miami, from 1985 to 1987, and is currently teaching at Ohio State University, Columbus.

Scully, Julia. "Seeing Pictures: Tony Mendoza's Picture Stories Are Engaging, Amusing, and Disarmingly Honest." *Modern Photography* 50, no. 1 (January 1986): 10, 12.

Duane Michals
United States, b. 1932

Self Portrait as I Were Dead, 1968, printed later
Gelatin-silver print, ed. 8/25
5 x 7⁷⁄₁₆ in. (12.7 x 18.9 cm)
AC1992.197.92
PLATE 107

Educated at the University of Denver and Parsons School
of Design in New York, Michals began to work as a free-
lance photographer in 1958. His work has appeared in the
pages of *Vogue*, *Mademoiselle*, *Esquire*, and *Scientific
American*. Michals, who has taught periodically at the
New York School of the Visual Arts, is primarily known for
his photographic sequences and works that combine text
and images.

Livingstone, Marco. *Duane Michals: Photographs/
Sequences/Texts, 1958–1984*. Exh. cat. Oxford: Museum of
Modern Art, 1984.

Pierre Molinier
France, 1900–1976

226

Untitled, c. 1966
Gelatin-silver print
6¹¹⁄₁₆ x 4¹¹⁄₁₆ in. (17 x 11.9 cm)
AC1992.197.93
PLATE 98

A self-taught artist, Molinier was one of the founding
members of the Artistes Indépendants de Bordeaux in 1927.
After meeting André Breton in 1955, he took part in surre-
alist exhibitions. In 1966 he began employing multiple
images and retouching to assemble photomontages that
characteristically challenge preconceptions of identity
and gender.

Monterosso, Jean-Luc. "Molinier: The Precursor." *Cimaise*
37, no. 6 (June–August 1990): 85–92.

William Mortensen
United States, 1897–1965

Self-Portrait, 1932
Gelatin-silver print with texture screen
10⁵⁄₁₆ x 8⁷⁄₁₆ in. (26.2 x 21.4 cm)
AC1992.197.94
PLATE 50

Mortensen studied drawing and painting at the Art Students
League in New York. By 1925, after working as a staff pho-
tographer for Western Costume Company in Los Angeles
and opening his own commercial studio in Hollywood,
Mortensen had begun shooting movie stills, being the first
to do so using a small-format camera. In 1930 he founded
the Mortensen School of Photography in Laguna Beach,
California, which he ran for the next thirty years. One of
the chief proponents of pictorialism, Mortensen is best
known for his fantasy compositions, glamour portraits,
and female nude studies.

Irmas, Deborah. *The Photographic Magic of William
Mortensen*. Exh. cat. Los Angeles: Los Angeles Center for
Photographic Studies, 1979.

Georg Muche
Germany, 1895–1987

Self-Portrait, c. 1920
Gelatin-silver print
6¼ x 4¹¹⁄₁₆ in. (15.9 x 11.9 cm)
AC1992.197.95
PLATE 23

After studying painting in Munich and Berlin, Muche
taught at four different art schools in Berlin from 1913 to
1933, including eight years at the Bauhaus with Wassily
Kandinsky, László Moholy-Nagy, and Paul Klee. Muche's
work in the 1920s showed a mystical, abstract quality that
gradually became more figurative during the next decade.
His photography relied heavily on the visual precepts and
techniques of the Bauhaus. From 1939 until 1958 he taught
at the School of Textile Engineering in Krefeld, after which
he went into semiretirement, living in Lindau on Lake
Constance.

Neumann, Eckhard. *Bauhaus and Bauhaus People*. Rev. ed.
New York: Van Nostrand Reinhold, 1993.

Eadweard Muybridge
England, active United States, 1830–1904

A: Walking B: Ascending a Step C: Throwing the Disk D: Using a Shovel E, F: Using a Pick, 1885, printed 1887, from the series *Animal Locomotion*
Collotype print
11³⁄₁₆ x 10⅛ in. (38.4 x 25.7 cm)
AC1992.197.96
PLATE 9

Muybridge immigrated to the United States in 1850. He began the serious practice of photography while on an extended return visit to England in the 1860s. After returning to San Francisco in 1867, he undertook a successful series of photographic expeditions to Yosemite, Alaska, and Central America. Muybridge, in 1872, was the first to isolate and photograph successive stages of rapid movement. He continued his motion studies in California until 1883 when, at the invitation of the University of Pennsylvania, he relocated to Philadelphia to pursue more scientific investigations of people and animals in motion. The result, *Animal Locomotion*, was published in 1887.

Muybridge, Eadweard. *Human and Animal Locomotion*. New York: Dover Publications, 1979.

Nadar (Gaspard-Félix Tournachon)
France, 1820–1910

Self-Portrait in Indian Costume, c. 1863
Albumen print
6³⁄₁₆ x 4¹⁄₁₆ in. (15.7 x 10.3 cm)
AC1992.197.97
PLATE 5

Nadar studied medicine in Lyon before becoming an illustrator and journalist. Then, in 1854, he established a photographic portrait studio in Paris. His images quickly became the benchmark of portrait photography, and his studio was a gathering place for the leading intellectuals and artists of his day. An innovator, Nadar was the first to produce aerial photographs (taken from a balloon) and also the first to employ artificial lighting as a means by which to photograph.

Gosling, Nigel. *Nadar*. New York: Alfred A. Knopf, 1976.

Bruce Nauman
United States, b. 1941

Study for Holograms, 1970
Suite of five offset photolithographic prints; ed. 4/150, ed. 8/150, ed. 22/150, ed. 22/150, ed. 2/150
20⅜ x 26 in. each (51.7 x 66 cm)
AC1992.197.98.1–.5
PLATE 108

Nauman received his bachelor's degree from the University of Wisconsin, Madison, in 1964 and two years later earned his master of fine arts degree from the University of California, Davis, where, along with classmates Frank Owen and Steve Kaltenbach, he studied with William Wiley and Robert Arneson. He has worked alternately in paint, three-dimensional mixed media, performance, video, and holograms. Nauman had his first solo exhibition at the Leo Castelli Gallery in 1968 and was given a retrospective at the Los Angeles County Museum of Art in 1972.

Cordes, Christopher, ed. *Bruce Nauman, Prints 1970–1989: A Catalogue Raisonné*. New York: Castelli Graphics, 1989.

Floris Michael Neusüss
Germany, b. 1937

Photogram Principle, Self-Portrait, 1972
Gelatin-silver print
12¹⁵⁄₁₆ x 8 in. (32.8 x 20.3 cm)
AC1992.197.99
PLATE 106

Neusüss studied under Ernst Oberhoff in Wuppertal from 1956 to 1958, Hanna Seewald in Munich from 1958 to 1960, and Heinz Hajek-Halke and Helmut Lortz in Berlin from 1960 to 1962. He worked in the Staatliche Museen, Berlin, photo studio from 1962 to 1963 and then opened a studio of experimental photography in Munich in 1966. Since that time he has been working as an independent artist, exhibition organizer, arts administrator and educator, and photographer in Berlin, Vienna, Munich, and Kassel.

Neusüss, Floris M. *Das Fotogramm in der Kunst des 20.Jahrhunderts*. Cologne: DuMont Buchverlag, 1990.

Beaumont Newhall
United States, 1908–93

Self-Portrait at the Museum of Modern Art, New York,
1970, printed 1978
Gelatin-silver print
8⅜ x 13 in. (21.3 x 33 cm)
AC1992.197.100
PLATE 110

Educated at Harvard University (1926–31, 1933–34), the
University of Paris (1933), and the Courtauld Institute of
Art, University of London (1934), Newhall was both a pho-
tographer and a pioneer photohistorian. He served as the
first curator of photography at the Museum of Modern Art,
New York, from 1940 to 1945. In 1948 Newhall was named
curator of photography and ultimately director of the
George Eastman House in Rochester, New York, a position
he held until his retirement in 1971. He then taught at the
University of New Mexico, Albuquerque, while continuing
to write and publish. His 1949 book, *The History of
Photography*, was last revised in 1982 and has served as the
basic text for two generations of photohistorians.

Newhall, Beaumont. *Focus: Memoirs of a Life in Photography.*
Boston: Bullfinch Press/Little, Brown and Company, 1993.

Paul Outerbridge, Jr.
United States, 1896–1958

Untitled [Test Shot for 4 Roses Advertisement], c. 1938
Color carbro print
16⅛6 x 12¾ in. (40.8 x 32.4 cm)
AC1992.197.101
PLATE 71

Outerbridge received his training at the Art Students
League in New York, the Clarence White School of
Photography, and with the sculptor Alexander Archipenko.
He worked as a painter and designer while also doing free-
lance advertising photography. In 1925 he established a
studio in Paris, coming into contact with such artists as
Man Ray, Picasso, and Brancusi before returning to New
York in 1929 and reestablishing himself as a photographer.
His experimentation and use of tricolor carbro printing in
commercial photographs brought him much success. In
1940 Outerbridge published his book *Photographing in
Color* and three years later relocated to Laguna Beach,
California, where he worked as a portrait and advertising
photographer as well as a designer of women's fashions.

Dines, Elaine, ed. *Paul Outerbridge: A Singular Aesthetic.*
Santa Barbara: Arabesque Books, 1981.

Roger Parry
France, 1905–77

Self-Portrait, 1936
Gelatin-silver negative print
8⁵⁄₁₆ x 6½ in. (21.1 x 16.5 cm)
AC1992.197.102
PLATE 62

Educated in Paris at the École Nationale Supérieure des
Beaux-Arts and the École Nationale Supérieure des Arts
Décoratifs, Parry, a painter, worked as a draftsman and
designer until 1928. He was then introduced to photogra-
phy by Maurice Tabard, for whom he worked as an
assistant doing advertising illustration. Parry's photography
was used to illustrate Léon-Paul Fargue's *Banalité* in
1930—one of the earliest photographically illustrated
examples of surrealist literature. In 1932 his work was
included in an exhibition of the work of surrealist artists at
the Julien Levy Gallery in New York. After World War II
Parry became head of photography and art director for the
publishing house Gallimard.

Krauss, Rosalind E., and Jane Livingston. *L'Amour Fou:
Photography and Surrealism.* New York: Abbeville Press,
1985.

Irving Penn
United States, b. 1917

Self-Portrait, c. 1943
Gelatin-silver print
4⅛ x 7⅜ in. (10.5 x 18.7 cm)
AC1992.197.103
PLATE 96

Penn studied with Alexey Brodovitch at the Philadelphia
Museum School of Industrial Art from 1934 to 1938 before
becoming a designer in New York. In 1942, following a
year spent painting in Mexico, he returned to New York as
assistant art director for *Vogue* magazine. The following
year he contributed his first cover photograph. After serv-
ing as a documentary photographer in the American Field
Service, Penn returned to work with Condé Nast
Publications in 1946 and by 1953 had established his own
studio in New York as a freelance advertising, fashion, edi-
torial, and portrait photographer. In 1984 John Szarkowski
organized a retrospective of his work at the Museum of
Modern Art, New York.

Penn, Irving. *Passage: A Work Record.* New York: Alfred A.
Knopf, 1991.

Alphonse-Louis Poitevin
France, 1819–82

Self-Portrait, c. 1853
Salted-paper print
5⅝ x 4⅟₁₆ in. (14.3 x 10.3 cm)
AC1992.197.104
PLATE 1

A chemist and chemical engineer, Poitevin became interested in photographic processes after publication of the experiments of Louis-Jacques-Mandé Daguerre and William Henry Fox Talbot. His experiments led to the development of a means of photochemical engraving and laid the basis for photolithography. He held patents in France and England that included processes for collotype and carbon printing as well as for the production of a direct positive.

Frédéric Proust, "Le 3ᵉ homme de l'histoire de la photographie: Alphonse Poitevin (1819–1882)," *Prestige de la photographie*, no. 2 (September 1977): 4–59.

Edward Quigley
United States, 1898–1977

Self-Portrait, c. 1931
Gelatin-silver print
13⅟₁₆ x 10⅟₁₆ in. (35.4 x 27.7 cm)
AC1992.197.105
PLATE 37

Born in Philadelphia and self-taught as a photographer, Quigley began his career in 1920. A modernist, he exhibited alongside Edward Weston, Alfred Stieglitz, and Edward Steichen in a group exhibition at the Cleveland Museum of Art in 1934. Though he earned his living as a portrait and commercial photographer, Quigley was noted for his industrial and architectural studies as well as for his photograms and light abstractions.

Friedman, Barry, and Robert A. Sobieszek. *Edward Quigley: American Modernist*. Exh. cat. New York: Houk Friedman Gallery, 1991.

Arnulf Rainer
Austria, b. 1929

Untitled, 1975
Gelatin-silver print, crayon, and graphite
7 x 9⅜ in. (17.8 x 23.9 cm)
AC1992.197.106
PLATE 103

Rainer was a member of the surrealist group of painters who founded the Hundsgruppe in 1950. His gestalt approach to painting and abstraction is evident in his many extended bodies of work. He produced his *Crucifixion* series from 1953 to 1956; his *Übermalungen* (Overpaintings) occupied him from 1954 to 1965; and *Proportion Studies*, geometric collages constructed from colored paper and plastic objects, were realized between 1953 and 1959. In 1968 Rainer began to employ photographs as a base upon which to paint and draw, a method he used in the making of his *Facefarces*, *Bodyposes*, and *Hiroshima* series.

Rainer, Arnulf. *Remnants: Painted-over Paintings*. Trans. J. W. M. Willet. Stuttgart: Edition H. Mayer, 1978.

Oscar Gustav Rejlander
Sweden, active England, 1813–75

Self-Portrait, c. 1860
Albumen print
7⅞ x 5⅞ in. (20 x 14.9 cm)
AC1992.197.107
PLATE 6

Born and educated in Sweden, Rejlander studied painting and sculpture in Rome before arriving in England in 1841, where he subsequently learned photography from Nicholas Henneman in 1853. He moved to London in 1860 and began to concentrate more and more on photography, becoming quite celebrated after Queen Victoria purchased a print (one of three) of *The Two Ways of Life* (1857) for Prince Albert. Rejlander is most noted for his allegorical and theatrical tableaux produced through the use of multiple negatives.

Spencer, Stephanie Laine. "O.G. Rejlander: Art Photographer." Ph.D. diss., University of Michigan, 1981.

Emery P. Révés-Biró
Hungary, active United States, 1895–1975

Self-Portrait with Nude Model, 1930s
Toned gelatin-silver print
14⅞ x 11⅜ in. (37.8 x 28.9 cm)
AC1992.197.108
PLATE 44

Révés-Biró was a fashion photographer active in the United States during the 1920s and 1930s. His work was widely seen in *Harper's Bazaar* and other publications.

Werner Rohde
Germany, 1906–90

Self-Portrait, 1929, printed c. 1960
Gelatin-silver print (reversed negative)
9½ x 6¾ in. (24.1 x 17.2 cm)
AC1992.197.109
PLATE 34

Born in Bremen, Rohde began studying painting in 1925 at the Werkstatten Burg Giebichenstein in Halle, where he became familiar with the work of Hans Finsler, who was teaching photography there. By 1927 he was producing his own photomontage work. He continued to photograph during a two-year stay in Paris. After returning to Bremen in 1931, Rohde began producing fashion and advertising photography while still struggling as a painter. Following his service in the German army during World War II he worked as a stained-glass painter—his father's profession—until resuming his photographic work in the 1970s.

Taubhorn, Ingo, and Ferdinand Brüggemann. *Werner Rohde: Fotografien 1925–37*. Exh. cat. Essen: Museum Folkwang; Berlin: Nishen, 1992.

Lucas Samaras
Greece, active United States, b. 1936

Photo-Transformation 8/19/76, 1976
Manipulated dye-diffusion transfer (SX-70 Polaroid) print
3⅛ x 3¹⁄₁₆ in. (7.9 x 7.8 cm)
AC1992.197.110
PLATE 123

Samaras immigrated to the United States in 1948 and studied at Rutgers University, New Brunswick, New Jersey, with Allan Kaprow and at Columbia University, New York. Though he has worked as a painter and sculptor as well as participating in theater and "happenings," Samaras has concentrated on photography since the late 1960s. In 1970, working with a Polaroid 360, he produced his first "auto-portraits," autobiographical studies in which he recorded himself in all manner of disguise and contortion. Samaras began producing "photo-transformations" in 1973, manipulating the chemistry of Polaroid SX-70 images and creating an expressionistic and psychological commentary on the self-portrait. Samaras regularly inserts himself as well as evidence of process into his images, whether they be the still lifes he produced from 1978 to 1980, the large-scale portraits done from 1978 to 1983, or his more recent panoramas and grids.

Samaras, Lucas. *Samaras: The Photographs of Lucas Samaras*. New York: Aperture Foundation, 1987.

Jan Saudek
Czechoslovakia, b. 1935

The Target, 1984
Six toned and colored gelatin-silver prints
Approximately 8⅝ x 6½ in. each (21.9 x 16.5 cm)
AC1992.197.110.1–.6
PLATE 133

Born in Prague, Saudek studied there at the School for Industrial Photography. He has been a freelance photographer in Prague since the early 1950s. His work typically involves precise staging and direction in the production of sensuous and moody figure studies that are subsequently toned and hand-colored.

Saudek, Jan. *The World of Jan Saudek*. Millerton, New York: Aperture, 1983.

Cindy Sherman
United States, b. 1954

Untitled, Film Still #3, 1977
Gelatin-silver print, ed. 9/10
6⅜ x 9³⁄₁₆ in. (16.2 x 23.3 cm)
AC1992.197.112
PLATE 115

Untitled, Film Still #5, 1977
Gelatin-silver print, ed. 2/10
6¾ x 9½ in. (17.2 x 24.1 cm)
AC1992.197.113
PLATE 116

Educated at State University of New York College at Buffalo, Sherman works as an independent photographer and artist in New York. Her fabricated and directed images, in which she assumes the role of both photographer and photographed, are at once iconic and narrative. In her series *Untitled Film Stills* she used stereotypical images of women, appropriated from cinema and television, in order to raise and examine issues of self-identity. In her *History Picture* series Sherman used postmodern strategies to probe the position and role of the artist. A major exhibition of her work was organized in 1987 by the Akron Art Museum and was subsequently seen at the Whitney Museum of American Art, New York, and the Institute of Contemporary Art, Boston.

Sherman, Cindy. *Cindy Sherman*. New York: Pantheon Books, 1984.

Arthur Siegel
United States, 1913–78

Self-Portrait with Abbott Distortion Easel, 1937
Gelatin-silver print
13¹⁄₁₆ x 9 in. (33.2 x 22.9 cm)
AC1992.197.114
PLATE 68

Educated at the University of Michigan, Ann Arbor, and at Wayne State University, Detroit, Siegel studied photography under László Moholy-Nagy at the New Bauhaus School in Chicago. During the 1940s he worked as a photographer for Roy Stryker at the Farm Security Administration, for the Office of War Information, and for the United States Air Corps Aerial Photography Department. Following World War II he worked as a freelance magazine and industrial photographer. Until 1968, when Siegel began to focus more exclusively on teaching at Wayne State and the Chicago Institute of Design, his work had been seen regularly in the pages of *Life*, *Fortune*, and *Time*.

Edwynn Houk Gallery, Chicago. *Arthur Siegel: Retrospective*. Exh. cat., 1982.

W. Eugene Smith
United States, 1918–78

Self-Portrait, c. 1968
From the series *The Loft from Inside In*
Gelatin-silver print
13⅜ x 9½ in. (34 x 24.1 cm)
AC1992.197.115
PLATE 95

Primarily self-taught as a photographer, Smith studied at the University of Notre Dame. He worked as a freelance photojournalist in New York until serving as a photographer and war correspondent in the Pacific during World War II. After the war he resumed work as a photojournalist and educator. His affiliation with *Life* magazine during the 1940s and 1950s resulted in his most recognizable photo-essays, "The Country Doctor," "Spanish Village," and "A Man of Mercy." Smith worked as an independent documentary photographer from 1954 until 1975, when he published *Minimata*, his last effort, a chronicle of the effects of industrial pollution on a Japanese city and its people.

Willumson, Glenn G. W. *Eugene Smith and the Photographic Essay*. Cambridge: Cambridge University Press, 1992.

Michael Spano
United States, b. 1949

Self-Portrait with Eyepatch, 1987, printed 1988
Solarized gelatin-silver print, ed. 1/15
22¼ x 16⅜ in. (56.5 x 41.6 cm)
AC1992.197.116
PLATE 129

Following his undergraduate work at Queens College, New York, Spano earned a master of fine arts degree from Yale University, New Haven. A street photographer who works with panoramic and sequence cameras, he also teaches at the School of the Arts in New York and serves as curator for the Midtown Y Photography Gallery. Spano's work was included in the 1985 exhibition *New Photography* at the Museum of Modern Art, New York.

Laurence Miller Contemporary Photographs, New York. *Michael Spano: Constructions*. Exh. cat., 1990.

Anton Stankowski

Germany, b. 1906

Simultaneous Enlargement, 1937
Gelatin-silver print
11 x 7⅜ in. (27.9 x 18.7 cm)
AC1992.197.117
PLATE 42

After studying with Max Burchardt at the Folkwangschule in Essen from 1927 to 1929, Stankowski worked as a freelance painter and graphic designer in Zurich and then in Stuttgart until 1940. Following his service in the German army and internment as a prisoner of war during World War II he resumed his career as a graphic and commercial artist. In 1972 he was the head of visual design for the xx[th] Olympiad in Munich.

Rattemeyer, Volker. *Anton Stankowski: Aspekte des Gesamtwerks.* Exh. cat. Kassel: Orangerie, 1986.

Elfriede Stegemeyer

Germany, b. 1908

Self-Portrait, 1933
Gelatin-silver print
9⅜ x 7 in. (23.9 x 17.8 cm)
AC1992.197.118
PLATE 55

Stegemeyer attended universities in Berlin and Munich, studying art history and geography. She began to study photography at the Kunstgewerbeschule Fotografie after moving with Otto Coenen to Cologne in 1931. Traveling to Paris with Coenen, she was introduced to Raoul Hausmann, with whom she was to work for the next few years. Following World War II she moved to Innsbruck, Austria, where she began to concentrate on painting. Her photographic work during the 1930s is typical of her "new objectivity" contemporaries, those artists reacting against expressionism. The first exhibition of her work in the United States was held in 1983 at Sander Gallery in New York.

Lichtenstein, Therese. "Exhibition Review: Elfriede Stegemeyer at Sander Gallery." *Arts* 58, no. 6 (February 1984): 37.

Edward Steichen

Luxembourg, active United States, 1879–1973

Self-Portrait with Brush and Palette, Paris, 1901, printed 1903
Photogravure print
8⁷⁄₁₆ x 6⅜ in. (21.5 x 16.2 cm)
AC1992.197.119
PLATE 15

Steichen immigrated to the United States with his family in 1881. He studied painting at the Art Students League in Milwaukee but was largely self-taught as a photographer. A member of the Photo-Secession, he worked closely with Alfred Stieglitz at the gallery "291," which opened in 1905. Steichen was a painter and photographer in both New York and Paris until 1922; then he began concentrating exclusively on his photography in New York. He established a career as an advertising, fashion, and portrait photographer working for such clients as Condé Nast Publications and the J. Walter Thompson advertising agency. Following his service as director of the United States Navy Photographic Institute during World War II, Steichen became the first director of the Department of Photography at the Museum of Modern Art, New York, a position he held from 1947 to 1962.

Kelton, Ruth. *Edward Steichen.* Millerton, New York: Aperture, 1978.

Ralph Steiner

United States, 1899–1986

Self-Portrait, 1929, printed 1980
Gelatin-silver print
9⅜ x 7⁹⁄₁₆ in. (24.5 x 19.2 cm)
AC1992.197.120
PLATE 36

Educated at Dartmouth College, Hanover, New Hampshire, Steiner then studied at the Clarence White School of Photography in New York from 1921 to 1922. He began a career as an advertising and public relations photographer in 1923, but after meeting Paul Strand in 1928, he increasingly concentrated on freelance work and filmmaking.

Zucker, Joel Stewart. "Ralph Steiner, Filmmaker and Still Photographer." Ph.D. diss., New York University, 1976.

Alfred Stieglitz
United States, 1864–1946

Self-Portrait, Cortina, 1890, printed c. 1934
Gelatin-silver print
4⅞ x 6¹¹⁄₁₆ in. (12.4 x 16.7 cm)
AC1992.197.121
PLATE 12

Educated in New York and Berlin, Stieglitz began to photograph while living in Germany. Returning to the United States in 1890, he was active with the Amateur Photographers of New York and was a contributor to the *American Amateur Photographer*. By 1897 he founded and was editor of *Camera Notes*, published by the New York Camera Club. In 1902 he led the formation of the Photo-Secession and the following year began publishing and editing *Camera Work*, which continued for the next fourteen years. He opened the Little Galleries of the Photo-Secession ("291"), where he exhibited and championed the new "modern" art and its creators. The closure of "291" coincided with the demise of *Camera Work* in 1917. He directed the Intimate Gallery from 1925 to 1929 and then An American Place until 1943, primarily promoting modern painting, including that of his wife, Georgia O'Keeffe, to whom he was married in 1924. Stieglitz's own photographic work included insightful psychological portraits, soft-focus and straight modernist compositions, and his "equivalents" series of cloudscapes.

Greenough, Sarah, and Juan Hamilton. *Alfred Stieglitz: Photographs and Writings.* Exh. cat. Washington, D.C.: National Gallery of Art, 1983.

Seneca Ray Stoddard
United States, 1843–1917

Glass Globe at Fort William Henry Hotel, New York,
c. 1885
Toned albumen print
3¹¹⁄₁₆ x 2¹⁵⁄₁₆ in. (9.3 x 7.5 cm)
AC1992.197.122
PLATE 7

Stoddard worked as a painter, lecturer, cartographer, surveyor, and, by 1867, a landscape photographer, concentrating on the Adirondacks region. His stereo and large-format views were primarily produced for the tourist trade but were also used as source material for painters and as telling documentation during the legislative struggle to ensure the preservation of the Adirondacks region.

Fuller, John. "The Collective Vision and Beyond—Seneca Ray Stoddard's Photography." *History of Photography* 11, no. 3 (July–September 1987): 217–27.

Lou Stoumen
United States, 1917–91

My Feet and Shoes, Saylor's Lake, PA, 1935
Gelatin-silver print
10½ x 10¹⁄₁₆ in. (26.7 x 25.5 cm)
AC1992.197.123
PLATE 60

A self-described street photographer, Stoumen was educated at Lehigh University, Bethlehem, Pennsylvania. He became a member of the Photo League in New York and was the editor of its monthly publication in January 1941. He then joined the United States Army as a combat photographer and war correspondent. Following the war he began working as a freelance photographer, journalist, and eventually filmmaker. Stoumen's photographs were included in the *Family of Man* exhibition at the Museum of Modern Art, New York, in 1955, and he has received two Academy Awards, in 1957 and 1964, for his documentary filmmaking.

Enyeart, James L. *Lou Stoumen: Photographs 1934–1977.* Exh. cat. Carmel, California: Friends of Photography, 1978.

Tato (Guglielmo Sansoni)
Italy, 1896–1974

Self-Portrait, 1923
Gelatin-silver print
4⅛ x 5⅞ in. (10.5 x 14.9 cm)
AC1992.197.124
PLATE 22

Self-taught as a painter and photographer, Tato adopted his
pseudonym as he became involved with the second-genera-
tion futurists in Bologna in 1919. In his photography of the
1920s and 1930s he employed photomontage, photocollage,
and multiple exposures to continue in the "photodynamist"
tradition of futurist photographer Anton Giulio Bragaglia.
Like Bragaglia, Tato, with his multiple-image and portrait
photography, attempted to convey the emotional, psycho-
logical, and spiritual as opposed to merely rendering
a likeness.

Lista, Giovanni. *I futuristi e la fotografia: Creazione fotograph-
ica e immagine quotidiana.* Modena: Panini, 1985.

Val Telberg
Russia, active United States, b. 1910

Self-Portrait in St. Mark's Place, c. 1948
Gelatin-silver print
9¹⁵⁄₁₆ x 7¹⁵⁄₁₆ in. (25.3 x 20.2 cm)
AC1992.197.125
PLATE 90

Born in Moscow, Telberg was educated in England, France,
Japan, and the United States and earned a degree in chem-
istry from Wittenberg College, Springfield, Ohio, in 1932.
He was self-taught as a painter until attending painting
and cinematography classes at the Art Students League in
New York in 1942. Moving to Florida, he supported him-
self by photographing nightclub patrons and operating a
tourist photo concession, but he began a career as a pho-
tographer in earnest when he returned to New York in
1944. In 1968 he moved to Sag Harbor, New York, where,
in addition to photomontage, he began producing multime-
dia artworks and nonobjective sculpture.

San Francisco Museum of Modern Art. *Val Telberg.*
Exh. cat., 1983.

Jerry Uelsmann
United States, b. 1934

Bob and I and Other Friendly Creatures, 1971
Gelatin-silver print montage
8⅝ x 7 in. (22 x 17.8 cm)
AC1992.197.126
PLATE 105

Uelsmann studied photography as an undergraduate at the
Rochester Institute of Technology with Ralph Hattersley
and Minor White from 1953 to 1957. In 1960 he received a
master of fine arts degree from Indiana University,
Bloomington, having studied under Henry Holmes Smith.
His distinctive use of photomontage allows for the seam-
less assembly of mythic and personal worlds. In addition to
working as a photographer, Uelsmann has taught at the
University of Florida, Gainesville, since 1960.

Enyeart, James L. *Jerry N. Uelsmann, Twenty-five Years:
A Retrospective.* Boston: New York Graphic Society, 1982.

Umbo (Otto Umbehr)
Germany, 1902–80

Self-Portrait on Beach, c. 1930, printed 1980
Gelatin-silver print, ed. 33/50
11⁷⁄₁₆ x 8⅝ in. (29.1 x 22 cm)
AC1992.197.127
PLATE 33

Umbo studied art under Walter Gropius, Paul Klee, and
Wassily Kandinsky at the Weimar Bauhaus. He was a
studio photographer and photojournalist in Berlin until
1945 and then relocated to Hannover, where he continued
to work until his death. He served as a photography
instructor in Bad Pyrmont, Hannover, and Hildesheim.

Spectrum Photogalerie, Hannover. *Umbo: Photographien,
1925–1933.* Exh. cat., 1979.

Susan Unterberg
United States, b. 1941

Self-Portrait, 1984
Chromogenic development (Ektacolor) print (from an
SX-70 Polaroid)
18¾ x 18⁷⁄₁₆ in. (47.6 x 47 cm)
AC1992.197.128
PLATE 132

Educated at Bennington College, Bennington, Vermont,
and Sarah Lawrence College, Bronxville, New York,
Unterberg earned a master's degree in photography from
New York University in 1985. Recently she has produced
diptych studies concerned with the relationships between
mothers and daughters and between fathers and sons.

Laurence Miller Contemporary Photographs, New York.
Susan Unterberg: Fathers and Sons. Exh. cat., 1990.

James Van Der Zee
United States, 1886–1983

Self-Portrait in a Boater Hat, c. 1925
Gelatin-silver print
9⅜ x 7 in. (23.9 x 17.8 cm)
AC1992.197.129
PLATE 25

Self-taught as a photographer, Van Der Zee worked as
a darkroom assistant and photographer in a New York
department store until establishing his own studio in
Harlem in 1916. His efforts as a portraitist and indepen-
dent photographer served to document African-American
life in Harlem between 1916 and 1969, when he retired.
Van Der Zee resumed work as a professional photographer
only three years preceding his death.

Willis-Braithwaite, Deborah. *Van Der Zee: Photographer,
1886–1983.* Exh. cat. New York: Harry N. Abrams in associa-
tion with the National Portrait Gallery, 1993.

Carl Van Vechten
United States, 1880–1964

Self-Portrait, 1934
Gelatin-silver print
13⅞ x 10¹⁵⁄₁₆ in. (35.2 x 27.6 cm)
AC1992.197.130
PLATE 54

Van Vechten was educated at the University of Chicago and
was largely self-taught as a photographer. A drama, liter-
ary, and music critic as well as a writer, editor, and
novelist, Van Vechten worked as an independent portrait
photographer in New York from 1932 until his death. His
portraits of major theatrical and literary figures provide a
stylish and diverse cultural document of his time.

Davis, Keith F. *The Passionate Observer: Photographs by Carl
Van Vechten.* Kansas City, Missouri: Hallmark Cards, 1993.

Roman Vishniac
Russia, active Europe and United States, 1897–1988

Notre Dame de Paris, c. 1935
Gelatin-silver print
6¼ x 5 in. (15.9 x 12.7 cm)
AC1992.197.131
PLATE 59

Educated in Moscow and Berlin as a medical scientist and
orientalist, Vishniac was a self-taught photographer. In his
early documentary work he chronicled Jewish life and culture
in Germany and Eastern Europe until his immigration to the
United States in 1940. In New York he worked as a freelance
portrait photographer as well as a medical microphotogra-
pher. In 1983 his images of the Warsaw ghetto during the
1930s were published as *A Vanished World*.

Capa, Cornell, and Bhupendra Karia, eds. *Roman Vishniac.*
New York: Grossman Publishers, 1974.

Andy Warhol
United States, 1928–87

Untitled, 1964
Gelatin-silver print
7¾ x 1½ in. (19.7 x 3.8 cm)
AC1992.197.132
PLATE 97

Warhol received a bachelor of arts degree from Carnegie Institute of Technology, Pittsburgh, in 1949 and then moved to New York to work as a commercial artist and illustrator. Drawing upon his commercial experience and the imagery of consumer culture, Warhol began as a painter, reproducing the icons of 1960s America. By 1963 he had begun to use photo-silkscreen techniques and the duplication of appropriated imagery from advertising and newspapers to explore the interstices connecting popular culture, art, and the artist. Warhol also made use of snapshot polaroids and photo-booth images, practiced filmmaking, and ran his own production studio and artist's space, the Factory.

McShine, Kynaston, et al. *Andy Warhol: A Retrospective.* Exh. cat. New York: Museum of Modern Art, 1989.

Weegee (Arthur Fellig)
Austria, active United States, 1899–1968

Self-Portrait, c. 1940
Gelatin-silver print
13⁷⁄₁₆ x 10⅝ in. (34.2 x 27 cm)
AC1992.197.133
PLATE 76

236

Weegee (a name adopted in 1938 as a pun on the then-popular fortune-telling Ouija board and as a comment on his prescient appearance at crime scenes) immigrated to the United States in 1910. Primarily self-taught as a photographer, he worked as a tintype operator, photographic assistant, and independent street photographer before becoming a freelance news photographer in New York for such organizations as UPI, the *Herald Tribune*, the *Daily News*, the *Post*, and the *World Telegram*. Weegee also worked as a contract photographer, lecturer, film consultant, and sometime actor.

Stettner, Louis. *Weegee.* New York: Alfred A. Knopf, 1977.

William Wegman
United States, b. 1946

Half and Halfs, 1973
Two gelatin-silver prints (diptych)
7 x 10¹³⁄₁₆ in. each (17.8 x 27.5 cm)
AC1992.197.134.1–.2
PLATE 109

Wegman, an independent photographer and educator working in California and New York, was educated at the Massachusetts College of Art, Boston, and the University of Illinois, Urbana. While best known for his staged scenarios featuring his weimaraners Man Ray, Fay Ray, and Bettina, Wegman is also active as a video and conceptual artist.

Wegman, William. *William Wegman: Paintings, Drawings, Photographs, Videotapes.* New York: Harry N. Abrams, 1990.

Edward Weston
United States, 1886–1958

Self-Portrait, 1911
Toned gelatin-silver print
9 x 7 in. (22.9 x 17.8 cm)
AC1992.197.135
PLATE 18

Primarily self-taught as a photographer before he attended the Illinois College of Photography, Chicago, Weston opened his own studio in Tropico (now Glendale), California, in 1911. His production of soft-focus pictorialist images gave way in 1922 to the harder, more modernist images with which he is most readily associated. In 1930 Weston was a founding member of Group f/64 along with Ansel Adams, Imogen Cunningham, Sonya Noskowiak, Henry Swift, Willard Van Dyke, and John Paul Edwards. Apart from photographing in Mexico from 1923 to 1926, the major part of his work was done in California. Weston's still lifes, nudes, and landscapes won wide acclaim and became the subject of a retrospective at the Museum of Modern Art, New York, in 1946.

Newhall, Beaumont. *Supreme Instants: The Photography of Edward Weston.* Boston: Little, Brown and Company, 1986.

Joel-Peter Witkin
United States, b. 1939

Portrait of Joel, 1984
Toned gelatin-silver print
14⅝ x 14⁹⁄₁₆ in. (37.2 x 37 cm)
AC1992.197.136
PLATE 134

Witkin studied sculpture at Cooper Union, New York,
and photography at the University of New Mexico,
Albuquerque. He has worked as an independent photogra-
pher since 1956; however, he has also been a combat
photographer in the United States Army, a color-photo
printer, a photography dealer, writer, and educator. He
currently resides and works in New Mexico, producing
large allegories that blend the sensual and the macabre.

Witkin, Joel-Peter. *Joel-Peter Witkin: Photographs*. Pasadena:
Twelvetrees Press, 1985.

Max Yavno
United States, 1911–85

Self-Portrait with Camera, 1977
Toned gelatin-silver print
11⁵⁄₁₆ x 10½ in. (28.7 x 26.7 cm)
AC1992.197.137
PLATE 111

Yavno, a self-taught photographer, was educated at the
City University of New York, Columbia University, and
later at the University of California, Los Angeles. He
worked as a freelance landscape, commercial, and docu-
mentary photographer in San Francisco from 1945. Yavno's
commercial images were seen in *Vogue* and *Harper's
Bazaar*. His documentary images of New York (1938–41
and 1979), Los Angeles (1945–49 and 1975–80), San
Francisco (1947), Jerusalem (1979), and Cairo (1979)
demonstrate a particularly urban sense of irony and drama.

Yavno, Max. *The Photography of Max Yavno*. Berkeley:
University of California Press, 1981.

Piet Zwart
The Netherlands, 1885–1977

Untitled, c. 1930
Gelatin-silver print
4⅞ x 6¹⁵⁄₁₆ in. (12.4 x 17.6 cm)
AC1992.197.138
PLATE 45

Zwart was educated at the Technische Hogeschool in Delft
and the Rijksschool voor Kunstnijverheid but was primar-
ily self-taught as a photographer and montage artist. He
worked as a graphic, industrial, commercial, and interior
designer as well as an architect and photographer. He
taught design in Rotterdam from 1919 until 1933 and in
Berlin at the Bauhaus in 1931. Zwart began to incorporate
photography into his work as a freelance graphic designer
after 1945.

Haags Gemeentemuseum, The Hague. *Piet Zwart*. Exh.
cat., 1973.

Abé, Kobo. *The Face of Another*. Trans. E. Dale Saunders. Tokyo: Charles E. Tuttle, 1966.

Ashbery, John. "Self-Portrait in a Convex Mirror." *Self-Portrait in a Convex Mirror*. New York: Viking Press, 1975, 68–83.

Aumont, Jacques. "Image, Visage, Passage." In Musée National d'Art Moderne. *Passages de l'image*. Paris: Editions du Centre Pompidou, 1990, 61–70.

Brooks, Peter. *The Melodramatic Imagination: Balzac, Henry James, Melodrama, and the Mode of Excess*. New Haven: Yale University Press, 1976.

Canguilhem, Georges. *The Normal and the Pathological*. Trans. Carolyn R. Fawcett with Robert S. Cohen. New York: Zone Books, 1989.

Centre National de la Photographie, Paris. *Identités: De Disdéri au photomaton*. Exh. cat., 1985.

Clark, Graham, ed. *The Portrait in Photography*. London: Reaktion Books, 1992.

Selected

Billeter, Erika, ed. *Self-Portrait in the Age of Photography: Photographers Reflecting Their Own Image*. Lausanne: Musée Cantonal des Beaux-Arts, 1986.

Duchenne (de Boulogne), G.-B. *Album de photographies pathologiques complémentaire du livre intitulé de l'électrisation localisée*. Paris: J.-B. Baillière et fils, 1862.

Ekman, Paul. *Emotion in the Human Face*. 2nd ed. Cambridge: Cambridge University Press, 1982.

Frank, Peter. "Auto-Art: Self-Indulgent? And How!" *Art News* 75, no. 7 (September 1976): 43–48.

Gottlieb, Carla. "Self-Portraiture in Postmodern Art." *Wallraf-Richartz Jahr*, no. 42 (1981), 267–302.

Landau, Terry. *About Faces: The Evolution of the Human Face.* New York: Doubleday, 1989.

Lavater, Johann Caspar. *Essays on Physiognomy...Illustrated by...or under the Inspection of Thomas Holloway.* Trans. Henry Hunter. London: J. Murray, 1789–98.

Maddow, Ben. *Faces: A Narrative History of the Portrait in Photography.* Boston: New York Graphic Society, 1977.

Magli, Patrizia. "The Face and the Soul." Trans. Ughetta Lubin. In *Zone 4: Fragments for a History of the Human Body, Part Two.* Ed. Michel Feher et al. New York: Zone Books, 1989, 86–127.

Sekula, Allan. "The Body and the Archive." *October* 39 (Winter 1986): 3–64. Reprinted in *The Contest of Meaning: Critical Histories of Photography.* Ed. Richard Bolton. Cambridge: MIT Press, 1989, 342–88.

Serpa, Luís, ed. *"Je est un autre" de Rimbaud.* Lisbon: Galeria Cómicos/Luís Serpa, 1990.

Sischy, Ingrid. "Self-Portraits in Photography." *The Print Collector's Newsletter*, no. 10 (January 1980): 189–93.

Starenko, Michael. "I to Eye." *Afterimage* 13, no. 6 (January 1986): 17.

Bibliography

Lingwood, James, ed. *Staging the Self: Self-Portrait Photography 1840s–1980s.* London: National Portrait Gallery, 1986.

Miami University Art Museum, Oxford, Ohio. *Reflections: Woman's Self-Image in Contemporary Photography.* Exh. cat., 1988.

Rose, Barbara. "Self-Portraiture: Theme with a Thousand Faces." *Art in America* 63, no. 1 (January 1975): 66–73.

Varnedoe, Kirk. "The Self and Others in Modern Portraits." *Art News* 75, no. 8 (October 1976): 64–70.

Welchman, John. "Face(t)s: Notes on Faciality." *Artforum* 27, no. 3 (November 1988): 131–38.